HIDDEN HISTORY

HISTORY

of

COLONIAL GREENWICH

Missy Wolfe

THE
History
PRESS

Published by The History Press
Charleston, SC
www.historypress.net

Front cover: Charles Mead House on Indian Field Road, circa 1889. *From the archives of the Greenwich Historical Society.*

Maps provided by the author, digitally created by Jennifer Reynolds, www.jenren.com.

First published 2018

ISBN 9781540227959

Library of Congress Control Number: 2017955899

Notice: The information in this book is true and complete to the best of our knowledge. It is offered without guarantee on the part of the author or The History Press. The author and The History Press disclaim all liability in connection with the use of this book.

In an engaging narrative informed by her transcriptions of seventeenth-century records in the Town's archives, Missy Wolfe provides fascinating insights that illuminate the challenges faced by settlers of a frontier town far removed from the colonial powers who fought over its boundaries. Readers will be entertained by the everyday details of creating order out of chaos through land lotteries, common fields and regulations to protect one's livestock and crops while sharing in the mandatory responsibilities to maintain the roads, build bridges and care for the poor.

—*Debra Mecky, Executive Director, Greenwich Historical Society*

CONTENTS

ACKNOWLEDGEMENTS

I am deeply grateful to the Greenwich town clerk, Carmella Budkins, for allowing me to transcribe and chronologically order the town's earliest archives, which form the basis for the information in this text. Debra Mecky, executive director of the Greenwich Historical Society, and archivist Christopher Shields were also very helpful over the several years it took to transcribe and write this story. Historian Joseph Zeranski added critical insights and Sam Sturgis of New England Historic Genealogical Society is collaborating with me to eventually post the transcriptions and photographs of each of the 1,500-plus handwritten town archive documents. Editors Elizabeth Bruno, Patty Brooks Walker and Abigail Fleming were invaluable aids and eyes, as was historical consultant Dr. Charles Gehring, director of the New Netherland Research Project.

My husband, Scott Wolfe, provided constant love, support and advice. I could not hope for a better team to complete this work about a town that I treasure.

Prologue

THE ARCHIVES OF
THE FIRST CENTURY

This history is only possible through the comprehensive transcription of the Town of Greenwich archives from the 1600s and early 1700s. Located in the Greenwich Town Hall's Vital Records Vault, the first Land Records and Commonplace Books, "as bound," are wonderfully conserved, but until the advent of modern dictation technology, they were neither fully transcribed nor in any semblance of chronological order. These documents from three centuries ago were hand-written by second-generation local Puritans who first governed the town. The documents were written by clerks or recorders who used turkey and goose quills to record meetings and land transactions by candle and firelight in brave little homes set in a vast, undeveloped and challenging wilderness. Their writing is legible in many cases and difficult to discern in others. It informs one of antique syntax, period punctuation and local colonial and European slang. The writing is often tiny and without margins, maximizing the use of scarce and imported English ledger paper. The documents come from multiple ledgers that have lost their bindings over time and turmoil and sometimes their page numbers. They are occasionally bound upside-down and often badly faded. Through re-ordering and complete transcription, these first documents tell this full story of the creation of the town, a rich and largely unknown tapestry of social, civic, theological and agricultural construction.

The town-wide, communally and privately farmed Greenwich Plantation was a great labor, carved out of an unforgiving, rocky forest and re-imagined as a new kind of Protestant society that also rejected some of the

governance, economics and land ownership rules of English towns. This great effort sought to create a community that would please God better with its new theology, construction and management. On land previously burned, farmed, hunted and fished by Native Americans, a small, wooden neighborhood emerged, and miles of crude fencing were erected to enclose crops and "ruleable" cattle. Stones lying still for centuries were cleared to make rock walls, "hyways," animal pounds, chimneys and bridges. Trees were burned to make charcoal, and the bark was boiled for its tannins. Ancient Native American shell middens were shoveled away and burned to make lime and mortar. Mudflats and marshes were furrowed into saltworks. Vast common fields were created all along the Greenwich shoreline, replacing Indian grounds with winter wheat, flax, hay, corn and fruit orchards.

This plantation was extensively constructed, monitored, maintained, taxed, repaired and improved, but it operated for only one century. Almost forgotten forever, save its handwritten recording, this first Greenwich was almost completely destroyed and its livestock stolen in the American Revolution. Both English and Rebel troops were garrisoned in this "gateway to New England," and miles of its fencing were pulled up for fuel. Its large herds of livestock fed hungry soldiers. The town limped along as a decimated farming community, laid low again by the Civil War, until the arrival of the railroad in the late 1800s. Greenwich found new life as a resort destination. It marched forward, leaving its first century of international dispute, jurisdictional struggle, town creation and plantation past only on the shelves of the Town Hall Vital Records Vault.

RECORDKEEPING

From 1640 to 1656, Greenwich records were kept at Fort Amsterdam on Manhattan's southern tip. Town founders Robert and Elizabeth Feake and Daniel and Anna Patrick had the 1640s baptisms of their children recorded within Dutch New York archives, and the document confirming the famously scandalous divorce of Elizabeth Winthrop Feake Hallett is found there as well.

When the English took Dutch territories in 1664, barrels of paperwork, some likely concerning Greenwich, were burned by English soldiers. Remaining records were stored for safekeeping during the American Revolution in moldy conditions on ships anchored in New York Harbor.

They eventually made their way to the State Library in Albany, where they almost perished completely in the great State Library fire of 1911.

In 1664, the Connecticut Colony assumed jurisdiction over Greenwich after the collapse of the New Haven Colony, and it mandated local town governance and recordkeeping. Significant documentation began to be produced in the 1660s recording the creation of the town. Each conserved page of these records is now numbered by this author with modern page and document numbers. These document numbers are the reference numbers cited in the Endnotes as [xxx]. The transcribed records compose:

Land Records Book One Part One: Documents #1–406A
Land Records Book One Part Two: Documents #407–733
Land Records Book Two Part One: Documents #1275–1552
Common Place Book One: Documents #734–1176
Common Place Book Two: Documents #1177–1272

This document and page numbering sequence has been developed to supplement the numbering system used by the Grantee/Grantor Index Book #1. Numbered stickers have been placed on all pages of the transcribed books to note both page number and document number such that in the future a citation may read: [GLRB 1 / 2: 114, Doc. #167] (Greenwich Land Record Book One Part Two, Page number 114, Document #167, or [167] meaning Document #167.

Annotated transcriptions of these documents will eventually be paired with high-resolution photography. They will be posted online in chronological order at the website of the New England Historical and Genealogical Society in a fully searchable PDF format.

DOUBLE DATING FORMAT ON ARCHIVE DOCUMENTS

The double date format was used to note the difference between Julian/Old Style and Gregorian/New Style calendars. The English used Old Style, in which the New Year began on March 1 and dates were ten days later than New Style. The Dutch used New Style and the new year, which started the year at the beginning of January. To reconcile dates falling between January and March in a year would be written, for example, as 1640/1.

Spelling within the original archives is often phonetic and inconsistent, and the same is true for 1600s grammar and punctuation. Such inconsistency occurs by the same town clerk and between clerks. For modern readability, consistent, modern spellings, capitalizations, indentation and sentence periods have been adopted in this narrative. The most frequently used surname spelling of the period for an individual is also used, as there may have been up to nine different variations. Quoted content maintains the flavor and thought process of the era.

GROENVITS AT FIRST

The contrast of modern Greenwich, Connecticut, a cosmopolitan town now famous for its amenities and elegance with its wild, seventeenth-century beginning, frankly defies imagination. There used to be endless views of open pastures stretching to Long Island Sound, vast common fields that hosted huge flocks of sheep, swine, horses and cows. There were cranberry meadows, nut plains, rock quarries, impassible rock ridges, salt marshes, swamps and dark forests. When the Europeans arrived, the landscape began its dramatic change, even though Native Americans had been burning land for centuries to remove brush for easier planting and hunting and to improve long distance viewing and travel. Nowadays, the town sports thousands of grand houses, swish country clubs, swank boutiques, global corporations, crowded roads, and a noisy, yet economically vital railroad, plus two interstate highways.

The town's first incarnation was another world entirely, where bobcat, bear, wolf and beaver roamed free, great, lumbering oxen teams pulled plows in rocky meadows, sheep were sheared near the shoreline, cow herds crossed the Mianus River and wooden piping systems called waterworks drained boggy wetlands. Saltworks lay along the Mianus River and Long Island Sound; hay, corn, wheat and flax was grown; Indian wampum paid bills; and many local tanneries turned livestock into leather, shoes and gloves.

Native Americans were betrayed, angry, co-opted and estranged. The first Europeans here fought brutal battles with the regional Munsees, and relations stayed distrustful for decades. Puritan planners thought carefully

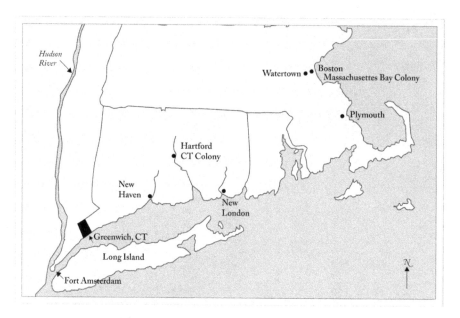

Greenwich in relation to Connecticut.

about how Greenwich could best be used communally and privately and how to distribute it equitably, but only among themselves.

At its founding in 1640, Greenwich was a rough, unknown and unclaimed borderland, uniquely sited between the grand claims of New Netherland to its south and those of New England to its north. These global forces fought dirty and diplomatically over claiming it, ultimately sending arrest warrants and armed soldiers to secure it. The second-generation Puritans who created the town were true to the Protestant spirit of their parents, and they relished defying authority even here. Ornery and outspoken, they stood their ground with grit in many a town meeting. Driven and sometimes daunted by Greenwich geography, they reordered the landscape to solve their problems pragmatically.

Not the placid two-dimensional caricatures of a joyless people who only went to church and wore tall gray hats with a buckle in the center, the second generation of Greenwich Puritans were tough, testy and determined. They were planters, cowboys and cowgirls, breaking wild horses for domestic use, riding and repairing long fences, clearing stony fields and planting, weeding, hoeing and harvesting—working a wild, wild East into not-so-subtle submission. They swam in rivers and ponds and at Greenwich Point. Both men and women, boys and girls, hunted, trapped and shot for their defense

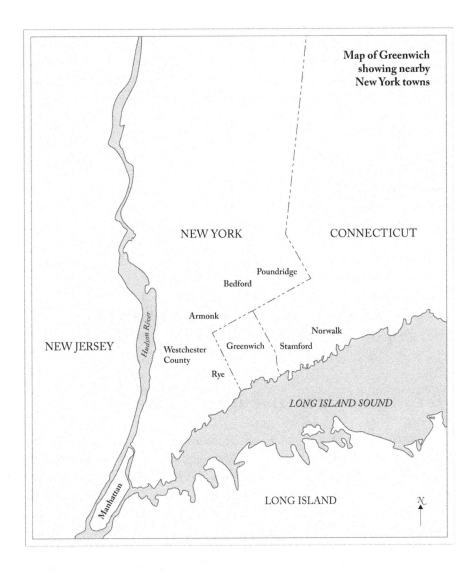

Map of Greenwich
showing nearby
New York towns

NEW YORK CONNECTICUT

Poundridge
Bedford

Armonk

Norwalk

NEW JERSEY

Westchester Greenwich Stamford
County

Rye

Hudson River

LONG ISLAND SOUND

LONG ISLAND

Manhattan

and their diet. They made rawhide, tanned leather and made and braided tack. They helped breed, birth, feed and raise lambs, calves, piglets and colts. Livestock was butchered and skinned; barrels were made and packed with salt meat. Some castrated, branded and earmarked livestock, while others drove herds to far pastures or felled trees to fashion fences and "hyways" through the forests.

Women homeschooled their children for the town's first eighty years, teaching them to sing psalms and read the Bible through and through before they taught them writing. They combed and carded flax, spun it, wove it and

created clothing. They also used all kinds of animal furs and tanned leathers. They wore colored dresses, hats, boots, capes and gloves but without the elaborate laces, ribbons or embellishments of "ungodly" Europeans. Their homes were spartan and simple—and sometimes lice infested—furnished with the barest essentials for family and farming. They nursed their families through scarlet fever, smallpox, cholera, worms, broken bones, bad teeth and broken spirits. They buried the many who didn't make it and trusted God had good reason for their frequent trials and sudden tragedies. They raised poultry, wrung their necks and then plucked them clean for pillows. They kept bees, made beer, tended gardens, boiled laundry and roasted dinner in a fireplace. They birthed their children using herbs, spirits, the Bible, family and friendships.

With new freedoms to speak their minds, the first in Greenwich demanded its voice. The town fought relentlessly with the Connecticut and New Haven Colonies, neighboring towns, sister communities, its own ministers, the Mianus River, a demanding landscape and fellow freemen. Challenged and challenging, Greenwich was home to these first and forceful "strivers."

THE DUTCH IN NORTH AMERICA

The Dutch financed the American explorations of Henry Hudson and Adriaen Block, allowing them to claim all the land from Delaware to Maine. By 1621, the West India Company (WIC) boasted of a charter to trade in animal fur and other natural resources all along the Hudson River. Trade famously occurred, but WIC operations in North America were originally plotted to win a war with Spain. Outposts in the Americas and the Caribbean were strategically planned for pirating passing vessels.

The Dutch called their territory New Netherland, and its formation was partially achieved through land purchases from "the Natives," "the Mahikanders," "the Pequattoos" and "Southern Indians." In 1633, the West India Company bought land called Conittekock on the Fresh River, now the Connecticut River. They built the small Fort Goede Hope at Hartford to hold Dutch claims there and to protect valuable seawant, or wampum-peague production there. Almost simultaneously, the English began populating these same places. Initially, the Dutch and the English allowed each other into their territories, but things turned tense quickly. Increasing Connecticut land claims by both nations were considered with suspicion and contempt.

ENGLISH LAND CLAIMS

The English claimed land through John Cabot's voyages, and to establish their settlements, they modeled Dutch financial innovations. Two English stock-issuing companies granted charters to authorize American settlements. The London Company of Virginia authorized Jamestown, and the Council for New England promised protections for settlers from southern New Jersey to Maine. When the council's charter failed in 1635, the legal standing for the English in America became perilous; John Winthrop, governor of the Massachusetts Bay Colony, had wisely obtained his charter from his king. As English settlers reveled in the abundance of North American land and the ease of escaping Winthrop's authority, they spread out, some purchasing land from natives with deeds. Reports of opportunity reached England, and between 1630 and 1640, almost twenty thousand English people arrived in the Northeast, greatly outpacing a far smaller population within New Netherland.

Many English moved into the Connecticut River Valley and onto western Long Island, very near the Dutch on Manhattan, which caused Winthrop to worry about losing his ability to maintain a model Protestant society. Also, the far-flung settlers held no legal charter. If Indian groups consolidated, the Dutch on the Hudson or the French near Canada attacked, there would be no protection for the English. All would be left defenseless.

CONFLICT IN EUROPE IS REFLECTED IN AMERICA

When Henry VIII divorced his country and church from Catholic authority in the 1530s, England's trade and navy deteriorated significantly, and the Dutch were the world's trading superpower. A century later, in the 1600s, Oliver Cromwell and Charles II made important legislative, diplomatic, economic and military changes that reinvigorated England. With brave new confidence, they paralyzed Dutch shipping through the English Channel and other profitable passages. These bold offenses caused a long period of ferocious naval battles called the Anglo-Dutch Wars. The first was fought from 1652 to 1654, the second from 1664 to 1667 and the third from 1672 to 1674.

The intense animosity between the Dutch and the English in Europe replicated itself in America when these global powers looked to their

American outposts to help support their hegemony. Both powers' operations were undermined from Boston to New York through trade and land title disputes. Hawkish Boston leaders urged attacks on the Dutch on Manhattan. English raids into Dutch territories on Long Island were blocked by roving and fast-acting Dutch strike forces. The English accused Dutch with ungodly attitudes, lack of adequate funding, improper management of territory for long-term occupation and failure to institute effective authority. These perceptions justified their jurisdictional overreaches and land seizures. Derision and marginalization characterized English perspectives on the Dutch near Manhattan.

THE TROUBLED GREENWICH FOUNDERS

The founding of Greenwich occurred as English Protestants sought even more reform in their homeland and created colonies in America as experimental outposts. The town of Greenwich's founding in particular reflects the Anglo-Dutch anguish in America, which threatened the life of town founder Elizabeth Fones Winthrop Feake Hallett. Elizabeth's mother was Anne Winthrop, sister of the governor of the Massachusetts Bay Colony, John Winthrop Sr. Elizabeth first married her cousin Henry Winthrop, the governor's son, but he tragically drowned on his first afternoon in America. Elizabeth then sailed to Boston from England, bringing Henry's baby with her. This toddler was Martha Johana Winthrop, who would later marry a Stamford, Connecticut man named Thomas Lyon.

Greeting Elizabeth and her child in the crowded Winthrop household, in addition to the governor and his wife, was her sister, who had married another son of the governor, John Winthrop Jr. He was accomplished and intellectually energetic but not as interested in Protestant versus Catholic issues as his father. He was fascinated instead by alchemy, horticulture, mineralogy and the medical arts. An adept administrator, he would become governor of the Connecticut Colony.

After Henry Winthrop's death, Elizabeth met and married Robert Feake, a wealthy Puritan jeweler, metalsmith and likely alchemist. He was raising his niece and nephew, Tobias and Judith Feake. Newly blended, the Feakes soon moved west to Watertown, Massachusetts, where they raised Martha Johana, the two Feake teenagers and four new Feake children for nine years.

In Watertown, they lived near one of the "Mustermasters," or military advisors to Boston's Bay Colony, Captain Daniel Patrick. He was English but spoke Dutch and had fought with the Dutch military. His wife was Dutch, the "comely" Anna Van Beyeren. Daniel Patrick was a challenge to the Puritans, a crude and rough soldier. He cheated on his wife, sexually assaulted other women in the Bay Colony and argued with his military superiors. The final straw for Winthrop, however, was Patrick's support of Anne Hutchinson, a self-styled Bay Colony preacher who disagreed with Winthrop theologically.

Patrick was banished from Boston and Watertown for insubordination, and he and his family moved with the Feakes from Watertown, Massachusetts, to Greenwich, Connecticut. Why the Feakes moved with the loutish soldier is unclear, and Patrick may have taken the Feake family with him as a retaliatory swipe at Governor Winthrop. Possibly, Patrick provided security and guidance to Robert Feake, who was becoming mentally unstable, or perhaps Elizabeth, who had medical training, wanted to care for her newly pregnant friend, the often cuckolded Anna Patrick.

A BORDERLAND CLAIMED BY THE DUTCH

Greenwich was envied property not only for its closeness to Manhattan's trading ports but also because the Dutch assessed it as having "flat and suitable land, with numerous streams and valleys, right good soil for grain, together with fresh hay and meadowlands." On April 20, 1640, Roger Ludlowe and Daniel Patrick bought land in Connecticut known as "Norawake," or Norwalk. Two months later, on July 1, 1640, Nathaniel Turner bought land for the New Haven Colony. Natively called Toquams and Rippowam, Stamford was first called the Wethersfield Men's Plantation for the close-to-Hartford and Connecticut Colony origin of its first residents. In this, the New Haven Colony may have been crowing over these Connecticut Colony defections. Just days after this purchase, Daniel Patrick claimed land southwest of Stamford in a joint and equal purchase with Robert and Elizabeth Feake.

On July 18, 1640, eleven Feake and Patrick family members witnessed Native Americans sign the deed for a part of Old Greenwich. This founding land was explicitly "beyond the bounds of Captain Turner's purchase," and the deed notes that a Stamford settler named Jeffrey Ferris had already purchased land "in all the necks." Elizabeth Feake bought

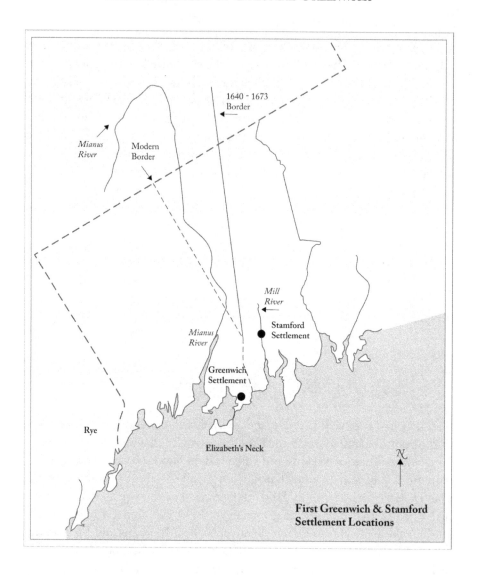

First Greenwich & Stamford Settlement Locations

Monakewaygo, modern Greenwich Point, as her own land. The deed language also restricted the native sellers for a mile farther beyond the founding deed's boundaries.

The Native Americans selling Old Greenwich land were Amogerone, Amsettheethone and his brother Owenoke. They were the sachems, chiefs or family heads who claimed seasonal use of the land near the western border at the Asamuck Creek, renamed Longmeadow Creek, which runs through Binney Park. Ramahtthoe and Nawhorone were the sachems of the eastern border, the Tatomuck/Patoumak or Tomac Creek, which is

visible in parts throughout the Innis Arden Country Club grounds. The purchase price for the founding land was twenty-four "coats," or bolts of duffels cloth, but the sellers may have only received eleven of the twenty-four owed them.

THE FIRST SIXTEEN YEARS OF DUTCH JURISDICTION OVER GREENWICH

Whether this founding land was under English or Dutch jurisdiction was unclear at first. The Dutch hadn't significantly challenged other English claims on the Connecticut River or the Ludlowe-Patrick purchase of Norwalk. Documents attest that Stamford men "assured" the Feakes and Patricks that their land was English, and Robert Feake wished for English jurisdiction. The Dutch, however, sent armed soldiers to the two families on October 15, 1640, three months after the founding deed was signed. Dutch director William Kieft "sent the vandrager [an ensign], and soldiers and required them to submit to the government or avoid the place." He warned them so they "may not pretend any cause of ignorance."[1]

The initial jurisdiction of Greenwich was well known to have been Dutch in the 1700s. The Reverend Stephen Monson wrote in the town's first history that Greenwich was "settled under the government of New Netherlands." Because of three confusing boundaries set by the 1650 Treaty of Hartford, however, the first jurisdiction became distorted to English ownership by the 1800s and current signage within the town maintains this inaccuracy.

Research shows the errors of an English claim.[2] When armed soldiers extracted an acknowledgement of Dutch jurisdiction, New Haven or Stamford made no challenge. Daniel Patrick stalled for time, "until the matter be made more clear," but Kieft recorded, "[t]hat one Daniell Patricke and some other English have undertaken…to build upon the lands of the honored Company by them called Greenwich; and considering well did find that the said land did belong to the said honored Company, did acknowledge the worthy Company to be their Patrons and took an oath of fidelity as they ought and also freely submitted themselves."[3]

One week later, Patrick agreed in practice and principle with Dutch jurisdiction when he brought his daughter Beatrice to Fort Amsterdam for her baptism. Clearly, the jurisdiction of Greenwich was unknown for

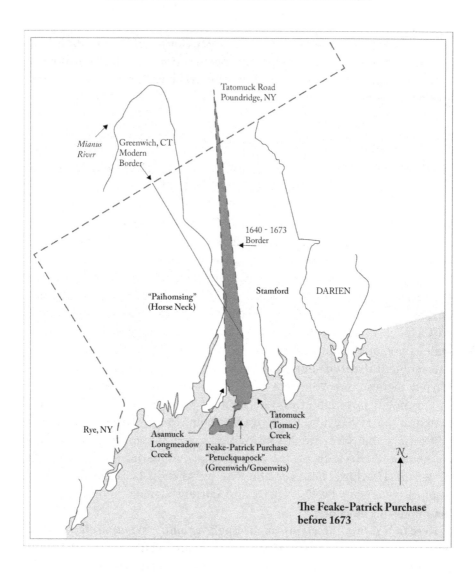

Tatomuck Road
Poundridge, NY

Mianus River

Greenwich, CT
Modern
Border

1640 - 1673
Border

"Paihomsing"
(Horse Neck)

Stamford DARIEN

Rye, NY

Asamuck
Longmeadow
Creek

Feake-Patrick Purchase
"Petuckquapock"
(Greenwich/Groenwits)

Tatomuck
(Tomac)
Creek

N

**The Feake-Patrick Purchase
before 1673**

only three months, from the Feake-Patrick purchase on July 18, 1640, until the soldiers' arrival on October 15, 1640. The soldiers' armed demand more effectively instituted Dutch jurisdiction over Greenwich than did any verbal English assurances, the nationality of its first European residents or personal desires of one founder. On April 9, 1642, Daniel Patrick sailed to Manhattan to acknowledge Dutch jurisdiction in writing.[4] Two months later, Robert Feake embraced his Dutch-ness as well, and on July 16, 1642, he and Daniel Patrick once again sailed to Fort Amsterdam to baptize two new children. New Haven did not list Greenwich under its jurisdiction

in October 1643,[5] and the Dutch referred to Greenwich as Groenwits (Groon-vits), a Dutch approximation of the word Greenwich,[6] to reinforce the Dutch ownership of their valuable new asset.

Greenwich was jurisdictionally Dutch for its first sixteen years, until it came under New Haven Colony's aegis in 1656.

A POLITICAL PAWN

Greenwich founder Elizabeth Winthrop Feake had her sixth child, a daughter named Sarah Feake, in 1648. After infant Sarah's death later that year, an unstable Robert Feake abandoned his family and returned to Massachusetts. How Elizabeth and William Hallett knew each other is unclear,[7] but as English people, the new couple asked the New Haven Colony for her divorce and their remarriage. This was rudely denied them. Choosing then to take advantage of their Dutch jurisdiction, they sought relief from Director Kieft, who did grant her a divorce.[8] Her marriage account remains undiscovered, but she began signing her name "Elizabeth Hallett" in 1649.

As her Hallett pregnancy progressed, sidestepped and scheming New Haven magistrates labeled Elizabeth an adulteress in an effort to slander and defame her. This was less about her marriage than a ploy to claim her land for the colony. Of the four Greenwich founders, Elizabeth was the easy target, for Anna Patrick was Dutch, Daniel Patrick was dead and Robert Feake didn't live in town anymore. Elizabeth was further defamed by two other men who also stood in line to inherit her land, her nephew Tobias Feake and her son-in-law, Thomas Lyon.

New Haven zealot Theophilus Eaton issued a warrant for the Halletts' arrest, even though he held no authority over them. He sought to seize half of their property and take away half of her children. He wrote that "some men" had appealed to Stamford to "save" their land from the Dutch and, since the Halletts had escaped, Stamford could claim it. The Halletts,

however, had no desire for Stamford to "save" their land from the Dutch. Eaton simply created this crisis to confiscate their estate.[9]

As Stamford men were coming to seize the children, Elizabeth and William Hallett escaped overnight to New London by boat. There, they were harbored for a year by Elizabeth's friend, cousin and former brother-in-law, John Winthrop Jr. Thwarted Stamford men sniffed that "the children went...if not naked, very unsatisfactorily appareled."

CONTENTIOUS REAL ESTATE BATTLES BEGIN THEIR LONG HISTORY IN GREENWICH

Tobias Feake and Thomas Lyon charged that William Hallett was an illegitimate head of household with no authority to have sold some of the Feake-Patrick property. Sanity hearings were held to see whether Robert Feake had properly passed on his right to sell land to the Halletts, but at these interrogations, Robert's testimony was inconclusive. The four men who had purchased land from the Halletts appealed to the new Dutch director, Peter Stuyvesant, to protect their purchases.[10] He upheld their titles and instructed Elizabeth to abandon William Hallett. This was only to pacify the English, for Hallett never left her.

PETER STUYVESANT STRENGTHENS HIS TITLE TO GREENWICH

On May 11, 1647/8, Peter Stuyvesant arrived at Fort Amsterdam on Manhattan's southern tip determined to defend Dutch land claims against escalating English challenges. Dr. Charles Gehring, director of the New Netherland Research Center in Albany, New York, commented:[11]

> By the time Stuyvesant arrived at Manhattan in 1647, New Englanders had occupied much of the land originally claimed by the Dutch. The Dutch trading post of Fort Good Hope (Hartford, Connecticut) was literally surrounded by English settlers.... The boundary between New England and New Netherland needed to be established before land-hungry farmers from Plymouth and Massachusetts Bay pushed further west into Dutch territory.

1648 STUYVESANT PURCHASE SHIFTS THE GREENWICH BORDER

On July 14, 1648, Stuyvesant strengthened his title to Greenwich. He purchased all the land from the west bank of the Kechkawes, the Mianus River, to Stamford's Seweyruc, or Mill River, from Westchester Munsees.[12] Through this purchase, Stuyvesant wrested the Feake-Patrick-Hallett property back from New Haven. His secretary, Cornelius Tienhoven,

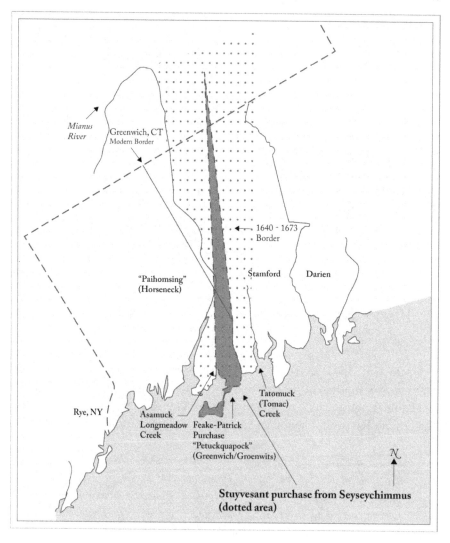

Stuyvesant bought land from the Mianus River (the Kechkawes) to Stamford's Mill River (the Seweyruc).

explained this to the West India Company as a strategy to block English colony encroachment toward Fort Amsterdam. It also expanded the border between New England and New Netherland three miles east, right up to Stamford's Mill River. This infuriated the English, and they demanded a new negotiation.

John Winthrop Jr. and Peter Stuyvesant arranged for the Halletts to return to Greenwich under the protection of the Dutch. It seems this English family was, ironically, safer among the Dutch than they were among their own. In 1649, they returned and Elizabeth confirmed Stuyvesant's purchase, "Through the mercy of God we are in health and peace at Greenwich....Ye Dutch Governor hath purchased all ye land along the coast."[13]

Friction only increased between New Netherland and New England. Eaton complained to Stuyvesant about the difficulty of rules mandated in one jurisdiction but not respected by the other. In the *St. Beninjo* affair, Stuyvesant captured a Dutch ship that failed to pay Dutch fees in English territory. The English protested and added this event to a growing list of grievances to be discussed at the 1650 Treaty in Hartford.

THE 1650 TREATY OF HARTFORD MAINTAINS GREENWICH AS A DUTCH TERRITORY

Dr. Charles Gehring noted further elements of the boundary dispute:[14]

When Stuyvesant confronted the boundary problem...not only had English settlements expanded even more widely, but also the international situation had become extremely unstable....The Dutch government was finding it difficult to figure out who was in charge across the channel....The [West India Company] directors had advised that he...keep the peace with New England as the English were much too powerful for them. With this in mind, Stuyvesant tried to negotiate an agreeable boundary which would insure the security of New Netherland and eliminate the continual disputes involving an area long lost to the English anyway.

1650 TREATY OF HARTFORD CREATES THREE BORDERS IN GREENWICH

Concerning Greenwich, the 1650 Treaty of Hartford was a masterpiece of obfuscation, for it created three borders between the Dutch and the English. One border was drawn at Mamaroneck, New York, which prevented the Dutch from establishing new households east of this line. A second border was on the west bank of the Mianus River, which is east of the Mamaroneck border. This was the limit of Dutch jurisdiction over the *land* belonging to New Netherland. Even farther east of this line was a third border drawn at Tomac Creek, the modern southern border between Stamford and Greenwich. This line defined the eastern limits of the Dutch jurisdiction

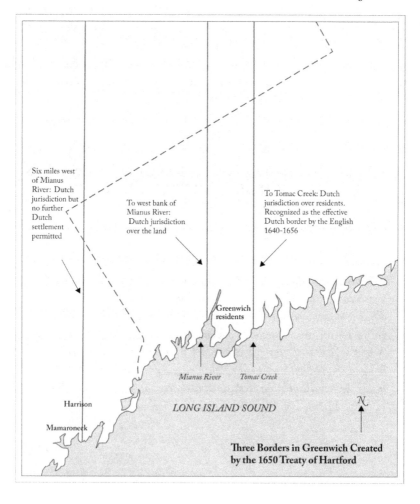

Six miles west of Mianus River: Dutch jurisdiction but no further Dutch settlement permitted

To west bank of Mianus River: Dutch jurisdiction over the land

To Tomac Creek: Dutch jurisdiction over residents. Recognized as the effective Dutch border by the English 1640-1656

Greenwich residents

Mianus River

Tomac Creek

Harrison

Mamaroneck

LONG ISLAND SOUND

N

Three Borders in Greenwich Created by the 1650 Treaty of Hartford

over the *people* of Greenwich, who resided only within Riverside and Old Greenwich at the time.[15]

Three years after the treaty, the English allowed settlers into Greenwich, and Stuyvesant complained bitterly. He accused the English of demonstrating "an insatiable desire of possessing that which is ours, against our protestations, against the law of Nations." In a long harangue, he complained of "offensive affronts, and unpleasing answers" and "sundry usurpations." To stress his benevolence to the English, he added, "We have not meddled with or interrupted any of the subjects of Greenwich nor the place itself; nor have we placed any magistrates therein but left them as Neutrals at this time."[16]

THE EASTERN BORDER BETWEEN NEW NETHERLAND AND NEW ENGLAND SHIFTS

The Greenwich border between New Netherland and New England shifted three times in the mid-1600s. In 1640, the border was set by the Feake-Patrick purchase at the Tatomuck Creek. In 1648, Stuyvesant's purchase moved the line eastward from the Tatomuck Creek to Stamford's Mill River. In 1650, the Treaty of Hartford reset the border west again

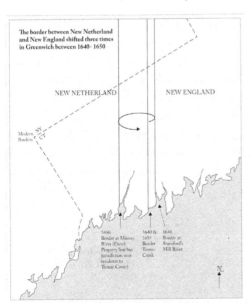

at the western bank of the Mianus River, but the Dutch reserved control of the town's population east of this line to the Tatomuck Creek. After the first fall of New Netherland to the English in 1664, the effective eastern border between Stamford and Greenwich remained at the Tatomuck, or Tomac Creek. The angle of this line, above the intersection of modern Palmer Hill and Stillwater Roads, was changed by the Connecticut Colony in the late 1600s.

THE FEAKES, HALLETTS AND PATRICKS BECOME QUAKER CHAMPIONS ON LONG ISLAND

William Hallett preemptively acted on the treaty's outcome in 1649, for if Greenwich fell to the English, the couple's arrest warrant could reactivate. Writing to John Winthrop Jr. in October 1650, Hallett despaired: "We hear that New Haven has propounded to our Governor to have Greenwich under them. We know not what is done as yet. I have sold my house and land and intend in the spring to remove nearer to Manhattan."[17] John Winthrop Jr. intervened with Stuyvesant, and the Halletts left Greenwich to move deep into the heart of New Netherland. Their farm, formerly "Jacques Bentyn's farm," is now known as Astoria, but it was called Hallett's Point for over two hundred years.

Tobias Feake and Anna Patrick, now married after Daniel Patrick's 1643 assassination by Dutch soldiers in Stamford, also moved to western Long Island around 1650 to live near the Halletts. Many western Long Island

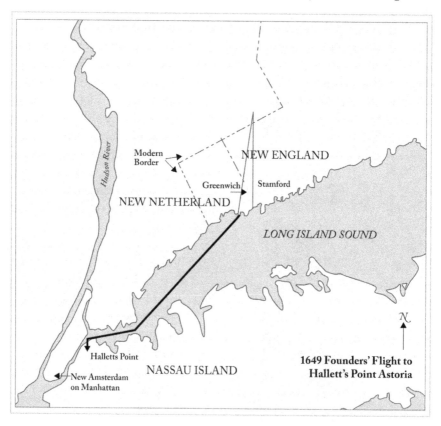

Hereticks

[N]o persons in this colony shall give an unnecessary entertainment unto any Quaker, Ranter, Adamite, or other notorious Heretick, upon penalty of five pounds...and further...that no person within this colony shall fall into discourse with such heretick... keep any Quaker's books or manuscripts containing their errors...and all such books...shall be suppressed.

Acts and Laws of His Majesties Colony of Connecticut: 24

towns were Dutch in jurisdiction at this time, but they were also largely populated with English people. These towns were attractive for those seeking English society with more relaxed Dutch oversight.

These villages were also the birthplace of the burgeoning and radical Quaker movement, which the Halletts, Feakes and Underhills and Elizabeth's children embraced and even championed. English colonies of this time and Peter Stuyvesant in particular prohibited religious expression that was not Protestant, and this included Quaker expression. Also known as the Society of Friends, this new movement rejected the authorities of ministers and magistrates, and it stressed internal discipline rather than external punishment. This was a new assumption of self-responsibility by its practitioners, and the society became wildly popular throughout western Long Island and Pennsylvania. The Quakers in Greenwich fractured support for a singular Protestant ministry.

Elizabeth's daughter Hannah Feake married Quaker John Bowne, who was arrested, imprisoned and banished from America for two years by Peter Stuyvesant for his religious preferences. Bowne successfully reversed his punishment, however, through an appeal to the burghers, or administrators directing the West India Company. William Hallett was also arrested by Stuyvesant for hosting a Quaker leader at his home, but this, too, was reversed, and Hallett remained an important sheriff and property owner within New Netherland.

Tobias Feake was the first to sign the Flushing Remonstrance, now thought to be the first document demanding religious freedoms in America. Elizabeth

Feake Hallett's sons from Robert Feake and William Hallett also helped construct the first Quaker meetinghouse in 1695 in Flushing (Vlissingen), New York. It is possible that Elizabeth and William Hallett are buried in unmarked graves here, if not in Mount Olivet Cemetery in Maspeth, New York, moved there from their original locations on Hallett's Point.

NEW AMSTERDAM BECOMES NEW YORK

In 1664, Richard Nicholls's naval fleet surreptitiously and successfully sailed into New York Harbor and captured New Netherland without a declaration of war on the Dutch-American territory. The English summarily renamed New Netherland "New York," which the Dutch protested strongly to, and laid long-term plans to re-secure it. At the close of the second Anglo-Dutch War in 1667, peace negotiations awarded the sugar colony of Surinam to the Dutch, and the English maintained their right to New York. In 1672, however, the Dutch retook New York, backed by a fleet of nineteen ships, a reinstallation of Dutch control that lasted for only one year. In 1674, the Treaty of Westminster restored New York to the English in a negotiated transaction, and the Dutch retained trade control of the East Indies.

Greenwich Jurisdictional Chronology

Pre-1640	Native American: Wiechquaesgeck/Munsees
1640–1648	Dutch: Willem Kieft, Dir. New Netherland
1649–1656	Dutch: Peter Stuyvesant, Dir. New Netherland
1656–1663	English: The New Haven Colony
1664–1776	English: The Connecticut Colony
1776–	American: The United States

THE GREAT MASSACRE

Dutch maps from the mid-1600s use three languages—Dutch, English and Native American—to describe the region of southwestern Connecticut. Mapmaker Nicholeas Visscher had never personally visited northeastern America, but he drew his map on the direction of Adrien van der Donck, a longtime Hudson River resident, astute administrator, attorney and Stuyvesant critic. This map, "Novi Belgii," or "New Netherland," excited public imagination. A focus on the Greenwich area shows "Manhattans," "Lange Eyeland," "Stamfort" and "Strotfort." When the Dutch renamed Greenwich "Groenwits" (Groon-vits), the typesetter spelled it as "Groeobis."

The founding purchase was natively named Petuckquapock or Betuckquapock. Linguists report native "ock" and "aug" endings are waterway descriptors. This site was so important that Visscher printed it, even though the name was larger than the land itself because Greenwich importantly defined the eastern border between New Netherland and New England. The insignificant Tomac or Tatomuck Creek, which runs through Innis Arden Country Club, also defined the border between English Stamford and Dutch Greenwich.

Note that "Petuckquapaen," reported in some town histories, is a distorted name. On a map he created in 1848, one Reginald Pelham Bolton changed the "pock" ending of Petuckquapock to "paen" without explanation. Town historian Spencer Mead distorted this imagined word further in 1911, using it as an Indian village name.

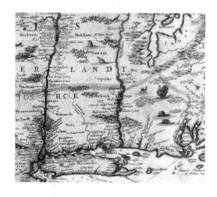

Close-up of Greenwich area on the 1650 Novi Belgii map. *Library of Congress.*

THE SIWANOYS NEVER LIVED IN GREENWICH

Native American scholar Robert Grumet offers evidence that the word *Siwanoy* meant "southerners," and that it was placed incorrectly by Visscher on the mainland in southwestern Connecticut. Grumet suggests the Siwanoys should more properly be located either on eastern Long Island near the Shinnecocks or closer to Delaware. There is one other Dutch map showing the name "Siwanoy" placed in the waters of Long Island Sound.[18] Van Der Donck himself wrote that the "Siavanoos" lived south of the Dutch on Manhattan, and the word may refer to either the Shawnee or the Delaware groups. In either case, it's clear that the "Siwanoy" never lived in southwestern Connecticut, much less the misspelled "Sinawoy," immortalized as a Cos Cob street name.

It was the Weichquaesgeck (Weck-as-qweeks or Wech-as-gecks) who lived in Westchester County and southwestern Connecticut. They spoke Munsee, the northernmost dialect of the eastern Algonkian language called Delaware.[19] The most important Indian trading path into and out of Manhattan Island from Westchester County was called the Weichquaesgeck Road. This path is now part of Route 9 as it runs along the Hudson River. It then ran from the upper west side of Manhattan Island, diagonally and south through Central Park, to reach Manhattan's southern tip, where Fort Amsterdam was located, the current site of Number One Broadway.

In the early 1600s, the region surrounding Manhattan Island was controlled by three major native groups: the Raritan in New Jersey, the Montauk on eastern Long Island and the Weichquaesgeck in Westchester County. They and other Connecticut and Westchester groups were "subservient to the enforced dominations of the more inland Mohawk Iroquois who compelled them…to pay tribute to their military superiority."

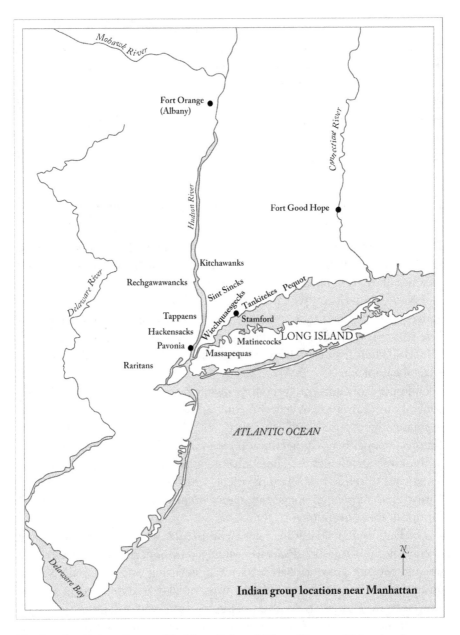

Map based on Robert Grumet, *The Munsee Indians, A History* (Norman: University of Oklahoma Press, 2009).

When referring to Indians in general, the Dutch called them the "Wilden," "Wilden Menschen" or wild people, and the English called them "savages." The Indians called the Dutch "Swanniken," from the time they first knew of them at one of their first settlements at Swanendael, in Delaware, and for reasons unknown, they called Englishmen "Owanux," although Indians near Hartford noted that it was sometimes hard for the Indians to tell the English apart from the Dutch.

Turmoil in Native Communities

Native Americans near Manhattan were convulsed with changes caused by the European influx. Besides alcohol, firearms and new diseases in their societies, they contended with power shifts between the Dutch, the English and Native Americans, which upset historical legacies within and between native groups. They faced widespread dispossession of their lands and new concepts of justice, trade, land ownership and land sales and political alliances. Their lives were irrevocably altered with new physical, social and tactical complexities.

Differing concepts of property ownership were a major point of contention. Europeans believed that through their laws, they had permanently "purchased" property. Native Americans interpreted European paper deeds as a temporary loan of land, a negotiation that could be renewed or canceled. These divergent perceptions prompted Native Americans to request repeated payment, which gave rise to the derogatory phrase "Indian giving," suggesting native unfairness, which in reality was a European misconception.

The Dutch enforced trading rules inconsistently, which was another source of confusion and injustice. Rules were changed without clear communication, pricing became uncontrolled and trade licensing was ignored. Simple misunderstandings between cultures were quickly manipulated to benefit one party over another. Another explosive issue was the introduction of domesticated European livestock into Native American planting fields that had no protective fencing. Destruction of these fields resulted directly in food shortages, and this was sometimes intentional. Native communities facing starvation retaliated by killing precious European horses, oxen, swine, sheep and cattle. Manhattan and its surrounds in the mid-1600s were anxious and violent places, where former friends could turn assassins in an instant.

KIEFT'S WAR IN GREENWICH

In the early 1640s, Fort Amsterdam director William Kieft quite irrationally decided to eliminate the very people whom the Dutch relied on to make pelt trading profitable. In 1643 and 1644, he launched three forays against Native Americans from Tomac Cove in Old Greenwich. These were led by John Underhill, who had perpetrated the 1637 Mystic Connecticut massacre. The massacre of 1644 occurred in southwestern Connecticut or Westchester County and destroyed the lives of five to seven hundred men, women and children one freezing February evening.

FIRST FORAY

The first foray in 1643 was to retaliate for a lone attack by Mianus, or "Mayn Mayane's" on three armed "Christians" in Greenwich earlier that year. Mianus killed one of these men, injured the second and was himself killed by the third. Mianus, in return, was decapitated and his head brought to the Dutch in Fort Amsterdam on Manhattan to show that Kieft's War had now expanded into Connecticut. The Dutch reported:[20]

> *One hundred and twenty men were sent thither under the preceding command. The people landed at Greenwich in the evening from three yachts, marched the entire night, but could not find the Indians, either because the guide had given warning or had himself gone astray. Retreat was made to the yachts in order to depart as secretly as possible. Passing through Stamford some Englishmen were encountered who offered to lead soldiers to the place where some Indians were.*

The soldiers failed to find any Indians on their first stomp through the rocky Greenwich wilderness, and when they returned to John Underhill's house in Stamford, Daniel Patrick ridiculed them for their failure. Believing Patrick himself knew no one would be found, a Dutch soldier shot Daniel Patrick in the face. Governor Winthrop recounted the harrowing details of this assassination:[21]

> *About this time Captain Daniel Patrick was killed at Stamford by a Dutchman, who shot him dead with a pistol. This captain was entertained*

by us out of Holland (where he was a common soldier in the Prince's guard) to exercise our men. We made him a Captain, and maintained him. After, he was admitted a member of the church of Watertown, and a freeman. But he grew very proud and vicious, and for though he had a wife of his own, a good Dutch woman and comely, yet he despised her and followed after other women; and perceiving that he was discovered, and that such evil courses would not be endured here, and being withal of a vain and unsettled disposition, he went from us, and settled down not twenty miles from the Dutch, and put himself under their protection, and joined to their church, without being dismissed from Watertown: but when the Indians arose in those parts, he fled to Stamford and there was slain. The Dutchman who killed him was apprehended, but made an escape; and this was the fruit of his wicked course and breach of covenant with his wife. With the church, and with that state [New Netherland], *who had called him and maintained him, and he found his death from that hand where he sought protection. It is observable that he was killed upon the Lord's Day in the time of the afternoon exercise (for he seldom went to the public assemblies). It was in Captain Underhill's house. The Dutchman had charged him with treachery, for causing 120 men to come to him upon his promise to direct them to the Indians, etc. but deluded them. Whereupon the Captain gave him ill language and spit in his face, and turning to go out, the Dutchman shot him behind in the head, so he fell down dead and never spoke. The murderer escaped out of custody.*

Patrick's death undoubtedly caused shock and economic crisis for his family, but few others mourned his loss. John Underhill even allowed his murderer to escape from his home.

SECOND FORAY

A second foray from Tomac Cove took some prisoners, killed two Native Americans and destroyed an uninhabited but significant native village:[22]

Sixty-five men were dispatched under [George] *Baxter and Peter Cock, who found them* [Indian houses] *empty, though thirty Indians could have stood against two hundred soldiers, inasmuch as the castles were constructed of plank five inches thick, nine feet high, and braced around with thick plank studded with portholes. Our people burnt two, reserving the third for*

a retreat. Marching eight or nine leagues farther, they discovered nothing but a few huts, which they could not surprise as they were discovered. They returned, having killed only one or two Indians, taken some women and children prisoner, and burnt some corn.

KIEFT BEGS WINTHROP FOR ASSISTANCE

By late 1643, Kieft was desperate for more military support. The West India Company turned him down quickly, since it had just lost an important battle in South America. Kieft then turned to Governor John Winthrop Sr. in Boston; he offered Winthrop twenty-five thousand guilders for a force of 150 men. Amazingly, he also promised Winthrop, leader of the English, Dutch Fort Amsterdam as collateral. Winthrop ignored this bounty and considered the offer "a plot of the Dutch Governor to engage the English in the quarrel with the Indians, which we had wholly declined, as doubting the justice of the cause."[23] The poor but pious New Haven Colony also cold-shouldered Kieft but pledged to reconsider when the situation worsened.

Willem Kieft entirely mismanaged the Indian trading relationship, which was critical to generate revenue and protect the lives of all Europeans living throughout the "tristate" region. Many urged him to stop the escalation of European-Indian violence, and few condoned large-scale Indian slaughter. To discourage him, a council of eight men tried to make Kieft personally lead and bear responsibility for any expeditionary forces.

Kieft declined personal involvement but hired John Underhill for the job, one of the few men in the region with the stomach to pursue such endeavors. Underhill acted on an offer from a Native American traitor and led his troops to a large assemblage of Indian people who had gathered to celebrate a February full moon. This was the Cos Cob traitor who had failed to lead Dutch troops to an inhabited village in the first foray, leading to Daniel Patrick's death. Ostensibly intent on proving his loyalty to the Dutch, this native man forever estranged himself from his own people.

Third Foray

Underhill then launched the third, largest and most violent foray from the Feake-Patrick property in Old Greenwich in 1644:[24]

One hundred and thirty men were accordingly dispatched under General Underhill and Ensign Hendrick van Dyke. They embarked in three yachts, landed at Greenwich, where they were obliged to pass the night by reason of the great snow and storm. In the morning they marched northwest up over stony hills, over which some were obliged to creep. In the evening, about eight o'clock, they came within a league of the Indians, and inasmuch as they should have arrived too early and had to cross two rivers, one of two hundred feet wide and three feet deep, and that the men could not afterwards rest in consequence of the cold, it was determined to remain there until about ten o'clock. Orders having been given as to the mode to be observed in attacking the Indians, the men marched forward toward the huts, which were set up in three rows, street fashion, each eighty paces in length, in a low recess of the mountain, affording complete shelter from the northwest wind.

The moon was then at the full and threw a strong light against the mountain, so that many winter's days were not clearer than it then was. On arriving, the enemy was found on the alert and on their guard, so that our people determined to charge and surround the huts, sword in hand. The Indians behaved like soldiers, deployed in small bands, so that we had, in a short time, one dead and twelve wounded. They were likewise so hard pressed that it was impossible for one to escape. In a brief space of time, one hundred and eighty were counted dead outside the houses. Presently none durst come forth, keeping themselves within the houses, discharging arrows through the holes. The General, seeing that nothing else was to be done, resolved with Sergeant Major Underhill to set fire to the huts. Whereupon the Indians tried every way to escape, not succeeding in which they returned back to the flames, preferring to perish by fire than to die by our hands.

What was most wonderful is, that among this vast collection of men, women and children, not one was heard to cry or to scream. According to the report of the Indians themselves, the number then destroyed exceeded five hundred. Some say, full 700, among whom were also 25 Wappingers, our God having collected together there the greater number of our enemies, to celebrate one of their festivals. No more than eight men in all escaped, of whom even three were severely wounded.

The fight ended, several fires were built in consequence of the great cold. The wounded, fifteen in number, were dressed and sentinels were posted by the General. The troops bivouacked there for the remainder of the night. On the next day, the party set out much refreshed in good order, so as to arrive at Stamford in the evening. They marched with great courage over that wearisome mountain, God affording extraordinary strength to the wounded, some of whom were badly hurt and came in the afternoon to Stamford after a march of two days and one night, with little rest. The English received our people in a very friendly manner, affording them every comfort. In two days they reached here. A thanksgiving was proclaimed on their arrival.

The Munsee massacre of 1644 shocked the Dutch, the English and the remaining Native American community. Europeans who participated did not boast or write of it in any personal documentation yet discovered—perhaps a protection from Indian reprisal. The event was no doubt a body blow to regional Native Americans, and it ended large-scale conflict for ten years, until the Esopus War ignited. Small and sporadic skirmishes did continue for many years.

John Underhill remained in a highly agitated and aggressive state for at least a week after his actions, and on March 17, 1644, he wreaked havoc in a tavern near Fort Amsterdam. A witness reported:[25]

Three men and their wives had been dining at the New Amsterdam tavern of Philip Gerritssen, when Underhill, George Baxter, and the drummer of their militia noisily arrived. The diners asked the soldiers to drink in another room, which they did, but the soldiers soon asked those in the adjacent dining room to join them. Upon their refusal, reports one of the diners, Underhill and his companions, with drawn swords, knocked to pieces all but three of the mugs which hung from the shelf in the tavern, as may be seen by the marks which remain in the shelf and by the cuts and hackings in the posts and doors; furthermore endeavoring by force, having drawn swords in their hands, they came into the room where the invited guests were. This was for a long time resisted by the landlady with a leaded bludgeon and by the landlord by keeping the door shut, but finally John Underhill and his companions, in spite of all opposition, came into the room, where he made many unnecessary remarks. Having his sword in his right hand and scabbard in his left, he said (to one of the men who was a minister), "clear out of here or I shall strike at random." Presently some English soldiers came likewise to assist him, whereupon Underhill and

his companions became guilty of gross insolence, so that the fiscal and the
guard were sent for and....Underhill was ordered to depart...to prevent
further, more serious mischief, yes, even bloodshed, [and] we broke up our
pleasant party before we had intended.

Shortly afterward, twenty-three families from Stamford, a third of its population, moved across Long Island Sound to Newtown and Flushing, Long Island, to put distance between themselves and the surviving Wiechquaesgeck.[26] Daniel Denton, the son of Stamford's Richard Denton, who may have been a participant, wrote that it was amazing to him how the Indian populations had declined so quickly in the region. Remaining Natives requested a formal cessation of hostilities from Underhill in Stamford on April 16, 1644,[27] but after signing this, Kieft asked Underhill to continue his killing. Underhill, perceiving he was pleasing God by removing Satan's agents from the world, proceeded to Long Island for further atrocities.

Greenwich and Stamford settlers were ostensibly grateful for Underhill's destruction of the Wiechquaesgeck. Years later, Robert and Elizabeth Feake's daughter, Elizabeth, married John Underhill, and they had five children together. The Feakes and the Underhills would become even more tightly entwined through other marriages in future generations.

AFTERMATH

A report to Holland explained the subdued but still troubled aftermath of these tragic episodes:[28]

The winter passed in this confusion mingled with great terror; the season
came for driving out the cattle, which obliged many to desire peace. On the
other hand, the Indians seeing also that it was time to plant maize, were
not less solicitous for a cessation of hostilities, so after some negotiation,
peace was concluded in May 1643/44. This truce was broken when
Wappingers, north of the Weichquaesgeck, hijacked a boat with 400 hides
coming from Ft. Orange [Albany] killing nine, including two women, and
taking one woman and two children prisoner.

The spring planting season brought about a lull in hostilities. Kieft's brutal interventions had shifted the balance of power toward the Europeans,

which was his intention, but he neither eliminated the Indian population nor entirely scared them away. He did cause untold European and Indian deaths, from which the Europeans eventually recovered but the native community never did. Area settlers begged for Kieft's replacement, urging the West India Company to send someone who could restore a productive and positive relationship, "so that the entire country may not hereafter be at the whim of one man, again reduced to similar danger."

The company finally replaced Kieft, and when Peter Stuyvesant arrived in 1648, directors advised him against pursuing Kieft's disastrous policies. Kieft himself never made it home to Holland. His returning ship wrecked near Swansea, and he drowned, taking a suspicious fortune of 400,000 guilders to the bottom of the sea with him as well as many important papers concerning New Netherland. The company counseled Peter Stuyvesant to institute "a lenient Indian policy":

A LENIENT POLICY TOWARD THE INDIANS IS DIRECTED—7TH APRIL 1648

We shall first reply to your Honor's report on the condition of our territory there, in which you complain that the soldiers are very disorderly and without discipline. It looks as if the slackness of the late Director and the neglect of duty by the preacher have been the cause of it and we expect your Honor to redress it, even as a tree, which has been growing some time and has run wild, must be pruned with great care and bent with a tender hand, to be brought into a good shape.... [O]f the native inhabitants of these territories; that they must be governed with kindness and the former wars incline us to believe it; we would have preferred to avoid these wars.... [U]nder our present circumstances a war would be utterly unadvisable.

COLONY CONTROL

Strict New Haven

After Greenwich had been lightly governed by the Dutch for its first sixteen years, it came under the control of the extremely controlling New Haven Colony in 1656. This was six years after the Treaty of Hartford had been signed and eight years after William and Elizabeth Feake Hallett fled Greenwich to save their lives from New Haven administrators.

New Haven Colony founders were a small group of like-minded individuals who tried to create a community that followed the Old Testament for guidance. This lifestyle, they believed, would truly please God and create greater human reward, physically and psychologically. Politically, such a result would showcase their religious philosophy to be more effective than that of the Connecticut or Massachusetts Bay Colonies, while exposing the limitations of Catholic belief. It would also justify New Haven's ardent denunciation of their pro-Catholic English king. In executing its strategy, colony leaders were punitive. They required their citizens to forsake many accepted pleasures of the era and consoled them with the abstract reward of God's grace. A constant state of control and somber supplication to God was imposed, which even the devout quickly found difficult, if not impossible to achieve. This strict interpretation of Protestantism conflicted with the diverse inclinations of its human population and gave rise to ridicule from monarchists in England. Puritan leaders were mocked as fanatics and their followers caricatured as pious and grim.

New Haven's concept was created by the ambitious Reverend John Davenport, whose followers had been Protestants in England. Significant to their future failures in America, there were very few farmers among them. Davenport partnered with wealthy merchant Theophilus Eaton, who was Davenport's former schoolmate, a parishioner and son of the minister who baptized him. When these two men decided on American immigration, Davenport resigned his vicarage and moved to Holland. As followers joined him there, they came to include Captain Nathaniel Turner, who would purchase Stamford for New Haven. The Eaton and Davenport group moved to the Massachusetts Bay Colony in 1636.[29] Spurning the Bay Colony to seek virgin territory for their unique society, they looked toward Connecticut.

Their real estate reconnaissance began in Quinnipiac, but this was quickly dismissed after homesteaders there had spent their first winter in cellars, "partly underground covered with earth," and other uncomfortable pits as there was no available housing. The New Haven area pleased them, and it

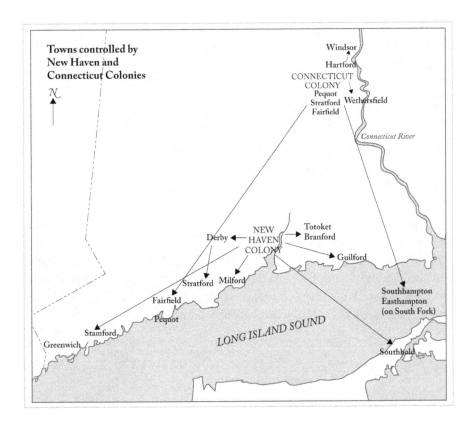

was already "civilized," since the Dutch had previously arrived, and had named the area Rhoodeberg or "Red Mountain," establishing a trading fort on the shore. The English established themselves without a legal charter; neither did they own a purchase deed from the Dutch. Here Davenport and company staked their claim on purchases from Native Americans, just as the Pilgrims in Plymouth had done.

New Haven leaders jealously watched the Connecticut Colony create settlements at Pequot, Stratford and Fairfield after the Pequot War of 1637. Seeing expansion as a key to achieving political, religious and regional success, the New Haven Colony also tried to "hive out." It joined the New England Confederation, a group of jurisdictional authorities and, in doing so, became a jurisdiction. Guilford and Milford, twelve miles away, came under its control, followed by Totoket, eight miles to the east. Totoket was begun by Samuel Eaton, brother of Theophilus, but it failed as a standalone town and later developed into Branford. Through the efforts of Nathaniel Turner, New Haven established Stamford, forty-two miles to its southwest, and controlled the towns of Southhold on Long Island, Paugasett (Derby) and Hashamamock near Southhold. It tried to subjugate the Long Island towns of Oyster Bay and Huntington, but embarrassingly, these towns, along with Southampton and Easthampton, preferred to align themselves with the Connecticut Colony at Hartford. New Haven also tried but failed to establish a settlement in Delaware.

STAMFORD, CONNECTICUT

The purpose of Stamford was to lure those leaning Davenport's way theologically away from Connecticut Colony's settlement at Wethersfield and to further expand New Haven's territory southward. Stamford was religiously led by Richard Denton. Other leaders included Matthew Mitchell, Andrew Ward, Richard Coe and Richard Gildersleeve. These men promised to reimburse the New Haven Colony for settling them, and they explicitly acknowledged New Haven jurisdiction.

GREENWICH PROTESTS NEW HAVEN'S GOVERNANCE

The West India Company was barely funding its North American operations by 1655 because of its war with Portugal over Brazil and expensive conflicts with the English. On Manhattan, Peter Stuyvesant feared attack from English settlements, who were correctly reassessing the financial, military and political weakness of New Netherland. He was also facing down English settlers within his bounds who demanded a louder voice in Dutch affairs. On October 6, 1656, New Haven realized Stuyvesant's weakness and seized Greenwich, threatening to jail any resident who objected to the action. Soon, some Greenwich citizens formally acknowledged New Haven governance, but that didn't mean they liked it.

The document submitting Greenwich to New Haven was signed by those who probably would have preferred Connecticut Colony jurisdiction, for word quickly reached New Haven that Greenwich planters, who had recently signed themselves over, would now tolerate governance only from England itself. New Haven deputies "received intelligence...that Greenwich men do absolutely refuse to submit and will not yield unless forced or ordered by the State of England."[30]

Resistance against New Haven turned violent at least once. On May 28, 1658, Richard Crabb and his wife charged New Haven men with "taking away their land without commission." A chaotic incident occurred when Stamford authorities came to arrest Greenwich Quaker Thomas Marshall, whose religious practice was banned.

"Goodwife Crabb...went into the other room and made herself fast by shutting the door, and Richard Crabb used means to open the door again and...when she came again [she]...held up her hands and said, the vengeance of God hangs over your heads at Stamford for taking away our land without commission and of wronging them....[S]he also told Goodman Bell he was a liar, a traitor and a villain...and Goodman Bell said he hoped she was not a witch....[T]hen she fell upon the officer John Waterbury and said he was a traitor."

One of the Stamford men continued that she "fell a railing upon me and said that we had stolen away Greenwich and we had no commission, relating it several times over with many retorting speeches. When I said, Goodwife Crabb, I should be glad to see you at Stamford meeting, she answered and said that she would never come while she was living....She

continued in those railing speeches almost an hour together, she calling for drink to refresh her...to go on...in those wicked speeches which was dreadful to hear."[31] Over Mrs. Crabb's strident objections, Greenwich remained subjugated.

NEW HAVEN COLONY FAILS

Settlers within New Haven were prosperous English merchants, tradesmen and professionals, lawyers, schoolmasters and administrators. They selected this place to express their ideology but also to protect their families and livelihoods from the civil unrest in England. Seeking relief from the old-world dangers, they now assumed new-world expenses. Travel, explorations, land purchase and the construction of homes, barns, boats, carts, mills, roads and fences lightened their purses quickly and deeply. The cost of raising livestock, farming and building, along with payments for ministers, medicine, muskets, midwives, furniture, fabric, shovels and scythes, was daunting. Many lost money when New Haven's Delaware plan failed, then lost more when its ironworks venture failed. These colonists were devastated when a ship full of their exports was lost at sea, along with seventy of their New Haven friends, including Nathaniel Turner. Some returned to Europe, and others agitated for a war with the Dutch to gain more territory.

By 1660, many of the colony's leaders had died, and few stepped forward to continue the defense of New Haven's worldview and its draconian enforcement. This colony failed to create a monastic community for a large population or address a multitude of secular problems. These included its settlement without charter and its non-contiguous patchwork of settlements, made even more disjointed by its plan for a Delaware outpost. Geographically, it was sited in a place that proved inconvenient for shipping to Europe. Agriculturally, it offered subsistence farming for non-farmers. Leaders limited the voice of their people, reserving it only for church members. This alienated many and created widespread criticisms.

The colony's decision to harbor those who were complicit in the hanging of King Charles I in England also defeated improvement efforts when the English monarchy was restored. Those who had roundly denounced the monarchy trembled at retribution they knew was soon coming their way. William Hooke, the brother of a regicide, remarked,

"I know not what will become of us. We are at our wit's end." Another recognized his colony as "the despised ones." New Haven came to face increasingly jurisdictional assaults by the Connecticut Colony. This litany of limitations resulted in the colony's dissolution and absorption by the Connecticut Colony in 1665.[32]

GREENWICH UNDER THE CONNECTICUT COLONY

With the administrative changes overseas and New Haven's perilous posturing, the Connecticut Colony saw its chance to assume a more powerful footing. In a bold move that swept away prior agreements with the New England Confederation, it requested a charter from Charles II that allowed the colony vast new jurisdiction over land controlled by Rhode Island, the New Haven Colony, the Swedes in Delaware and the Dutch. The leadership was spectacularly successful in this and gained Greenwich and Stamford. Greenwich entered the chartered commonwealth of the Connecticut Colony on April 20, 1662.

Charles II quickly blew up this agreement, however, and granted his brother, the Duke of York, a whopping amount of American territory that included some of the Connecticut Colony's recent grant and all of Dutch-held New Netherland. This shocked the jurisdictional structure of the American Northeast, and four royal commissioners visited from England with an eye to reorganization. Saybrook, Hartford and New Haven then merged under a new Crown-approved charter that recognized a large region, now collectively called Connecticut, as a distinctive English territory.

LOCAL GOVERNANCE BEGINS

THE SEVEN PROPRIETORS OF 1664

When the Connecticut Colony ordered local supervision of many small and remote towns under its jurisdiction, seven earnest men assumed governance over Greenwich, a full twenty-four years after the town's founding. The mens' guidance for governing came from Connecticut Colony rules based on Roger Ludlowe's *Code of 1650*, the *Capital Laws of 1642* and *Acts and Laws of His Majesties Colony of Connecticut.*

Six of the seven proprietors of 1664 were sons of Puritans who first arrived in Boston. These men knew one another and the Greenwich founders before settling in Stamford and Greenwich because almost all had also lived in Watertown, Massachusetts. Their common path to southwestern Connecticut was for their parents to have traveled from England to Boston, then on to Watertown, just west of Boston. Many of these then moved to Wethersfield, just south of Hartford, then on to the Stamford/Greenwich area. Perhaps they moved as a group from Wethersfield to Stamford, for Greenwich's founding was only eighteen days after Stamford's.

The first seven townsmen of 1664 were Jeffrey Ferris Sr., Joshua Knap Sr., Joseph Ferris (Jeffrey's son), John Renalds, Angel Husted, John Mead Sr. and John Hobby.

These seven were also prepared for governance by learning from the innovations of their parent's generation. They agreed upon a "plantation

covenant," an oath of communal fidelity, which set forth the aspirations of a private and communally farmed community.[33] They pledged universal support for a Puritan minister, as mandated by the Connecticut Colony. They envisioned growth and proposed that future qualified land-owning residents would enjoy the same benefits as all the rest, unlike New Haven's costly misstep.

INVENTING AMERICAN GOVERNANCE

There were many social and civic innovations created by the first wave of English immigrants. This generation faced the heroic task of establishing orderly, functional and flourishing societies that no longer imitated old-world English models. These sought an innovative mechanism for achieving synchronous success for both communal and private interests.

Much like Galileo, who rattled Europe's perception of the world by proposing a sun-centered universe rather than an earth-centered one, the Puritans radically placed the family at the center of their world, ahead of the church, business interests and the government. The rebalancing of these competitive powers caused a change in the operations of small, new, American communities. Towns, now governed by their own residents, gained a stronger voice in the governance of their local ministers. In Greenwich, this new relationship meant that ministers, finding their disciplinary prescriptions rejected or overridden by municipal committees, left town quickly and often. Ministers also walked a new tightrope and faced resistance in reckoning the proper balance between their flock's economic success and the level of success that they deemed would offend God. Defining "humility," a critical dimension of the Puritan psyche, now became a minefield in the New World, where economic success for subsistence farmers was critical in proving the rightness of their theology. How to balance spiritual humility and economic success at the same time remains an important quest in modern Greenwich. Residents of new American towns now also challenged colonial leadership with an outspoken fervor they could not have in Europe. Over time, both religious and civic leaders increased the control they exerted to maintain order in rambunctious yet fragile new settlements. For opportunistic immigrants grappling with entirely new freedoms and limitless land, these restraints caused tension, distress and anxiety. These concerns, plus undefined

jurisdictions between church and state authority, personal and community obligations created conflicts, schisms and societal stresses not unlike those they hoped they had left far behind.

LAND MANAGEMENT

When Europeans arrived in the 1630s and 1640s and found large tracts of land already claimed by neo-American lords, this old English model was rejected, and revised rules for land ownership were instituted. Immigrants to New England had come from three types of English town structures: open-field manorial villages, incorporated boroughs and the small private farming communities of English East Anglia. To create new land ownership models, they drew from all three experiences. It was decided that vast tracts, with vague boundaries and questionable acquisition from Native Americans, would be owned by a town, rather than one individual, and it would be governed by a committee of residents. Town proprietors, townsmen or selectmen would staff each governing committee, and uniquely, these people would not be aristocrats, lords, aldermen or chancellors.

The legal ability of untitled, non-noble townsmen to make land grants under English law was neither tested nor fully understood, but town land grants commenced regardless. In the case of Greenwich, the founders purchased land where no town existed. Their personal purchase was one jointly owned private farm, a town in name only. When the founders decamped, it was sold and divided into smaller private farms until the early 1660s. The resulting small neighborhood formed only the beginning of a town. Through one of the borders set by the 1650 Treaty of Hartford along with town land purchased from Quakers, who had "illegally" purchased from Native Americans, the town claimed land six miles west of the Mianus River. By October 1660, some Greenwich men referred to themselves as townsmen, and clearly, a governing entity had evolved to manage their Old Greenwich neighborhood.

THE LONG MEADOW

Modern Binney Park hosts the Long Meadow, which lies on both sides of the Longmeadow Creek in Old Greenwich. It first reached all the way to Long Island Sound, but now the railroad obliterates much of its original length and beauty. The Long Meadow Creek was natively named the Asamuck, and this creek was the western boundary of the founding Feake-Patrick purchase. The Long Meadow was a patchwork of privately owned and fenced meadows and homelots throughout the 1660s. Some of the first homes were sited on the bluff on the west side of Sound Beach Avenue for views of the livestock and planting fields of Binney Park below. In 1666, it was "ordered that the upland that lies on the northeast side of the Longmeadow Brook so called, is to have thirteen rods of fence layd out to it." There were sixteen to seventeen rods of fence on its west side.

Crossing the Longmeadow Brook was a priority. In 1663, the town directed "a sufficient cart bridge over Longmeadow Brook to be made." Ten years later, John Bowers rebuilt it as a substantial bridge "not larger than it currently is" in return for perpetual tax relief and avoidance of fence maintenance. In 1678, John Bowers sold two and a half "shares" of his bridge building or "casy" work[34] over the Longmeadow to Daniel Smith. He sold his own property here that same year but reserved access to it every year after the *mishamos*, or Indian corn harvest.[35]

THE FIRST COMMON FIELD

The town's first fenced-in common field, in addition to its many private enclosures, incorporated some portion of modern Innis Arden Country Club and the Old Greenwich Civic Center grounds, just west of the Tatomack or Tomac Creek. Support for this finding comes from James Palmer's one-and-a-half-acre homelot bounded "by the street westerly, by Totamuck harbor easterly, by Walter Butler's homelot southerly, and by *the common* northerly."[36]

Later, in 1706, a fence line joined Lockwood Avenue and Old Club House Roads to completely fence off most of southern Old Greenwich. This fence line ran from the "Grimes land" on the western edge of Old Greenwich (the Shorelands Road area) to Tomac Creek on its eastern edge. This fence line coexisted with crossing, perpendicular roadways, and

it was not unusual for fencing to block roadways. To pass along an unpaved roadway by foot or by horse, one opened and closed field gates along the way to reach one's destination. In later years, Greenwich residents were frequently directed to remove any fencing that obstructed public roadways.

COMMONS

Greenwich residents imitated the farming of Wethersfield, Connecticut, and Watertown, Massachusetts, by using a combination of open/common fields and private farming. In Europe, owners of common fields were land-owning individuals and private institutions, such as the church. Farmers unhappily "rented" parcels of manor land and paid the lord or entity usage fees and taxes. In America, the town would now uniquely grant or sell land to individuals to use both "in common" and privately.

The sharing of a common field was called one's "right in commons," and such fields allocated scarce resources such as seed, fertilizer, water, farming equipment, livestock power and harvesting labor. Natural resources now became available to all in town-owned land, including wild animals, nuts and cranberries, salt hay, sea life, salt, rocks for fencing, trees for building, pine to turn into turpentine and tar, tree bark for leather-making tannins and charcoal, medicinal plants and shell middens to burn for lye to make mortar and clean hides. Common fields equitably allocated arable planting land, grazing land and woodlands. Within the common fields, each person's particular section was further enclosed with fencing. There was also a social advantage, as participation created social and civic bonds. Farming issues were discussed communally, and group decisions were rendered.

Private farms, preferred by East Anglia immigrants, competed more for natural resources but offered the advantages of greater personal control, expansion ability and production output. In 1637, in Watertown, where many of the first Greenwich townsmen originated, 60 percent were from East Anglia, as reported by Powell. Synchronously operating private and common farms allowed the enterprise of the individual along with that of the commonwealth to succeed, which significantly strengthened the early communities.

Greenwich Plantation Positions

The population grew, and the Myanos Neck Field, now modern Riverside, was farmed communally for food and leather production. The first town meetings of the 1660s saw the original seven selectmen facilitate Long Meadow bridge construction, form rules for abandoned home lots, grant home and swamp lots, create fines and impound livestock that damaged property, order livestock drives to and from Cos Cob, create rules for common fence building and set fines for those who neglected repair. They created rules for paying a future schoolmaster, recruiting a suitable minister and deciding which part of the wilderness would get fenced in first. They determined road maintenance duties for all citizens above the age of ten. They became agricultural arbiters, deeming when livestock was let into and out of common fields and when the community crops were to be planted and cleared. They also began to appoint residents into a rotation of communal farming positions. The first recorded town meeting of 1663 appointed John Bowers and Joseph Finch to be sheepmasters for the town flock, which may show the priority of town concerns, along with hyway surveyors and road cutters. In 1668, road surveyors were paid in seawant or wampum. The list of town appointed positions would eventually grow to include clerks or recorders, meeting warners, meeting moderators, treasurers, listers (asset tabulators), constables, sealers of weights and measures, chimney viewers, leather sealers, grand jurymen, packers of meat and cutters of steers, cullers of (barrel) staves, fence viewers, keykeepers of the common field gates, tythingmen, collectors of the minister's rates, shepherds, cowkeepers, branders, pounders (animal impounders), field stewards, innkeepers and, eventually, in 1710, a school committee.

Admission to Greenwich

One could participate in the private and common field farming of Greenwich only if one had been formally admitted as a male head of household and had pledged an oath to support the town administratively, functionally and economically. These were the "Freemen" of Greenwich. There were others who lived in town but did not own land, such as skilled town shepherd John Tash; James Rite, a biscuit baker; and Thomas Pent, the town's first schoolmaster. These individuals never participated in the town's many land

Freemen

Be it enacted such as [all who] shall desire to be admitted Freemen... shall bring a certificate...that they are persons of a quiet and peaceable behavior, and civil conversation; and that they have accomplished the age of twenty one years, and have the possession of freehold estate to the value of forty shillings per annum or forty pounds personal estate....And it is further enacted...that if any Freeman shall walk scandalously or commit any scandalous offence, it shall be in the power...to disenfranchise such Freemen...til by his good behavior the Court of Assistants shall see cause to restore him to his freedom again.

Acts and Laws of His Majesties Colony of Connecticut in New England: 40

distribution lotteries. Other tradesmen, such as blacksmith Thomas Bullis and Jasper Videto, the common field waterworks-maker, were granted land by the town in exchange for their services. Bullis was later able to buy, sell, pass on and exchange his town-granted properties. Videto died in 1686, shortly after arriving, so his land grant passed to his son, who was able to sell it many years later.

Requirements for living in Greenwich became more defined by 1665. One had to supply a letter from a minister, magistrate or selectman of a prior residence that testified as to one's "orderly life and conversation." Exceptions to this were made for those who were already "well known to the town's good satisfaction."

CURRENCY

To pay their bills and generate revenue, many currencies were used. There was no domestically produced colonial currency before 1652, as only the king could mint coins, which limited supply for the colonies. Greenwich used barter, seawant or wampum-peague, called *peague*, the shell currency of Native Americans. In 1671, Joseph Mead was "paid in

wheat, peas, pork and Indian corn a fourth of sack" for "freeing the town of their engagement unto Daniel Patrick [Jr.]" John Mead and James Ferris gave Patrick "sack of them, [sherry], a cow a piece to be faire with calf or a calf by the side…in such condition as may fully satisfy." In 1668, Jonathan Renalds and William Ratleff were paid in seawant for their survey work. In 1674, Steven Sherwood paid a portion of the seventy-pound price for his land in seawant.

Peague

It is ordered by this court and decreed that no peague white or black be paid or received but what is strung and in some measure, strung suitably, and not small and great, uncomely and disorderly mixt as formerly as it hath been.

Code of 1650:78

THE TOWN CLERK OR RECORDER

Before Greenwich gained a clerk, years would pass between a land sale, a birth, death or marriage and its recording. The Feake-Patrick "founding deed," created in 1640, was not recorded until 1686, or forty-six years after the event. The first clerk was Joshua Knap, but the clerk with a most extraordinary dedication and tenure was his relative Timothie Knap. One of the first residents of 1656, Timothie Knap began his long and diligent career in 1688. He served in many other town positions in addition to clerking; he created many of the town's first roads and surveyed its first public and private lands. After sixteen years of duty, his position was challenged in 1704: "Joseph Finch Senior and Jonathan Heusted and Jonathan Renalds Senior have summoned Timothie Knap to court for not delivering [town records] unto them." Others came to his defense and "do utterly deny and forbid their proceeding in the towns name any

> ### Remarkable Passages of Gods Providences [Miracles] *Also to Be Recorded by Town Clerks*
>
> ...which have beene remarkable, since our first undertaking of these plantations...to gather up the same, and deliver them into the Generall courte in September next, and if it bee judged then fitt, they may bee recorded...
>
> *Acts and Laws of His Majeties Colony of Connecticut: 102*

further." Knap's inability may have been due to a stroke, as his signature becomes jagged and uneven at this time—dramatically different from his many previous signings. Knap continued recording all town records until 1725, when he was eighty-nine years old. Joshua Knap Jr. assumed his duties until 1732, followed by John Knap until 1745.

THOMAS BULLIS: TOWN BLACKSMITH

The town "being sensible of the great necessity of a blacksmith at Horseneck," hired Thomas Bullis, "blacksmith of New York" on January 21, 1696. He was given a homelot of five acres between the homelots of Joseph Heusted and Joseph Ferris. The town requested that he "pay and defray the town charges and that he shall improve himself at his trade for the supply people for iron work."

THE FIRST SCHOOLMASTER

In 1667, Greenwich parents longed for a schoolmaster, or dame, but the population was only twenty-seven European families, and Connecticut Colony law directed that one need not be hired until the population reached fifty families. Families, some with more than thirteen children each, hatched a plan to gain a teacher and offered to pay one according

> ## *Schooles*
>
> It being one cheife proiect of that old deluder, Satan, to keepe men from the knowledge of the scriptures, as in former times, keeping them in an unknowne tongue, so in these latter times, by perswading them from the use of tongues, so that at least, the true sence and meaning of the origin all might bee clouded with false glosses of said seeming deceiver; and that learning may not bee buried in the grave of our forefathers, in church and commonwealth, the Lord assisting our indeavors. It is therefore ordered by this courte and authority thereof, that every towneshipp within this jurissdiction, after the Lord hath increased them to the number of fifty howsholders, shall then forthwith appointe one within theire towne, to teach all such children, as shall resorte to him, to write and read, whose wages shall bee paid, either by the parents or masters of such children or by the inhabitants.
>
> *Code of 1650: 91–92*

to the proportion of the number of children per family sent. If money fell short, even those with no children would contribute to the schoolmaster's support. This plan failed, and hiring a teacher wasn't recorded for yet another decade.

Thomas Pent became the town's first schoolmaster in 1695, even though the population was only thirty-four European families, after fifty-five years of homeschooling for town children. Pent was asked to teach for six months, beginning on October 15, and only those who sent children to school were obligated to pay him. In 1701, a schoolmaster search occurred again, and the population had increased to forty families.

THE FIRST CONSTABLES

The first constables were Joseph Mead Sr. and Joseph Ferris, appointed in 1683. Their duties were to be the town's first tax collectors. Joseph

> ## Constables
>
> It is ordered by the authority of this Court, that every constable within one jurisdiction shall henceforth have full power to make, signe and put forth pursuits or hue and cryes, after murderers, malefactors, peacebrakers, theeves, robbers, burglarers, and other capitall offenders, where no magistrate is neare hand; allso, to apprehend, without warrant, such as are overtaken with drinke, swearing, saboath-breaking, slighting the ordinances, lying, vagrant persons, night-walkers, or any other that shall offend in any of these.
>
> *Code of 1650:40-41*

Mead, perhaps not relishing tax collection, and John Hobbe disputed this appointment shortly thereafter, charging that the town meeting where it had occurred was disorderly and the appointment was illegal. Greenwich constables or tax collectors were also charged with delivering town payments to the Connecticut Colony.

1667 CENSUS

By 1667, the (Old) Greenwich residents who were allowed to buy land included twenty-five families, excepting the founding Feake and Patrick families, who had moved to live on the western end of Long Island close to Manhattan. Listed Greenwich family heads included Jeffrey Ferris, Thomas Sherwood, John Mead, Angel Heusted, Robert Heusted Jr., John Hobby/ Hubbe, Robert Williams, Edmund Sticlund, William Grimes, Thomas Marshall, Timothie Knap, William Hubbart, John Bowers, Joseph Finch, Daniel Smith, Jonathan Renalds, Thomas Close, Samuel Jenkins, John Emry, Gershom Lockwood, William Ratleff, John Banks, Richard Bullerd, John Palmer and William Rundle. Native Americans and perhaps enslaved individuals continued to live within Greenwich, but their names and family size is unknown.

Early Greenwich Residents Who Moved Away, Besides the Founding Feake and Patrick Families

Edmond Stickland	Pre-1649
John Rockwell	Pre-1649, from Stamford
Andrew Messenger	Pre-1649
Thomas Sherwood	Pre-1650, established Rye
Peter Meacocks	Pre-1650
Richard Latting	established Lattingtown, New York
Richard Crabb/Mrs.	Pre-1652, from Stamford
Richard Vowles	Pre-1656
John Coe	Pre-1649 Established Rye
Robert Williams	Pre-1660
Matthew Bellamy	arrived 1669, moved 1673

QUALIFIED RESIDENCY AND THE TREATMENT OF STRANGERS

Those arriving without formal admittance, particularly the indigent, were "warned off" from settling. Care from town coffers was reserved for established town residents for whom disposable revenue was limited. Caring for drifters threatened the stability of local economies, so they were sent away. Sending away strangers was not unique to Greenwich; it was a mandated policy of the Connecticut Colony:

> *May 21, 1688 at a town meeting, the town being acquainted of strangers one Gabriell Sharle [Charles] a despised helpless man destitute of money or relations and the taking up his abode amongst us and the prevention of which the town doth hereby disown him being any of their poor neither will they contribute any of their money for his support under that denomination neither was he ever admitted into town by their knowledge or consent.* [37]

> ## *Inhabitants Whom to Be Admitted*
>
> Be it enacted...that no transient person shall be allowed to reside, and make his or her abode in any township in this colony, (Apprentices under age and servants bought for time excepted), upon pretence of hiring or being hired...And it is further enacted...that the civil authority...are hereby empowered to order any vagrant or suspected person or persons to be sent back Constable to Constable to the place or places whence he or they came; unless such person or persons can produce good certificate, that he or they are persons of good behavior, free from all engagements, and at liberty to remove themselves as he or they shall see meet: and if such persons shall return after they are sent back...they shall be severely whipt, not exceeding ten stripes.
>
> *Acts and Laws of His Majesties Colony of Connecticut in New England: 58*

A SLAVE POPULATION

The plantation covenant of Guilford references "those that belong to us," and this may refer to families as well as young Europeans "bound" for a period of time to work for others. It might also refer to a Native American slave population that predated African and Caribbean slaves. The early Greenwich archives mention two enslaved people, and there may have been more. The 1692 will of Gershom Lockwood Sr. gifts "a certain nigro girl" to his daughter Sarah Lockwood "at his decease." The 1699 will of John Renalds Sr. gifts his wife, Judah, "my negro woman." [38] In 1739, Justus Bush owned slaves valued at £120.

POVERTY

Treatment of the poor was regulated by the Connecticut Colony, and in 1680, Governor William Leete clarified that each town was to care for its

own poor, particularly its "worthy poor" who could potentially be paid for assisting with the abundant work that was needed in the colony. The "unworthy poor" were those deemed beggars, vagrants and vagabonds who could be punished. Greenwich townsmen were compassionate, however, toward their own. In 1685, the town was "acquainted with James Palmer's distressed condition for want of provision for his family and in order [for] the prevention...of the same and that he or his may not suffer" sent John Mead Sr. and Joseph Ferris "to go to his house to make inquiry." James was a son of Judith Feake Palmer Ferris Bowers.

Greenwich founder Elizabeth Winthrop Feake Hallett's daughter, by the drowned Henry Winthrop, also experienced deprivation. Martha Johana Winthrop had married Thomas Lyon, and this couple lived within Stamford. In writing her uncle, John Winthrop Jr., she reveals her poverty-stricken life:[39]

To my loving and kind Uncle, Mr. John Winthrop, at Pequot, this dd. From Stamford, ye 23 March, 1648/9

Most Loving and Kind Uncle and Aunt,
My humble duty remembered unto you...I humbly thank you for your great love and care toward me in that you have sought to know how it is with me. Mr. Eaton being here I have sent by him plainly and nakedly how it is. I hope he will acquaint you. For my own part I am weaker than ever I was and not able to do anything, scarce to take my own vittles when it is set by me. I likewise have a very bad stomach, but...because of my breeding my stomach is very choice and dainty, which causes me to suffer the more, my husband being not able nor at leisure to get me what I would. Here is no help to be got, neither by neighborhood nor servants, my husband being forced to do all both for himself and me, which is great hindrance and loss. I entreat you, good Uncle, consider my condition as it is and help me a little with some of your castoff clothes, for I know not how to do when the Lord please to give me another little one. For my husband's part, he does what he can for me and I am sorry he should suffer so much for me, for he drinks water that I might drink beer, eats Indian [corn] that I might eat wheat, and fares hard & works hard that I might not suffer; but you may consider partly his condition that he cannot do as he would....Remember my duty to my Mother. I sent a letter to her. I hope she hath received it....In haste, I rest Your humble and dutiful cozen, Martha Johana Lyon.

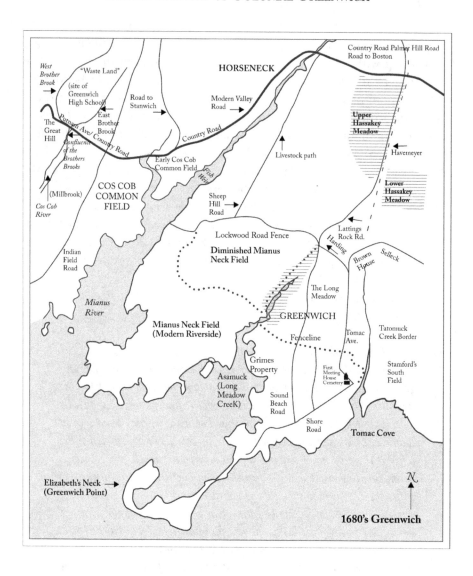

Martha Johana would die shortly after this letter. She likely died at the age of twenty-six from lead poultices applied to open sores, given to her by both her mother, Elizabeth Feake Hallett, and her uncle, Governor John Winthrop. In the late 1640s, her husband, Thomas Lyon, also wrote to the Winthrops, asking for any available hoes and scythes they could spare.

Long-Term First Settlers

SETTLER	ARRIVAL	NOTES
Jeffrey Ferris	1640	1664 Proprietor with son Joseph. In Stamford in 1640. On the first purchase deed he owned property "in all the necks." Purchased some Feake-Patrick-Hallett property in 1648/49.
John Renalds	1640	1664 Proprietor. Married to Sarah. In Stamford first.
Robert Heusted	1649	In Stamford previously. Two sons were 1664 proprietors.
Timothie Knap	Pre-1656	Purchased Vowles property. Son of 1664 proprietor Joshua Knap.
John Marshall	Pre-1656	Left Greenwich 1656. Returned by 1687.
William Hubbard	Pre-1658	Purchased John Coe's property.
Thomas Studwell	1658	Purchased Crabb property. Sold to John Mead in 1661 [#814]
John Hobby	Pre-1659	1664 proprietor
John Mead	1660	1664 proprietor. Purchased Crabb and Studwell properties.
William Grimes	Pre-1663	No family members mentioned in his will. Friend of Joseph Ferris.
Daniel Smith	1663	Husband of Hannah Knap, daughter of 1664 proprietor Joshua Knap
William Rundle	1663	Born in England (1647–1714). Sons: W., Samuel, John and Abraham.
John Bowers	Pre-1663	Married first Judith Feake Palmer, then Hannah Close Knap. Town minister, 1677+.
Joseph Finch	Pre-1663	Born in Greenwich (1640–1714), married Elizabeth Austin, daughter of John (II)

SETTLER	ARRIVAL	NOTES
William Ratleff	Pre-1664	Died by 1687, married Elizabeth Ratleff Boulden, who moved to Milford. Son William remained in Greenwich.
Richard Bullard	1669	Sold house and property by 1674 to Jonathan Lockwood.
Thomas Youngs	1669	1645–1720. Moved to Oyster Bay, Long Island.
Thomas Close	1669	Brother-in-law to 1664 proprietor Joshua Knap.
Steven Sherwood	1670	Link to Thomas unknown. Brother-in-law to 1664 proprietor Angell Husted.
Ephraim Palmer	1672	Stepson of 1664 proprietor Jeffrey Ferris.
Thomas Austin	1673	Father-in-law of Hannah Ferris, daughter of 1664 proprietor Joseph Ferris
John Tash	1679	Shepherd
Joshua Baisham	1681	
Thomas Pineare	1681	
[Robert] and Margaret Kitchell	Pre-1682	
Richard Boland	????	Sold all of his holdings or "land of no value" to Micall Shay/Shaze of Poitonwall [?] on New York and to John Mead in 1676. [1205, 811]

6

GROWING PAINS

DANIEL PATRICK JR. SIGNS OVER REMAINING FEAKE-PATRICK LAND TO THE TOWN

In 1669, those townsmen who knew the obstinate personality of Captain Daniel Patrick worried that his son, Daniel Jr., still claimed some of the founding purchase. Captain Daniel Patrick was assassinated in 1643, shot dead in John Underhill's house in Stamford after a failed Indian raid. They worried the town could be charged with illegally selling or developing land that he still legitimately owned. Another complication was that Captain Patrick's widow, Anna, had married Tobias Feake, who was Robert Feake's nephew. Tobias Feake could also claim inheritable Patrick property through his new wife, and it was difficult to discern what parcels of the joint founding purchase could be his. The town asked Daniel Patrick Jr. to quitclaim, or renounce, any remaining rights of his father. In return, the town gave him fifty pounds, a horse and a saddle. He also received wheat, peas, pork and Indian corn, a fourth of a sack (sherry) in good condition and two cows, each "faire with calf [pregnant]" or "a calf by the side [newly calved]." Daniel Jr. had moved to Castle Hill in the Bronx, very near to Hallett's Point. He had also been making claims to some property in Rye.[40]

JOHN FEAKE SELLS HIS GREENWICH LAND

John Feake, son and heir of founders Elizabeth and Robert Feake, sold his land to the Town of Greenwich in October 1701, some sixty-one years after his parents' purchases. This was either his own land or more remains of his parents' purchases. John had moved from Greenwich to Oyster Bay, Long Island, and lived, along with his brothers, very near John Underhill, who was married to his sister Elizabeth. John Feake sold his land to James Ferris Sr., Samuel Peck and Robert Lockwood.[41]

GREENWICH BOUNDS TAKE YEARS TO CONFIRM

The Treaty of Hartford set the western boundary of New England at the west bank of the Mianus River to keep the English away from the Hudson River by at least ten miles. This border changed with the charter of 1662, which expanded Connecticut to the Pacific Ocean. The Duke of York's grant of 1664 pulled the boundary of Connecticut back from the Pacific, but it now reached south to the Delaware Bay. Further negotiations in 1664 gave Long Island entirely to New York and gave Connecticut's southwest boundary a north–northwest direction, at a point where the Mamaroneck River meets

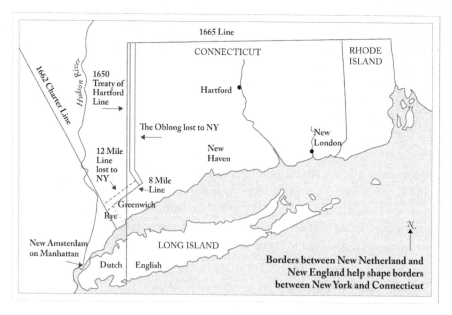

Long Island Sound. This line was entirely ignored, never surveyed and always disputed. A 1671 court fixed the western bounds of Greenwich at twelve miles from the Hudson River, but then the Dutch reclaimed New York for a year and all boundaries were called into question.

THE FORTY-YEAR EASTERN BORDER FEUD WITH STAMFORD

Inter-colonial disputes also caused the original eastern border of Greenwich with Stamford to shift from a north–south running line to a north–northwest running line at Palmer Hill Road and Havemeyer Lane. After twenty-seven years of peace, Stamford successfully convinced the Connecticut Colony Court to change the direction of the Greenwich-Stamford border in 1667. This made the new boundary align with the Greenwich-Rye border and parallel with the Stamford-Norwalk border. With this, Greenwich lost a significant amount of land to Stamford, along with its associated tax revenues. Greenwich men who had lived and farmed in the "lost wedge" on either side of the Mianus River Gorge for thirty years now found themselves Stamford residents. Greenwich was denied in its twelve appeals over forty years.

The point where the boundary changed direction is at the intersection of Palmer Hill Road and Havemeyer Lane, which was originally part of Laddins (Lattings) Rock Road. This intersection is, as original documents indicate, 1.0 mile west of Stamford's Mill River Falls. By curving modern roadway, it is about 1.4 to 1.5 miles. The original eastern boundary line ran due north from this point. Today's eastern town boundary, however, runs about 30 degrees north–northwest from this intersection. On the 1789 *Mapp of Stamford Township* this original eastern town border is shown and it is also remembered later as the eastern border of the Stanwich Parish.[42]

When this border first changed, Greenwich appealed to have the original boundary reinstated, "to promote a righteousness between a man and his neighbor and to affably see ancient and rational covenants." The town contended that the original 1640 border had been agreed to twice before. Stamford's Richard Gildersleeve, Andrew Ward and Robert Coe also agreed they had set the boundary with Daniel Patrick and Robert Feake "by mutual consent." Greenwich re-walked this line in December 1670 in preparation for a court hearing. John Mead was assisted by his son

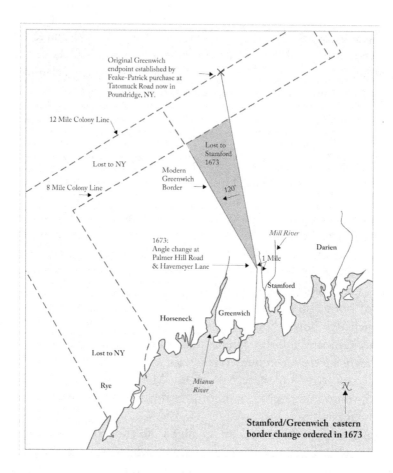

Original Greenwich endpoint established by Feake-Patrick purchase at Tatomuck Road now in Poundridge, NY.

12 Mile Colony Line

Lost to NY

8 Mile Colony Line

Lost to Stamford 1673

Modern Greenwich Border

120°

1673: Angle change at Palmer Hill Road & Havemeyer Lane

Mill River

Darien

1 Mile

Stamford

Horseneck

Greenwich

Lost to NY

Rye

Mianus River

N

Stamford/Greenwich eastern border change ordered in 1673

Joseph for this, and they required horses for their journey. The town sold them two, which the Meads paid for in wheat, peas and Indian corn. Notwithstanding these expenses and John Mead's sagacity, the court maintained its position. An attempt to "more fully convince" the court was made the following year by interviewing Robert Coe, who now lived on Manursing Island off Rye. He assured that Ward and Gildersleeve were

Opposite, top: The eastern border of the Stanwich Parish is shown here. The original eastern border is remembered by this parish line. A pencil line also shows the original line and angle change point. *Map of the Township of Stamford*, 1789. *New York Historical Society, M3.44.31.*

Opposite, bottom: Spencer Mead's combination of three maps. The western border of Stanwich parish is enhanced by author. Its truncated southwest corner shows the area of those who returned to Horseneck Parish, in the neighborhood of North Street and South Stanwich Roads and a street now under the reservoir near DeKraft and Butternut Hollow Roads. *Mead*, Ye Historie of Ye Town of Greenwich *(Harrison, NY: Harbor Hill Books, 1979).*

bona fide agents for Stamford and had true power to "covenant and agree" with Feake and Patrick on "how to run the line for the dividing of each town's bounds." In 1673, Stamford was urged to reinstate the original line running "from the falls of Stamford Men's Mill River due west a meet mile, and then ran north and south from that point."

Unable to broker a border reversion, the town doubled down and asked a new team of men to "maintain and make good" the old line, "fully according to the agreement made betwixt Stamford Men's predecessors and Greenwich men's predecessors." Reward was great if they succeeded, for the town was prepared to grant successful petitioners one hundred acres of

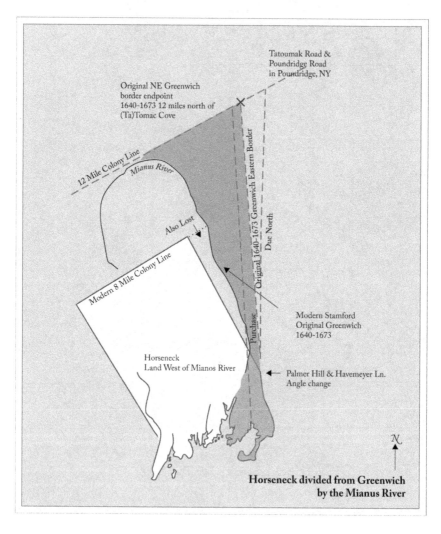

Tatoumak Road & Poundridge Road in Poundridge, NY

Original NE Greenwich border endpoint 1640-1673 12 miles north of (Ta)Tomac Cove

12 Mile Colony Line

Mianus River

Also Lost

Modern 8 Mile Colony Line

Original 1640-1673 Greenwich Eastern Border

Due North

Purchase

Modern Stamford Original Greenwich 1640-1673

Horseneck Land West of Mianos River

Palmer Hill & Havemeyer Ln. Angle change

N

Horseneck divided from Greenwich by the Mianus River

upland "six or seven miles distant from our town," *plus* Great Captain's and Little Captain's Islands. The town also planned a road to permanently mark the original boundary. In May 1673, all of this was denied.[43]

The next year, a petulant Greenwich decreed that "none of the Stamford men are to get or take any wood or timber in our bounds...unless they were given approval...in the regular way....Further...any of our inhabitants have liberty to fetch away that timber or wood that Stamford men have gotten in our bounds."

Eight years later, in 1682, Greenwich again protested the new line. In 1685, three senior men met with Stamford to obstinately insure the dividing line was run "according to the ancient covenant made between Stamford and Greenwich...made between our predecessors." The court reiterated its 1672 denial and now gave Stamford its patent, referencing the "parallel with Norwalk."[44] Greenwich appointed another committee in 1687 to "forever settle" the dispute. Still agitating in 1693, Stamford accommodatingly re-ran the line "according to the meridian."

Greenwich protested in 1695: "We do not enjoy our ancient properties according to covenant made and confirmed by our ancient predecessors." Some of the more truculent complained that the Fairfield Court was "not answering our expectation according to our ancient covenant." The most obstinate saw cause for a fourth trial, so that "love and peace may continue between each town, [and to ignore the court's decision], they requested a 'neighborly debate' with our neighbors at Stamford." Greenwich lost this debate when the court issued Greenwich its patent upholding the boundary that favored Stamford on May 21, 1697.[45] Regardless, some sought to sue Stamford in 1698 in another attempt. Even into 1706, Thomas Marshall, the town's attorney, was directed "to answer the charges at Stamford in an action which they have commenced against the town." Greenwich ultimately lost its forty-year border feud, and the new boundary remained, ceding the northern end of the Mianus River Gorge to Stamford.[46]

THE ORIGINAL NORTHERN BOUNDARY ENDPOINT LOCATED IN POUNDRIDGE, NEW YORK

The Feake-Patrick purchase deed stipulates that the founding boundary ran north of Tomac or Tatomuck Cove for "about" twenty miles. This was similar to Daniel Patrick's deed for half of Norwalk, which bounded

Above: The original Feake-Patrick purchase endpoint in Poundridge, New York. *Author photo*.

Left: Close to the Tatomuck Road in Poundridge, New York is Old Corner Road, marking an early Greenwich, Connecticut, and New York corner. *Author photo*.

his property inland to be "as far as an Indian can go in a day." The original "north-from-Tomac Creek" endpoint is found approximately sixteen miles due north of Tomac Cove. It is marked very appropriately at "Old Corner Road" and "Tatomuck Road," within Poundridge, New York. Through additional New York and Connecticut border negotiations in 1727, the northwest corner of Greenwich moved from Old Corner and Tatoumack Road in Poundridge to the intersection of Banksville Avenue and Taconic Road.

In 1875, the Stamford-Greenwich border was remapped for modern clarity. Comparing compass readings in 1875 with those of 1673, it was found that the 1673 readings were made following magnetic, rather than true north, readings and the difference was 2°42'. Granite cut stone monuments were placed every thousand feet or so and at prominent, observable places so that future surveys "would not be as difficult."[47]

DISPUTES OVER BOUNDARY WITH RYE AND BEDFORD

The boundary with Rye also fluctuated, given the same events affecting other Greenwich borders. Originally, Rye had been part of Connecticut, thus part of Greenwich, but in 1696, the court mandated a boundary line dividing Rye from Greenwich, which Rye refused to accept. When informed that "Rye people have appropriated land within our town bounds," Greenwich "acquainted them" with its disapproval. In May 1673, the court reiterated the border between "Greenwich and Rie…to be from the mouth of the Birum River to run up the river one quarter of a mile above the great stone lying in the cross passage of the said river and from thence the said commons upwards between Stamford bounds." There were property incursions as well. In 1679, Rye fashioned a pound, an animal enclosure also called a stockyard, within the bounds of Greenwich in order to "take horses." Rye had already taken some Greenwich horses and sold them off, "which is altogether offensive." Greenwich instructed Rye to return remaining horses so that "each man may have what may justly belong to them." In 1679, Rye also "acted irregularly in that they have brought their swine to Horseneck and they have left them to our hurt and damage." They are to "clear our lands of their swine and to do it effectually as that there may not be any more trespass of this kind."

In 1683, politicians reiterated that Rye belonged to New York. This remained officially unresolved for years, because neither state had surveyed the line. In 1696, New York also began pressing for ownership of Bedford, which struggled to remain a part of Greenwich. By 1703, the town had raised enough money, payable in currency or flax, to more officially mark these borders, and they were re-marked again in 1707. In 1710, two acres on the west side of the Byram River were litigated when Nathaniel Sherwood, a resident of Rye, claimed possession. Debate continued through 1715, and even tax collectors remained confused. Those living in Pimbewaug, now Pemberwick, also called Cauk's Purchase, refused to pay Greenwich minister's taxes, believing they belonged to New York. Tax collectors reported that "the inhabitants…were in a tumultuous and riotous manner [and] by strong hand we were resisted by one Adam Ireland of Cauk's Purchase aforesaid in the town of Greenwich." In 1717, the General Court confirmed Rye's New York border with Greenwich, but this was still not accepted. In 1726, the border was finally surveyed and agreed to by 1731. This ruling finally carved Rye and Bedford away from Connecticut and Greenwich jurisdiction.

CREATING THE TOWN

OLD GREENWICH

Old Greenwich lies east of the Mianus River, and it is where the town's Europeans first purchased land called Petuchquapock from Native Americans. It was named Greenwich and also called the East Society, later the Old Society when land west of the Mianus River was developed. Land west of the river was natively called "Paihomsing" and "Horseneck," by Europeans. The town's entire population was concentrated within Old Greenwich for the town's first forty years of European occupation. The Feakes, Patricks and Ferrises had their homes along the shore road here, but unfortunately, few manmade vestiges of this period remain beyond the Ferris House, a combination of seventeenth-century structures and the Tomac Cemetery, where many of the first here are doubtless buried.

THE FIRST ROADS

The first roads ran along the shore, connecting Elizabeth's Neck (Greenwich Point) to the Stamford settlement. To reach Stamford's mill at Broad Street and the Mill River—without crossing Stamford's west branch inlet—one would have traveled the Shore Road, up Sound Beach or Tomac Avenue to

Laddings Rock/Havemeyer Place to Palmer Hill Road and Broad Street. Palmer Hill Road was also called the Road to Boston, the Country Road and the Westchester Path, before there was any other way to cross the Mianus River. The 1600s Stamford settlement was clustered where the Stamford Town Center shopping complex exists today, surrounding the intersection of Broad Street and the Stamford Library.

Another very early (Old) Greenwich road accessed the Mianus Neck Common Field for residents living on the easternmost side of (Old) Greenwich. One access was from Shore Road to Tomac Avenue to Forest Avenue to Lockwood Road. Lockwood Road was the northern boundary of the great field, which initially encompassed all of the Riverside peninsula. The Country Road, also called the Boston Post Road, Putnam Avenue and U.S. Route 1, was perhaps the oldest road, traveled by deer and native Americans, then traders on horses and ox carts. The first southerly roads off the Country Road accessed Cos Cob Point, Rocky Neck Point, Piping Point, the Horseneck Common Field and Byram Neck. Stanwich Road, accessing Bedford, was one of the first roads reaching northward into wilderness from the Country Road. The road to Stanwich is first depicted in the Erskine-De Witt map *From Sawpitts to Stanwich* of 1778, drawn for the Continental army.[48]

OLD GREENWICH DEVELOPMENT

Prior to 1664, the town was a collection of just a few small private farms with one jointly farmed common field, some of modern Innis Arden Country Club. Planters maintained fences around their personal homelots as well as the common field. Tomac Avenue hosted the first meetinghouse and cemetery. Many of the first homes were built on Shore Road and Sound Beach Avenue. Richard Crabb had a fenced in homelot here by 1660 and eighteen acres on Elizabeth's Neck, now Greenwich Point. His homelot was "bounded by a fence" on its west, northwest and north. Farmers here also pastured animals on Captain Patrick's Islands, Hog Island and the Calf Islands off Old Greenwich, Riverside and Byram to keep them safe from wolves and poachers. The Calf Islands were quickly "improved" in the early 1660s to guard against jurisdictional claims by Rye.

Land Lotteries

The first grants of land from the town of Greenwich and distributed in town meetings were quickly criticized as to the amount of acreage granted, land locations and the rationale for dispensation. Joseph Finch received four acres within the Myanos Neck Field. Leftenant Jonathan Lockwood was granted some swampland in return for plank wood the town had borrowed from him. John Hobby Sr. received a building lot containing three acres "in consideration…of his journeys to Hempstead upon Long Island in the town's behalf."

As townsmen surveyed about fifty square miles of undeveloped territory, they rapidly concluded the need for a more equitable distribution mechanism. In 1639, the Massachusetts Bay General Court instructed regional towns to "go to their Plantations and allocate their lands." It was very important that land distribution was not accomplished by one individual or a private committee of people who could become corrupted and inequitable. An impersonal system was far less problematic. In Greenwich, as in Massachusetts towns such as Sudbury, and Watertown, lotteries were instituted. This too was an early Puritan innovation. Land lotteries distributed both common and private land, and the repeated use of them indicates they were accepted as fair and functional.

Common land differed from undivided land, in that undivided land was set aside for private, non-communal use. In "undivided land" lotteries, the town set a constant price per acre for all participants. The first price in Greenwich was set by Daniel Patrick himself, and he priced (Old) Greenwich land at ten pounds per acre, a price referred to for decades as "Patrick's Rate." Secondary sales from first land lottery owners to other individuals at market value then began the endless chain of private land ownership transfers. For common land lotteries, prices were set in proportion to the amount of land each participant already owned. Equated with personal wealth, this measure or proportion was also used to calculate the basis of taxation.

Land Named According to Its Degree of Development

Unlike their former New Haven Colony governors, Greenwich townsmen decreed that future inhabitants of western Greenwich would have the same

rights and privileges to participate in the ownership of outland as did the first seven proprietors or townsmen, who drafted the original covenant. From the outset, it was agreed that Greenwich land ownership would importantly remain "according to a rule of proportion." This meant land was to be purchased from the town at a specified and constant price per acre for private purchase and in proportion to one's assets for common land. The amount purchased privately was limited only by one's financial ability—after qualified admittance as a resident of the town.

The frontier was described in terms of its degree of development. Land undisturbed by any European was called "wilderness" or "outland." Land farmed communally was "commons" or "land in common." Land to be privately developed was "land laying undivided." After a lottery for common land, monies were held by the town to secure one's "right in commons." Referencing the amount of money put forth for such a purchase was expressed as "a twenty-seven pound right in commons." If the rate was ten pounds per acre, this meant one had received twenty-seven acres. Money held for future private farming was one's "right in land undivided."

Once surveyed and marked, properties were "land layd out," and these parcels were surveyed and marked before any roads, called "hyways," accessed them. The arrival of fencing, livestock, planting or buildings became "land taken up." Land that supported a dwelling house or "mansion" was a "homelot." Most often, a family would live in a homelot of three to five acres

Home-Lotts

[A]ll dwellings or mansion houses that are or shall be allowed in any town or plantation in this colony shall be upheld, repaired and maintained sufficiently in a comely way; also whosoever shall posess and enjoy any home-lott within any such town or plantation that is not yet built upon, he shall within twelve months...erect and build a house there fit for an inhabitant to dwell in...upon the penalty of twenty shillings per year for every breach of this order, to be paid to the town treasury.

Acts and Laws of His Majesties Colony of Connecticut: 50–51

that was fenced in and planted with fruit trees. Small houses in homelots were packed with people. Multiple generations—children, in-laws and all sort of relatives—lived together within these scarce and valuable dwellings. Families would also hold up to ten other land parcels at one time, for private and public use, that were widely scattered throughout town in various stages of development. These disparate parcels were investments and often not "laid out" nor "taken up" for many generations.

As these parcels became surveyed, they were marked with "stadles" or stakes, which sometimes bore an owner's initials. Boundary corners were also

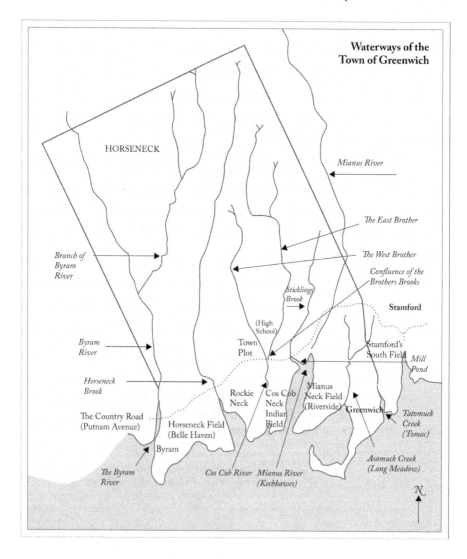

marked by trees, "bush trees," heaps of stones, piles of rocks and geological features such as "upland," or rising ridgelines, boulders, cliffs, coves, swamps and "crotches," which were steep ravines. Because there were few commonly recognized landmarks within vast stretches of land—such as the area between the Mianus and the Byram Rivers, about four miles apart—descriptions of wilderness purchases were often no more explicit than "land lying between the two rivers." This did not mean that a purchased parcel extended to each of these boundaries, only that it existed somewhere between them.

Parcel locations were often referenced by names of neighbors. A more specific land locator was whether land lay north or south of the "Country Road." The Country Road mostly followed modern U.S. Route 1, also called the Westchester Path, the Boston Post Road and Putnam Avenue. Originally, the Country Road included Valley Road and Palmer Hill Road.

THE SECOND GREENWICH COMMON FIELD: MAYANOS NECK FIELD IN RIVERSIDE

Riverside, first called Mianus/Mayanos Neck, was used for crops or livestock grazing prior to 1649. Two sales confirm this: Andrew Messenger sold his field on Mayanos Neck to Robert Heusted and William Hallett sold his "particular lot" on Mianus Neck to Jeffrey Ferris on December 5, 1650. Fourteen years later, in 1664, the great Mianus Neck Common Field was first mentioned. This great field was accessed from those who lived east of it in Old Greenwich. Originally, this enormous field was the entirety of the Riverside peninsula, south of Lockwood Road. Later, its size was reduced, likely as the Cos Cob Field and Horseneck Field (modern Belle Haven) were created. The original fence line for this field may have spanned the width of Riverside Neck and originated Lockwood Road. In 1687, the Mianus Neck Field ran "to the river." A diminished Mianus Neck Field was likely bounded by Riverside Avenue to its south and west, Lockwood Road to its north and Arch Street or fencing at the top of the Arch Street ridge to its east. This boundary is suggested by early roadmaps and the existence of open fields here well into the twentieth century.[49]

Mianus Neck Field was alternately referred to as the "commons," the "common field" and the "General Field." Communal barns and wooden irrigation systems called waterworks lay within it. It was enclosed by a sturdy log fence of "five rayles, four foot high," in 1681 and by stone walls in some

sections. In 1688, Gershom Lockwood reserved the liberty "to get and cart away stones from his land for the making and completing of the aforesaid range of fence." In 1693, the town directed the Mianus Neck Field to be planted in winter corn for two years, and for greater security, the fence should be made five feet high. This proposal was immediately rejected for being "a great inconveniency."[50]

The first lottery for Mianus Neck Common Field land was held in March 1664, with nineteen men participating. This event was called "the first divident," and those purchasing made history, for it marked the first time Greenwich land had been transferred to an individual after being claimed by Native Americans, the West India Company, two Connecticut colonies and the Town of Greenwich. Sixteen of the nineteen purchasers listed were Samuel Jenkins, Jonathan Renalds, John Hobby, Joseph Ferris, James Ferris, James Emery, Angel Heusted, Jeffrey Ferris, John Renalds, Joshua Knap, Willam Hubbard, Gershom Lockwood, John Bowers, Joseph Mead, John Mead and William Ratleff.

These four-acre lots were priced at "Patrick's Rate," which was ten pounds an acre. In period parlance, this was "an acre to ten pounds estate," and some of the more able purchased multiple four-acre lots. The lottery drawing number determined one's choice order of lot location within the field. One did not draw adjoining lots when purchasing multiples but had to exchange or sell disparate lots with adjacent landowners after the lottery to achieve a contiguous property. Townsmen decreed that one could sell or trade lottery parcels, but only with approval. In 1704, it was decided that lots in future lotteries would be laid out in three or more tiers, starting with those most northerly. In 1667, a second lottery was held for another portion of Mianus Neck Field, and this allowed the adult sons of local planters or yeomen to support their new families.

CREATING A CAUSEWAY

The Mianus Neck Field was separated from Old Greenwich by the Asamuck, or Longmeadow Creek, and a causeway "for carting" was needed to access the great field. Plans for a bridge, "firm and sufficient," were discussed in 1670. Lots were drawn to assign bridge maintenance terms for each resident, who complied or faced a fine of twelve shillings. This was likely a bridge crossing the Asamuck or Longmeadow Creek near the Perrott Library.

Goodman Heusted and John Mead were appointed overseers to ensure all faithfully discharged their duties. Work was mandated "on the bridge that belongs to Moyano Neck Field" as well, along with plans for all residents to improve the cartways "near to" the field.

WATERWORKS WITHIN THE FIELDS

Waterworks, drains, watering troughs and above- and below-ground pipes made from logs were a part of the town's common fields, and many above-ground structures channeled water, substantial enough "to stand for a fence." In 1686, the town hired Jasper Videto for his carpentry skills, and he was granted land in Mayanos Neck Field in return for "making and maintaining a sufficient waterwork for the security of the said field." Unfortunately, he passed away later that same year, so his son, John, helped complete many town waterworks projects. John laid hand-augured hollow tree trunks chiseled to fit snugly together end-to-end and sealed the joints with hot animal fat and dowel pins.

A wooden water pipe. Wooden piping systems in common fields were called "waterworks." Raised for proper pitch, the system also functioned as a fence line. *Thames Water Museum, Reading Berkshire, England.*

LOCATIONS OF EARLY WATERWORKS

1663: by the land of William Grimes in the Shorelands neighborhood and by Tomac Creek [246]

1667: running along the Mianus Neck Field fence to the river [110]

1686: in the southwest section of the Mianus Neck Field, eight or ten rods long [1297]

1687: near the Horseneck Field Fence, not exceeding nine rods in length; also at Horseneck Brook [178]

1691: at Byram Cove; waterworks at Horseneck Field also mentioned [1063]

1694: at Cos Cob Field, 9 rods or approximately 150 feet long; Horseneck Brook also mentioned [252]

1695: Thomas Close Sr. was to maintain the waterworks at Horseneck Brook [440]

1700: a town well is made in an Old Greenwich street [1146]

1705: waterworks are at the Myanos River [581]

1706: a fence ran from the waterworks "at Grimes's to the waterworks at Tatomack," suggesting a continuous fence line from Tomac Creek to Lockwood Avenue to Old Club House Road [1310]

THE UPPER HASSAKEY MEADOW DIVISION (HASAKE/HASSAKY/HASUKE/HASSAKE)

The lottery to divide the Uppermost Hassakey Meadows in North Mianus "lying to the south of the Westchester Path" (Palmer Hill Road)[51] occurred in 1670. Any shortage of land here would simply "be made up elsewhere." This meadow was accessed from Laddins Rock Road, and it was used for growing hay. Modern Hassake Road is the only marker memorializing this early field.

The Upper Hassakey Meadow was divided into two-and-a-half-acre lots, and this "second divident" was distributed among ten men. These participants were reconfirmed sixteen years later, likely due to confusion caused by changeable boundary marks. In 1684, the Upper and Lower Hassakey Meadows were surveyed to "appoint where the fence shall be made." In 1696, the town graciously granted the beloved John Hobby six acres of land against the south end of Hassakey Meadow for the space of ten years, "but if he shall survive longer he is to enjoy it during his lifetime."[52]

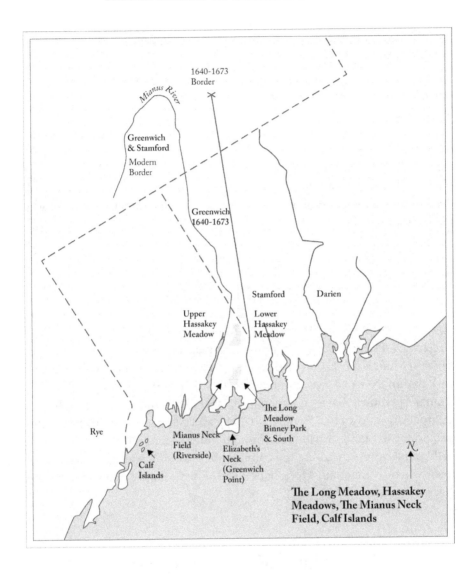

The Long Meadow, Hassakey Meadows, The Mianus Neck Field, Calf Islands

ABANDONED LAND

Some of the earliest settlers purchased or claimed lots but then moved on to explore the region further, leaving large parcels without a taxable owner, fencing or buildings. Daniel Patrick himself abandoned his extensive Norwalk purchase without fully paying for it when he settled in Greenwich. This abandonment created fallow acreage without clear title. Its owners were difficult to locate, and if they never returned, these parcels were hard

to resell. Abandoned lots also interrupted the development of cohesive communities, so it was subsequently mandated that if a lot owner deserted the town within a year of the land's purchase, the lot reverted back to the town, even with its improvements, such as a recent harvest or a standing crop in the field.

In 1674, there was a real estate dispute between the "pretended" rights of Richard Vowles and his sale of land to Steven Sherwood two years earlier. Since Vowles had left Greenwich, the town intervened and granted Sherwood seventy pounds or seven acres of "outlands" on the west side of the Mianus River "when such time those lands are laid out." Payment was made in wampum.

TOWN MEETINGS

Town meetings of the 1600s and 1700s concentrated on managing the Greenwich Plantation, which ultimately incorporated six great common fields; at Mianus Neck, Cos Cob Neck, Rockie Neck, Pipen Point, Horseneck and Byram Neck. Town meetings would determine planting schedules, animal rotations, fence maintenance, shepherd and cowkeeper hiring, meatpacking and animal feeding, breeding and gelding. Town meeting topics also addressed land distribution through lotteries and individual grants. In 1702, under pressure to use the common field lands for more homelots, the town voted to maintain Horseneck Field, Pipen/Piping Point and Rockie Neck as common fields.

PRODUCING MEAT AND LEATHER

Raising livestock in early Greenwich was easier than plowing its jagged, rocky fields, liberally studded with swamps, cliffs and boulders. Instead, the town produced meat, leather and leather end products such as shoes and gloves. There were many livestock pounds, or stockyards, all throughout town. Horsemeat, beef, pork, mutton and lamb were packed and shipped locally and as far away as Boston, Long Island and Manhattan. Town meetings appointed packers of meat and cutters of steers (gelders) as well as cullers of staves to make the barrels in which these products would be

Hides and Tallow Not to Be Transported

Be it enacted...that if any person in this colony shall endeavor to transport or send away any raw or unwrought hide or hides, skins or tallow out of this colony, by shipping them on board any vessel for that end, he shall forfeit the said hide or hides, skins or tallow so shipped, or the value thereof....And it is further enacted...that no master of any ship...shall receive any such hide...brought from beyond Seas...or the skins of Beaver, Moose or Otter.

Acts and Laws of his Majesties Colony of Connecticut: 49

And it is further enacted...that no persons...shall offer or put to sale any kind of leather which shall be insufficiently or not thoroughly tanned or which hath been over limed or burnt in the limes or [not] sufficiently dried or...not viewed and sealed according to law.

Acts and Laws of His Majesties Colony of Connecticut: 65

packed. Town meetings regularly appointed sealers of leather, individuals who graded the quality of various hides with a stamp called a seal. Tanners converted animal skins into finished leathers. Leather was tanned using salt and plant materials, and in this process, hides were hung on frames or poles. Saltworks existed along the Mianus River and in the many salt marshes surrounding the shores. Skins were repeatedly exposed to water that had been boiled with chestnut, oak or hemlock bark to absorb the tannins, which colored and softened them. Skins were then rubbed with waxes, oils, soaps or suet (animal fat) to make them soft, flexible and malleable. Leather tanning powered the town's economy until the American Revolution. In the 1780s, returning Revolutionary soldier Reuben Rundle tried to re-start his business of "tanning, currying and shoemaking," trades he had previously worked here. He was not successful, for American and British raiding parties had stolen most of the livestock during this war.

MANAGING THE FIELDS

As an agricultural manager, the town directed when livestock and crops were to be put in and cleared from the vast fields spanning all the peninsulas below the Country Road, or Boston Post Road, from the Mianus River to Byram, including the Riverside peninsula. One of the most recurring problems was animals let into the fields too early—before crops were cleared—resulting in heartbreaking damage. Owing to the size of these fields, the rolling terrain, the rocky geography and interior planting sections hidden by stone walls, it was difficult to assess complete animal removal. The town continually reiterated to its small, overworked and undersupplied population that official dates for crop and animal movement must be respected.

Fines were established to give teeth to these often-ignored directives. If livestock was left in the field after an official date, the animals would be impounded and come under town ownership, requiring a fine for their return. In 1666, this "poundage" was "two shillings six pence a head per horse or mare, twelve pence a head per swine and six pence a head per sheep plus damages." As a result of constant livestock abuse and the ravages of frequently fierce southwestern Connecticut weather, the Mianus Neck Field Fence was rebuilt in 1670.

FENCE MAINTENANCE

The local livestock population came to include oxen, dry cows (steers), wet cows (dairy or milking cows), swine or hogs, sheep, horses and wild horses, which post-Elizabethan Greenwich residents called "jadges." All of these animals, these "blessings of Providence," required enclosure. One of the fundamental causes of Kieft's War was allowing roaming livestock to destroy native planting fields. Natives retaliated by killing the free-ranging animals, which prompted an unending escalation in violence. In Greenwich, the common fields held animals during the winter and crops in the growing seasons. This was the two-crop rotation or open field system used in the Middle Ages in Europe, called "convertible husbandry" in modern terms. As more fields became available, planters may have used a three-year, three-field crop rotation routine, sowing a different crop in each field. Flax, oats, rye, corn, wheat, winter wheat and barley were here, along with grass for grazing.

The town obsessed over its fences, as they were critical for safeguarding its food and revenue sources. Fence maintenance became a subject of almost every town meeting in the town's first two and a half centuries. In 1666, each Old Greenwich planter was ordered to maintain a specific length and location of fence. This was determined by a 2:1 proportion at first, two rods of fence maintained per each acre of land owned within the field. Early deeds are often vague in acreage specifics but very clear as to fence maintenance responsibility. The proportion varied among fields. Neglecting repair after a single day's warning generated a fine. Ignore it a second day, and the fine was increased. By the third day of fence disrepair, the town would fix it and heavily fine each delinquent.

Creating and maintaining these vast fences required heroic effort. The fencing was under constant assault by the weather, kicking horses, powerful oxen, rooting swine, roaming sheep and hungry cattle eager to devour the wilderness just beyond their reach. They were grudgingly and poorly repaired by people of all ages, abilities, resolve, skill and resources and were said to cost more than the land they contained.

Jonathan Lockwood traded his fence responsibility in return for his making and maintaining "a great gate" in the fence "well hung with iron hinges as it may be for the town's safety respecting the town's crops."[53] Loathed and time-consuming fence maintenance duty was bartered by 1669. Repair responsibilities could be exchanged and sold by 1673.

In 1669, the Mianus Neck Field fence was judged to be so poorly maintained that a new approach was developed. People now had to label their sections with their initials, and "fence viewers" were appointed for inspections. Broken rails, holes under sections, loose posts and unstable railings required repair in twenty-four hours or brought a fine of twelve pence for each defect, per day neglected. A February day in 1671 saw all town residents repairing the Mayanos Neck Field Fence as a group effort and again on March 1 and March 10. In a practice that would last for a century, fence viewers were appointed officially in town meetings.

The town issued numerous directives, including:

1673: The Myano Field Fence must be made up sufficient to keep out hogs by March 3. Fence viewers will inspect by March 5. The field to be cleared of all cattle by March 6.

1678: The field to be cleared of men's crops in a week in October if the days remain dry. Cattle may be put in the field on October 5 after the crops are cleared. The fence is to be repaired, and hogs shall no longer be put in nor suffered there.

1685: Cattle and swine to be cleared by March 10…

1686: ruleable [domesticated] *cattle and swine to be turned out of the field by March 22.*

1695: Damage to the field has been…incurred in Myannos Neck by people baiting [feeding] *cattle wherefore…all cattle which are found inside shall be pounded…unless* [they are] *working oxen.*

1696: The pound for impounding creatures taken in damage shall be set up the lane against William Rundle's house that goeth northward.

Town Ordered Brush Cutting

Commons to Be Cleared

Be it enacted…that every male person fit for labour in each town in this colony from fourteen years old to seventy (except Magistrates, Ministers of the Gospel, Ruling Elders, School masters and Physicians), shall work one day in each year by themselves or some meet person…in cutting down and clearing the underwood in any highways, commons, or any places agreed on by the town…and every person and persons that do not attend and faithfully discharge the work, within three days after such neglect, he shall pay a fine of ten shillings to the town treasury.

Acts and Laws of His Majesties Colony of Connecticut 1702: 20

1677: Six men were directed to the "Pine Swamp" near the Stamford border to clear and kill all the underbrush and all other wood in seven years' time. [924]

1706: The townsmen order where they shall cut brush. [1234]

1710: The town released townsmen from cutting brush this year.

1717: It was ordered not to cut brush this year.

OLD GREENWICH DESIGNS WESTERN GREENWICH

G reenwich, west and north of Old Greenwich, remained undeveloped by 1664, stalled by the limiting Treaty of Hartford in 1650 and poorly managed by the New Haven Colony afterward. Expansion west of the Mianus River was planned for decades by Old Greenwich townsmen before homesteads were actually constructed, almost forty years after the town's founding.

THE COS COB COMMON FIELD

Many of the later 1600s settlers came from Stamford, and they also owned land within Stamford's South Field, immediately east of Old Greenwich. A number of Stamford roads reference the names of early Greenwich and Stamford planters, locations and luminaries, such as Davenport, Hobbie, Ferris, Lockwood, Baxter, Jessup, Hubbard, Hoyt, Howes, Tommuck, Laddins, Sherwood, Underhill, Selleck, Wittemore, Reynolds, Ponus, Myano, Shippan and Rippowam. Due to the jurisdictional chill from the boundary dispute with Stamford, use of Stamford's South Field was limited, and Old Greenwich planners looked west to Cos Cob to create a third common field.

A new field was planned for Cos Cob in May 1673, and it was laid out the next year. The location was "to run beyond the weir," along the western

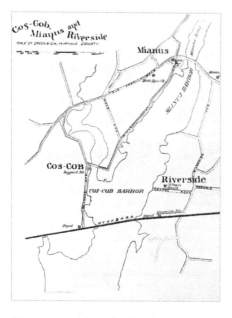

The earlier, smaller Cos Cob Common Field. *Connecticut State Atlas, 1893, D.H. Hurd & Co.*

edge of the Mianus River. (A stone, wood or net fish weir traps fish when tidal waters rise and prevents their escape when the tides recede.) Animals from (Old) Greenwich and the Mianus Neck Field were driven up Riverside Avenue, Sound Beach and Sheephill Roads to cross the Mianus River at the Palmer Hill Road crossing. From here, herds were driven down Valley Road to Cos Cob Field, which lay alongside the west bank of the Mianus River. The first pastures in Cos Cob were "south of Sticklons Brook" on Cos Cob Neck. The Cos Cob Brook is Sticlings Brook, named for Edmon Sticklund/Sticklon in 1648. It runs through the Cos Cob Firehouse property and flows into the Mianus River Mill Pond, an inlet of the Mianus River.

> *At a town meeting in April 28, 1668 it is ordered that the dry herd of cattle are to be driven out as far as Coscob Brook or to the west side of the brook....Also it is agreed the oxen are to be driven forth with dry cattle when men can spare them from their work. Further that if the oxen or ten dry cattle roam home they are to be driven forth and not neglected. [846]*

A 1701 document states that the Cos Cob Field reached to the Indian Field, and it likely became smaller over time. A diminished Cos Cob Field may have been the triangle-shaped enclosure, bounded by modern River Road, Mead Avenue and the Post Road, seen on the 1867 Beers map and in the 1893 Hurd Atlas for the state of Connecticut. The "great ridge" in Cos Cob, west of the Post Road and including modern Diamond Hill, may have been a natural, western border of the early Cos Cob Field.

THE FISH WEIR ON THE WEST BANK
OF THE MIANUS RIVER

The town's communal fish weir was located somewhere along the west side of the Mianus River, likely near the modern Post Road crossing. The "path to the weir" or the "weir path" was a combination of Valley and River Roads.

Fish weir across Trinity River. *Edward S. Curtis,* The North American Indian, *Taschen Publications.*

COS COB RESIDENTS

Old Greenwich residents Lockwood, Marshall, Hobby, Bullard and Jones were the first to have land granted on Cos Cob Neck. The first town minister, the Reverend Eliphalet Jones, was granted land near Sticlins Brook[54] so that he could turn his livestock out on the common. In 1670, Richard Bullard claimed land west of the Mianus as well. He had lived

in Old Greenwich for at least three years and then sold all of his holdings somewhere "between the Mianos and Byram River" to Joseph Ferris. He reserved the right to get timber and hay for livestock on land between Sticlons Brook and the Mianus River.

Attracting New Residents

Old Greenwich townsmen discussed who they wanted to live on the west side of the Mianus River and they also discussed how much money was needed to develop a second community. For adequate revenue, they calculated they needed to attract twenty-four new residents, whom they would settle on eighty acres on Cos Cob Neck. At the top of their list were two specific individuals.

John Marshall

Despite Connecticut Colony laws prohibiting Quakers, John Marshall was enticed to return to Greenwich in 1670. Marshall had the colorful history of being the man New Haven Colony had come to arrest in the 1650s but was defended by the hysterical Mrs. Crabb. His return came thirteen years after he was threatened, or actually arrested, by the New Haven Colony. That Greenwich Puritans coveted Marshall despite this law stands in testament to his good character, appeal and economic benefit. He was a glove maker by trade and became a long-term, respected administrator, highly involved in early town affairs. Marshall was offered a five-acre home lot and eleven extra acres in Mayanos Neck Field "at a place commonly called The Blind Garden."[55] In return for this property, Marshall was responsible for maintaining the Myanos Neck Field gate and 16 rods, or 264 feet, of fence.

John Hobby

John Hobby from Stamford was offered twelve acres on Cos Cob Neck south of Sticklings Brook in 1670. He accepted and also became an integral part of town government. In 1670, he built the first meetinghouse in Old Greenwich.

THE SELLER NECK AND THE DINERING ROCK ON COS COB NECK

In April 1670, John Marshall and Moses Knap were granted land on Cos Cob Neck between Jones's land and "the Seller Neck," presumably a shipping location. In this deed, a "great flat rock" is referenced on the west bank of the Mianus River. This rock, called "the Dinering Rock," was perhaps a 1600s Greenwich eating location.[56] This great rock became a landmark for westerly running land plots. At a land auction in 1696, Benjamin Mead bought land "lying westward from the Dinering rock for six shillings and penny in silver money per acre." In 1698, "the town per vote grant liberty unto the inhabitants at Coscob to mend the hyways from the Brothers to the Dinering rock."

JOHN AND MARY LYON WILLSON SEEK TO LIVE IN COS COB FIELD

Homesteads were not located within common fields, but in 1690, one well-connected couple, John and Mary Willson, requested to build a house within Cos Cob General Field. (John Willson had married Mary Lyon. She was the granddaughter of Greenwich founder Elizabeth Winthrop Feake Hallett. Her mother was Martha Johana Winthrop, the only child of Elizabeth and Henry Winthrop. Mary Willson's father was Thomas Lyon.) The town disagreed and decreed that the couple "shall not make a building lot in nor inhabit as a homelot."[57]

Mary Lyon Willson claimed she had never received her rightful inheritance due her from her founding grandmother and was obstructed by her father, Thomas Lyons, and two of her stepbrothers. She quitclaimed any demand on her inheritance in 1694 from stepbrother John Lyon at first, expecting to receive something from them.[58] When her stepbrothers Samuel and Joseph Lyon did not allow her anything, she took them to court in 1705. The court, after years of litigation, decided in her favor, but her stepbrothers refused payment. Ultimately, Mary received fifty pounds. These court papers are included within the Town of Greenwich Archive transcriptions.

THE ORIGIN OF THE NAME COS COB

There is no written documentation of the origin of the name Cos Cob, so all proposals have and will continue to be speculations. To the many available, this author adds her own.

The native name of the Mianus River was spelled "Kechkawes," as interpreted by the Dutch. The name is recorded within the deed of the Stuyvesant purchase of Greenwich that stretched from the west bank of the Mianus/Kechkawes River to Stamford's Mill River. The Mill River was natively named the Seweyruc. The Dutch ear is hearing either a native word directly, or this is heard secondhand from English people. The 1600s Dutch would pronounce Kechkawes as "Cake-a-vess," according to Dr. Charles Gehring, director of the New Netherland Research Center. English pronunciation of this native word may have been "Kech-ka-wess," "Kech-coss" or potentially, "Koch-coss." If the English corrupted the native name of the Mianus River, Cos Cob may be named for the inlet of the "Kech-coss" or "Koch-coss" River, a significant geological feature of this village.[59]

Natively named "Paihomsing," town residents named land on the west side of the Mianus River "Horseneck," perhaps due to the shape of Cos Cob Point on Cos Cob Neck or from a native word that approximated the sound of the word Horseneck.

PLANNING HORSENECK

Preliminary plans for a second community, on the west side of the Mianus River, began in May 1669. At a town meeting, "Sargent" Gershom Lockwood, Goodman Heusted, Jonathan Renalds, John Hobby and John Mead were directed to find "encouragement...for the settling of a township." They were to cross into western Greenwich, "to view and consider it." Assessing the islands off Greenwich in 1669, townsmen also discussed making a road or hyway on Hog Island near Old Greenwich and on Calf (Calves) Island off Byram's Shore Road, for such improvements would clearly claim them as Greenwich property and secure them from Rye. "Work" on the Calf Islands commenced in 1669, and the islands were surveyed for lot distribution that year. Rye, for its part, had provocatively allowed its livestock to roam into Greenwich.

The attention of the planners was focused next on forty acres on Horseneck Point, which is modern Belle Haven. In 1669, livestock was driven to graze by Horseneck Brook, which is located to the east of the Belle Haven peninsula.[60] Some of the Horseneck Field or Belle Haven peninsula acreage had already been purchased from Native Americans directly by John Banks, a Quaker from Fairfield. Townsmen immediately sought a land transfer to claim all of Horseneck Point and relocate any private land owner, particularly a Quaker, to the town's more western border. They negotiated a successful land exchange with Mr. Bancks, and they also offered another Quaker, Thomas Youngs, five acres near Mr. Bancks, "whenever the [Byram] Neck came to be laid out."

> *On the third of the first month:* [16] 73:74
> *At a town meeting Joshua Knap, John Hubby, John Mead are appointed and fully empowered to go to Horseneck to see how far it may be convenient to exchange Mr. Bankses forty acres of land upon the above said neck… the above said three men appointed are to lay out forty acres elsewhere.… And if John Mead should fail of gout to attend the business then Angel Heusted is to attend in his room viz. John Mead. Also they are to lay out an addition to Mr. Bankses other land on Byram Neck to the quantity of twenty acres or less if they see meet. Also it is granted to Mr. Banks the whole plane lying by Birum River side and so by Westchester Path.… The grant…is upon this condition that Mr. Banks above said does resign up to the town…that Indian purchase respecting Birum Neck and any other land thereabouts.* [904]

HORSENECK BROOK FIRST CONSIDERED AS THE SECOND TOWN LOCATION

The Horseneck Brook flows into Long Island Sound on the eastern side of the Belle Haven peninsula. It is just west of today's Metro North Greenwich Train Station, the area between Greenwich Avenue and Belle Haven. Large amounts of fill, the railroad and I-95 highway obliterate the original landscape here with its original unobstructed view of Long Island Sound, and it is difficult to imagine this land as unpopulated field, stream and forest. The Horseneck Brook, valued for its fresh water for the new Horseneck Town, is almost entirely piped over today as it winds

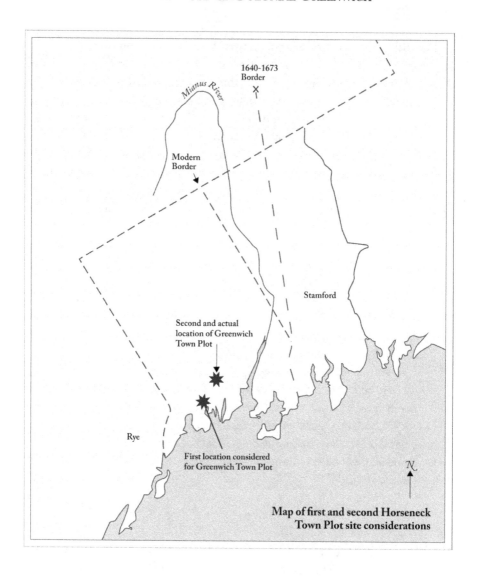

Map of first and second Horseneck Town Plot site considerations

through car dealerships, under and around roads, I-95 and the elevated Metro North train track bed. As it nears Long Island Sound, it is largely no longer visible. Happily, the Bullis House remains on the Post Road near this waterway, the only reminder of the town's past in this area. As the first townsmen planned to expand westward in 1670, they sent four men to inspect this area to see if it could host a second town sized at 120 acres:[61]

At a town meeting it is ordered and appointed that Mr. Hobby, Gershom Lockwood, John Mead and Joseph Feris are to lay out a township upon the land lying near by Horseneck Brook to the number of thirty lots, four acres to a home lot if the tract of land will bear it and to be mindful for a piece of land for a common.

Plans to establish the second town plot in this location were abandoned, however, as regional and international events unfolded and this location was considered too vulnerable to military attack from Long Island Sound.

THE LIST OF 1672: AN EXCLUSIVE RIGHT TO OWN

In 1672, another lottery was held to allow those living east of the river to purchase land lying west of the river. Those purchasing were the "Proprietors of 1672," and they gave themselves and their successors the right to be the only persons to own land south of the Country Road between the Mianus River and the Byram River.

The List of 1672. *Greenwich Historical Society Archives.*

At a town meeting held in Greenwich anno 171[missing] January 11 day the town by vote do grant that all the land within the bounds of Greenwich...to the persons that are the successors of the seven and twenty men that the land was granted to below the country road below Birum River and Myanus River according to the list taken in the year 1672. [974]

The twenty-seven who gave themselves this privilege were the increasingly intermarried families of John and Joseph Mead, William Hubbert, William Ratleff, William Rundle, John and Ephraim Palmer, Steven Sherwood, Joseph and James Ferris, John and Jonathan Renalds, Jonathan and Gershom Lockwood, Angel Heusted, John Austin, John Bowers, Walter Butler, Thomas Close, Joseph Finch,

John Hobby, Samuel Jenkins, Joshua Knap, John Marshall, Samuel and Jeremiah Peck and Daniel Smith. In future land transactions, one's right to participate in western Greenwich land lotteries was referenced as one's "right according to the List of 1672."

EXPANSION STALLS FOR FIFTEEN YEARS

Even though the first settlers hungered to cross the Mianus River to develop land westward, global events ignited to prevent further physical settlement throughout the 1670s and early 1680s. Anglo-Dutch hostilities flared again overseas, and this reverberated in the New World near New York. The Dutch fought yet another great war with England, assisted by France, from 1672 to 1674. In North America, the Dutch burned tobacco transports in Jamestown, Virginia, and beyond.

Greenwich viewed these events with alarm and retrenchment, especially in 1674 when the Dutch, backed by a fleet of nineteen ships, retook New York, which included its former territory of Greenwich. John Coe's son rabble-roused residents from Greenwich to New Rochelle to resist Dutch control, which brought forth a strenuous complaint from Fort Amstersdam governor Peter Stuyvesant. Mamaroneck submitted itself to Dutch jurisdiction, but other towns resisted. John Banks, whose father had purchased land in Byram near Rye, more forcefully stated Connecticut's objections to renewed Dutch ownership and was imprisoned for it. The General Court of the Connecticut Colony had asked that he make Connecticut's complaints known to the Dutch commander Anthony Colve, whereupon Banks was held for fifteen days "under restraint." Armed Dutch vessels were seen on Long Island Sound. Stamford, Rye and Greenwich appealed to Boston for help.

The renewal of Dutch control over the region functionally lasted for one year, until 1675, when the English, represented by Governor Andros, asserted control over the Dutch in America's Northeast a second time. The departure of the Dutch and the reinstallation of the English froze the region's economy for a decade, further complicated by the new threat of a war with Native America. King Philip was the name Europeans had given to Indian leader Metacom or Metacomet, who had created Indian alliances to stop European expansion throughout New England. This war ignited in Massachusetts and Rhode Island and threatened to spread throughout the Northeast.

Preparing for King Philip's War

When King Philip's War erupted near Boston, New York governor Edmund Andros wrote Connecticut governor William Leete on October 10, 1676: "[T]here is an extraordinary confederacy between all ye neighboring Indyans & Eastward...to attack Hartford itself and some other places about Greenwich...5 or 6000 Inyans enjoyned together." Greenwich immediately admonished Ephraim Palmer and Joshua Knap to make a fortified structure within Old Greenwich "for the town's security under God." The town fortified the "townhouse" and counseled threatened residents to "repair there in case of alarm." Leftenant Jonathan Lockwood traveled to Governor Andros to secure ammunition.

Residents maintained night watches for a Native American assault that never occurred, and they quickly abandoned their tedious chore. By November, frustrated townsmen warned that "there is too much slackness and dysfunction in watching and warding and the great inconvenience and danger that may fall out there."[62] They directed that any person who had watch had "half an hour after the drum is beaten to attend to their watch. Those failing to appear on time shall forfeit one shilling and be liable to pay another to watch or ward."

After the threat of King Philip's War subsided in 1678, (Old) Greenwich people thanked Governor Andros for his assistance. The town, "having considered Governor Androses kindness and great favor...in a time of war and in [our] great need for [30 pounds of] powder" gave him "a suitable beast...faire with calf," or, a pregnant animal.

In 1674, the Peace Treaty of Westminster restored New York to the English in a negotiated transaction, and the Dutch retained trade control of the East Indies. Old Greenwich townsmen, prevented from expanding across the Mianus River during these times, used this decade of war with the Dutch and the Indians to further plan the arrangement of Horseneck.

The Greenwich-Trained Band

Local town militias were mandated by the Colony of Connecticut, and military positions such as leftenant, ensign, sargent and captain became attached to surnames in 1686. These titles connoted positions within the Greenwich Militia, also called the Greenwich Trained Band. Leftenant

Jonathan Lockwood and Sargent John Bowers, who became an ensign the following year, were the first officers of the Greenwich Militia in 1686.[63]

Militias

[E]very male person from sixteen years of age and upwards (except assistants, Justices of the Peace, Ministers, Impotent men which are incapable, Indians, Malattoes and Negroes) shall serve on the Military Watch, and all persons who are absent at sea, their estates to provide a man in their stead and place, when the turn of Watching comes to such family or House; and all aged or weak persons and widows...shall provide a person to watch.... [T]he commission officers shall provide a suitable house to keep a court of guard with firewood and candles as there shall be need.

Act and Laws of His Majesties Colony of Connecticut in New-England: 82

In 1744, twenty-four men from Horseneck, Greenwich and Stanwich Parishes were mustered to fight in King George's War, 1744–48. In 1755, seventy-eight men or more were also recruited to serve in the French and Indian War.

EXPANSION WEST
OF THE MIANUS RIVER

CROSSING THE RIVER

On December 13, 1687, the town was "sensible of the great want of a footbridge" across the Mianus River and commissioned Gershom Lockwood and William Rundle to build one at the Palmer Hill crossing. This original crossing site is underwater, due to a dam near the Post Road crossing site. This causes the water north of the dam to rise about sixteen feet higher than it would be naturally. In 1695, the town again "became sensible to the great necessity for a horse bridge over the Mianus River for the convenient and safe passing over of people and their horse or feet upon their occasions." Jonathan Whelply presented himself for building the bridge, "sensible and sufficient and...suitable passage for horse to pass over with two bushels of corn on his back without hazard or damage by the rails of said bridge." The town agreed to pay Whelply one bushel of good and merchantable Indian corn per head for every male person in the list of estates for 1695. It would also give him "the help of a team of two oxen, one horse and a man for ten days for his improvement in said work." The work to enhance the Palmer Hill Road river crossing was to be completed in the summer of 1695, with payment made in the winter. The town was obliged to "raise said bridge when fully framed." In 1696, a census "of the heads" was taken to calculate how much each resident owed him "upon the bridge account."[64]

Almost twenty years later, in 1713, the town needed a replacement bridge and turned to the wealthy British aristocrat and Scarsdale land speculator

Colonel Caleb Heathcote to rebuild it and make some boats. Heathcote's financing may have fallen apart, for in October, "the [town] make choice of Thomas Marshall and Benjamin Mead to take care of the bridge at Mianus River to make it new to get the logs and bring them to the place upon the town's charge and it is to be raised for highway work." In 1714, the town appealed to the General Court in Hartford to build a bridge spanning the Mianus, but this was denied.[65]

THE RIVER CREATES PROBLEMS

Unanticipated through forty years of planning, the two villages of Old Greenwich and Horseneck were separated by a very wide river, and residents found it frustrating to be bound by the same common field rules, land prices, tax rates, ministry support and personnel choices. Horseneck people, who were even closely related to Old Greenwich settlers, particularly resented "Old Society" requirements that they cross the river to attend church in Old Greenwich. This meant crossing the river at Palmer Hill Road and then traveling all the way to Tomac Avenue. To travel the often steep and rocky dirt paths, fraught with ruts and stumps in all kinds of weather, was treacherous and long, particularly in winter. In 1701, officials provided some relief when they allowed each society to manage their common field schedules on their own; to decide crop and animal schedules; and when and if winter wheat could be planted. And "whereas the situation of both inhabitants and fields are remote the one from the other," the town also allowed each side to "make choice on and appoint such officers as the law directs."

Agreements on town meeting locations also became contentious. In 1703, those on the east side of the river protested against a plan to hold half of the town meetings in Horseneck. Twenty-four household "heads," the majority of the population, signed a petition citing the physical difficulty of getting to the location as a significant obstacle.

LAND LESS EXPENSIVE IN HORSENECK

After Cos Cob was planned in 1674, the next surveys were for "all land lying between Mianus River and Byram River lying below Westchester Path,"

and the price per acre was set at ten pounds per acre. Work commenced "to lay out each man in due proportion according to each man's disbursements to Patrick's Rate." The surveyors of this significant acreage were Leftenant Jonathan Lockwood, Joseph Ferris, Angel Heusted, John Mead, John Renalds and Sargent John Bowers. Within one week they were to

> *take notice where it may be most convenient to take in a field and how the fence to be run for that and also how home lots may be laid out and where for commonance respecting each man's proportion in lands...shall be laid out...and the intent of the thing is that every man's lot is to be alike good as near as it can be or ordered by the layers out of the land in due proportion to each man.*[66]

In 1674, revenues raised through this plan were calculated. Presented by Joseph Mead in a town meeting, the initial plan was found insufficient, so

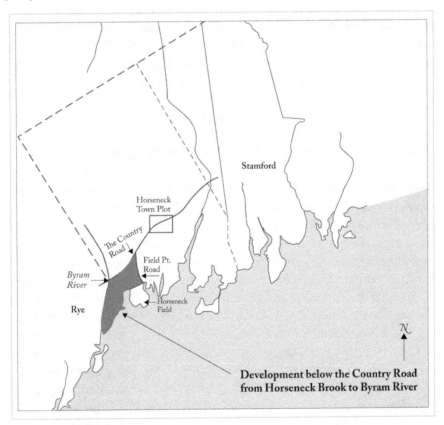

Stamford

Horseneck
Town Plot

The Country
Road

Field Pt.
Road

Byram
River

Rye

Horseneck
Field

N

**Development below the Country Road
from Horseneck Brook to Byram River**

townsmen increased the tax by thirty pounds on top of revenue accrued from Patrick's Rate alone. The "layers out" decided whether the land offered equitable acreage "in one divident" or whether an additional thirty pounds would be best gained through additional grants. The town pledged to stand by the decisions of the "layers out" and, if challenged, would further certify that the intent of the development was "that every man's lot is to be alike good as near as it can be or ordered by the layers out of the land in due proportion to each man." If some land was found "a bad or mean lot the layers out of land are fully empowered to make what addition in such cases they…see cause to do."

Another lottery was held, and Angel Heusted drew "the lots respecting each man's proportions." By 1679, almost forty years after the town's founding, land in Horseneck, below the Country Road between the Mianus and Byram Rivers, had been surveyed in preparation for the distributive lottery and money collected. This lottery was not held, however, until three years later, in 1682. Distractions arose concerning the settlement of Mr. Peck, a long-awaited minister, and by boundary arguments with Rye. Another lottery was conducted in 1683, for land below the Country Road from Horseneck Brook to the Byram River. A small parcel was sold between Horseneck Brook and the Byram River "to make good the towns debts."

THE HORSENECK TOWN PLOT

After rejecting a town plot location by Horseneck Brook, east of Belle Haven, planners looked for a new, safer location for the Horseneck Town Plot in 1679. The site they selected was a high plateau, over a mile inland from their first choice. The Horseneck Town Plot is clearly seen on the 1778 Erskine map *From Sawpitts to Stanwich*, drawn for General George Washington. This is the plateau that hosts the Putnam Cottage, and it does provide protection for Horseneck if attacked by water. At its highest point, where the Second Congregational Church now stands, one could have had a full visual survey of Long Island Sound.

The Town Plot was "above Horseneck Field," which is Belle Haven. It was bounded to its east by "The Great Ridge," seen rising above the sports fields at modern Greenwich High School, and below Temple Sholom. Old Church Road runs along the top of this Town Plot ridge north of the Country Road (Putnam Avenue), but this road was created later. The first

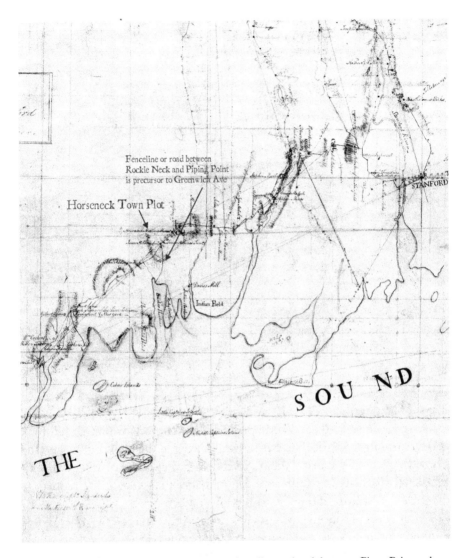

Greenwich Avenue and Arch Street began as a fenceline and path between Pipen Point and Horseneck common fields. *New York Historical Society map,* From Sawpitts to Stanwich, Stamford, Bedford, & Pine's Bridge on Croton River. No. 24. *Robert Erskine (1735–1780), Simeon DeWitt (1756–1834), Richard Varrick De Witt, donor, United States, Continental Army Surveying Department.*

north-running thoroughfare from the Town Plot traversed the hillside seen in back or west of the high school fields. It was called Oak Street and joined to modern Fairfield Avenue. "The North Street," which included North Maple, led off the Country Road northward and was first called the Road to Bedford. The Town Plot was bounded to its south and southeast by the

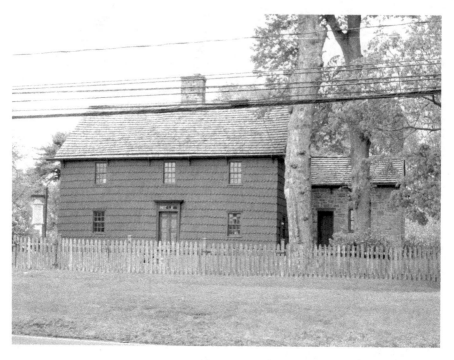

The Putnam Cottage on the town plot. *Author photo.*

aptly named Rockie Neck Common Field, which hosts western Millbrook and western Bruce Park. The North Field bordered the plot's north, and the Brunswick School's sports field at Northfield Street is its last vestige. Roads accessing this field were Sherwood and Lafayette, though not named so then. Dearfield Road did not exist until over a century later.[67]

Thirty acres of land within the Town Plot were set aside for the use of a minister, and men surveyed "what land they judge convenient." This would bolster recruiting efforts, and it did attract Jeremiah Peck. Having even larger aims, he requested land worth ninety pounds for himself and an estate worth fifty pounds for his son Samuel.

THE COUNTRY ROAD

The Country Road that wound through Greenwich was rocky, rutted, uneven, treacherous and often impassible. From Stamford's Broad Street

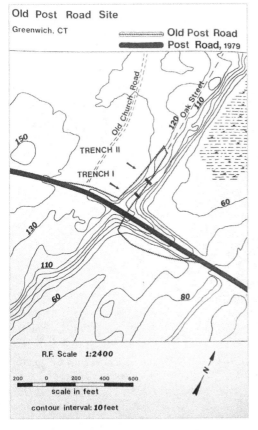

Above: "Putnam's Ride" showing switchback road behind Greenwich High School sports fields leading up to the Town Plot. *Spencer Mead*, Ye Historie of Ye Town of Greenwich *(Harrison, NY: Harbor Hill Books, 1979).*

Left: The switchback road topographically. *Cecelia S. Kirkorian and Joseph D. Zeranski, "Investigations of a Colonial New England Roadway,"* Northeast Historical Archeology *3, Fig. 1.*

one entered Greenwich on Palmer Hill Road. One crossed the Mianus River on a log footbridge that connected to Valley Road. From the Country Road, one would ascend the Great Ridge, switchbacking south and then head north to enter the Town Plot. This road then wound its way west through steep, stump-filled ravines or "Crotch Land" of Pemberwick, natively called "Pimbewalk" or "Pimbewaug."

There was also a direct footpath to the top of the Great Ridge. These flat fieldstone steps were just south of the switchback road, which was called the Great Ridge Road. Both accesses are now extinct, replaced by Putnam Avenue, also called the Post Road. There was also a later road running north below the ridgeline, east of but parallel to Old Church Road, which connected to North Street. A much later map labels this lost passage as Oak Street. Spencer Mead reports the fieldstone steps ascending the Great Ridge were removed during the American

Replacement of the switchback road to the Town Plot. "Putnam's Hill, Greenwich," John Warner Barber, 1836. *Gift of Houghton Bulkeley, 1953.5.111, Connecticut Historical Society.*

Revolution, but this is at odds with the story of Israel Putnam fleeing the British by riding his horse down them. The chiseled steps at the top of the Great Ridge by Old Church Road are a modern, fanciful creation to evoke this Revolutionary War event.[68]

Western Land Lotteries Are Finally Held

In March 1682, the town concluded that the future inhabitants of Horseneck "shall stand related unto Greenwich in civil, military and ecclesiastical order." A year later, the military component of the covenant was dropped, by design or mistake, in a re-affirmation of the desired relationship between the two town villages. With these good intentions proclaimed, planners had no idea of the difficulties they would face maintaining two sparsely populated villages, separated by a wide and inconvenient river and difficult topography.

After decades of deliberate planning, the lottery for land in Horseneck was finally held for about twenty participants in 1682. Men drew lots for common land in both Horseneck Field (Belle Haven) and for four acre homelots within the Town Plot. Surveying or "laying out" the parcels in Horseneck was completed in 1683 and approved in April, in spite of a protest from Leftenant Jonathan Lockwood, who objected to lots being laid out below the road, which he deemed "contrary to a former act." By the end of 1683, purchases were "layd out" for the remaining twelve. Those drawing the lowest lottery numbers received the most desirable lot locations. Some of this distribution for homelots extended north of the Brothers Brooks, above the Country Road, which may have caused the leftenant's objections. There was an additional lottery in December 1683 for ten participants, eight of whom were sons of established Greenwich residents.[69]

Almost immediately, individuals began to exchange, trade and sell their lots. The complaining Leftenant Lockwood exchanged his meadow at Rockie Neck for one laid out at Cos Cob. Samuel Jenkins sold his two parcels of upland, one in Horseneck Field, the other in the Town Plot, "adjoining to the field," to Joseph Ferris. John Austin sold his Town Plot land to his father-in-law, William Hubbert. Hubbert immediately sold this to Joseph Ferris. John Marshall, the Quaker, gained five acres in Horseneck Field and three acres in the Town Plot. In 1686, those Horseneck lots that

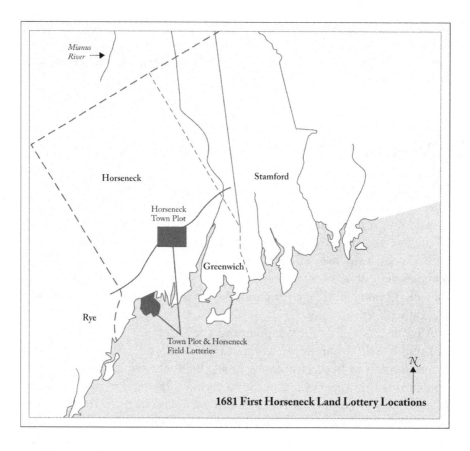

Mianus River →

Horseneck

Stamford

Horseneck Town Plot

Greenwich

Rye

Town Plot & Horseneck Field Lotteries

N

1681 First Horseneck Land Lottery Locations

were in swamps were rectified, "such persons wronged for want of their measure shall have it elsewhere." Five acres and one rood (a half acre) of "upland" was a common initial purchase.[70]

It was prohibited to take private land within 60 rods (990 feet) of the Country Road in 1691, and this may have defined the Town Plot first boundary. In 1705, prohibitions were increased that "no man to take any land within a mile of the Country Road." By 1712, fields had to remain 1.5 miles away from the Country Road, allowing a cohesive grouping of homelots, edged by more distant planting fields and animal pastures.[71]

TIMBER TROUBLES

In 1684, Greenwich had a "scarcity of rift timber," used for making clapboard or house siding. It was decreed that

> *no man either inhabitant or strangers shall get or cause to be got any sort of rift timber within the bounds of Greenwich for transportation overseas unless they worked the said timber into ware before transportation. It is to be understood that the restraint is laid upon getting of timber in our commons and if any man shall be found to break this act he shall be fined ten shillings to the town for every such tree which is got for the aforesaid intent.* [762]

John Mead Jr. and Jonathan Renalds policed this and were paid half of each fine "for their pains." At the end of 1697, "the town being sensible of damage of people carting York wood or firewood for transportation out of the town," declared that "all such wood cut on the west side of the Mianus River in the commons or common town land, shall be forfeited the one half to the complainer, the other half to the town treasury." The illegal felling, peeling and transporting of trees and the burning and transporting of coals out of town was also prohibited. (Tree bark was boiled to release tannins, which colored and softened leather.) Samuel Mills protested this "and is ready to give his reason at any time."[72]

THE HORSENECK COMMON FIELD

Managed by the town for over 150 years and perhaps much longer, this important field incorporated all of the Belle Haven peninsula, and it was bounded to its west by Byram Neck and to its east by Pipen or Piping Point, which is a point of land that hosts the modern Arch Street Teen Center. Off the east coast of Belle Haven/Horseneck Field lay a small island called "Grassie Island," now connected to Belle Haven by fill, and called Grass Island. In 1681, Horseneck Field was fenced in by "the road or Westchester Path." Any home or building lots planned for that area "shall be laid upon the line or first range, meaning to be chiefly below [or south] of the road aforesaid." "The front fence of these lots shall be fenced to enclose the land" and secure the land for seven years' time "against all ruleable [domesticated]

cattle." After seven years, the rear of these lots was also to be fenced and maintained by the lot owners to further secure ruleable cattle by a double fence line. The seven-year plan was quickly shortened to five. Maintaining the integrity of this fence and protecting one's home from free-roaming and destructive livestock was so important that only five years later it was mandated that any man who had developed his Horseneck lot "below the path" must make a secure fence around his lot "to fence himself off from the field."

Gates, Bars and Fences

Whereas it is found by experience that some persons are injurious to their neighbors by throwing down the fences and bars and leaving open that gates of corn fields and meadows, whereby much damage doth accrue to the proprietors of such fields or meadows. For the prevention whereof be it enacted…that whosoever shall throw down or leave open any gate, bars or fences, he shall pay a fine for every such default ten shillings.

Acts and Laws of His Majesties Colony of Connecticut: 45

In 1686, the Horseneck Field Fence needed repair "for peoples' security." These repairs were paid for by the town, a change in policy from making individuals responsible. In 1688, the town was "desirous of having a great gate" for carts to enter the field. Debtor Francis Thorne presented himself to make and maintain this gate "forever," in return for land. In 1690, cattle, horses, swine and sheep all running and feeding together caused such damage to the field and its fence in the winter that livestock were temporarily prohibited. In 1694, Horseneck Field was kept in winter wheat, instead of animals, for seven years.[73]

REGULATIONS FOR LIVESTOCK

In 1689, strong action was levied against Horseneck Field livestock that jumped, rooted, kicked and broke its way into planted crop fields.

> *Furthermore respecting of cattle and horses and swine who are found in our corn fields the town see cause per vote to lay this following penalty on each of them. Horses upon pounding to pay £.12 per head and just damage. Cattle to pay six pence per head with just damage. Swine to pay six pence per head and damage. Further, respecting the Field Fence, that persons who have had 22 hours warning of fence damage but neglected repair would pay the town for hired laborers at double wages.* [1045]

ROCKIE NECK

Rockie Neck is the peninsula west of Indian Harbor that hosts western Millbrook, the Wilbur Peck housing complex, Steamboat Road and western Bruce Park and reaches to Greenwich Avenue. The first mention of it was in the planning stage for land west of the Mianus in 1671. The waterway entering Rockie Neck, at the north end of modern Indian Harbor, was called the Cos Cob River. By 1683, Rockie Neck had been laid out, and many parcels were "taken up." In 1704, those owning land in Rockie Neck were responsible for maintaining the fence that ran from Rockie Neck to Pipen Point, to its west, for twenty-one years. Similarly, those owning parcels in Cos Cob Field, to Rockie Neck's immediate east, were responsible for the fence line that ran between Cos Cob Field and Rockie Neck. This line of fence, from Cos Cob Field to Rockie Neck, ran for 5,640 feet, a little more than one mile.

PIPEN/PIPING/POIPING POINT

Located adjacent to and west of Rockie Neck was the Pipen Point Field, the smallest of the six great common fields. This point, now greatly diminished by fill on either side of it, hosts the modern Arch Street Teen Center. The lottery for this field, which stretched north to the Post Road, well beyond I-95

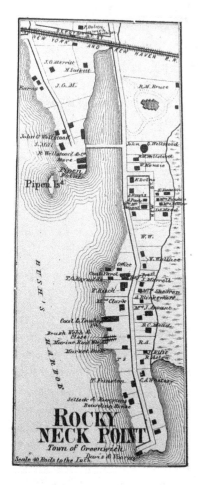

Rockie Neck Point close-up. *F.W. Beers, A.D. Ellis, G.G. Soule,* Atlas of New York & Vicinity, *1867.*

and the railroad to the Country Road or Putnam Avenue, was conducted in 1704, with twenty-two proprietors purchasing. The following year, these lots were "laid out." The Pipen Point Brook ran on the east side of this field, near to Rockie Neck Point. Cos Cob Field lay adjacent to Rockie Neck, and Rockie Neck lay adjacent to Pipen Point Field. This is verified by instructions for maintaining a fence line that connected them all:

> [W]*herefore the above said proprietors do by vote agree and conclude that those men that belong to Cos Cob Field shall make and maintain the whole string of fence between Cos Cob and Rockie Neck and that the proprietors belonging to the land upon Rockie Neck shall make and maintain a sufficient fence between Pipen Point Field and Rockie Neck.* [817]

In assigning fence responsibilities for the line between Rocky Neck and Pipen Point, in 1713, proprietors of land in Rockie Neck were to maintain the lower end of the fence to the sea, and those owning land in Pipen Point would keep up the upper end.

THE FENCE LINE THAT CREATED GREENWICH AVENUE

The fence line that separated the Horseneck and the Pipen Point Common Fields became Greenwich Avenue. Piping Point Field lay "below the Country Road" and extended from Horseneck Brook west to Greenwich Avenue. The fence line and forerunning line of Greenwich Avenue and Arch Street ran to the shore. This is clearly seen on the 1778 Erskine map.

CENTRAL GREENWICH NATIVE AMERICANS GRANTED LAND ON COS COB NECK

Greenwich originally claimed western Greenwich from one of the 1650 Treaty of Hartford borders, and in 1686, it strengthened its title here, in the land between the Mianus and Byram Rivers. In return for this title, the town granted land in Cos Cob to those Native Americans who had lived here, the "true proprietors of all the land or lands which lyeth between Mianos River and Biram River...unto the New York line." They were granted thirty acres on southern Cos Cob Neck, the "planting land that is fenced in at Cos Cob Neck the lower part which is below the sea, in a place called the Indian Field."[74] These Native Americans were:

> *Kowconnussa spelled also: Kowacanussa/Kowasconusso*
> *Koucko or Kocuki*
> *Peattun*
> *Queuerracqui also spelled: Querrucquis/Querruequy/Querrueggi*
> *Pakoichoro also spelled: Packoh choro/Pakechero/Pakehchoro*
> *and Rumpanus/Ruppunuss.*

The Indians' right to use the Indian Field was limited, only "during our lives and the lives of our papooses then to cease and to return to the town for the town to make use of and improve as their own property." The Native American witness to this exchange was Wesskun, "a sagamore of Wapping," who certified that the Indians participating were the true proprietors of the land. The Wappings lived along the Hudson River. European witnesses Thomas Close and Henry Rich confirmed Wesskun's words and added that "the above mentioned sagamore[s] are very old in appearance." Fifteen years later, Close and Rich recertified this agreement in giving the original document to Samuel Peck, justice of the peace, to file. The agreement specified

> *that three of the four are each of* [illegible] *years old and the fourth papoose is now a year old and Pako* [chero] *is mother of the girl which is ten years old and a mother* [illegible][missing] *second being child is a boy ten years old the said boys name is Orem and the third being a boy is ten years old his name is Wetorum and Kowaconusso his grandmother to the younger child is about a year old a boy and these four children* [illegible] *mentioned are the four papooses who are to enjoy the* [missing/illegible] *[missing]ntioned planting land during their lives.* [673]

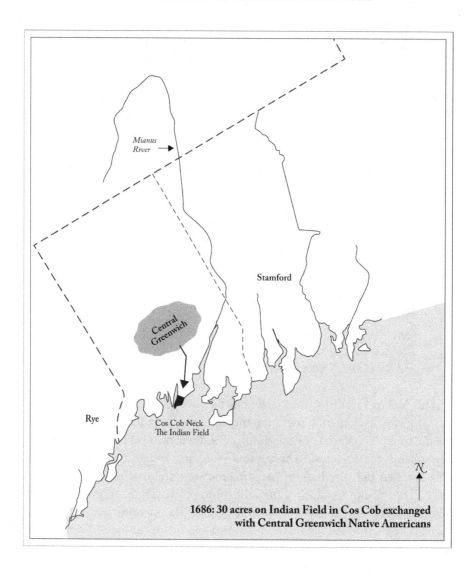

Mianus
River →

Stamford

Central
Greenwich

Rye

Cos Cob Neck
The Indian Field

ℵ

**1686: 30 acres on Indian Field in Cos Cob exchanged
with Central Greenwich Native Americans**

Seventeen years later, in 1703, "Wespahin and Orem/Aurems, and Pakcanahin, Indians, proprietors of the land on the east side of the Mianus River, sold their Indian Field back to the town forever."

Wespahin/Washpaken and Pakcanahin/Packanain sold their other land lying north of the colony line, near Bedford, New York, between the heads of the Mianus and Byram Rivers, to the wealthy Westchester land speculator Colonel Caleb Heathcote along with eight Stamford, Greenwich and Rye men. The Native Americans were joined in this sale

by "Ramhone," who may have been "Ramathone," one of the native American sellers of the 1640 Feake Patrick purchase in Old Greenwich. Native witnesses to this sale included "Meekrum" and "Kinhatem," likely the same native men as "Mecron" and "Kinhotam" who sold southern Pimbewaug/Pemberwick and southern Glenville, known as "Cauks Purchase" land to the town of Greenwich.

1688 Census

A record and account of those persons who are old and new inhabitants of Greenwich.
A listing of 54 heads of households in 1688

Anno 1688 May the 21ˢᵗ a record and an account of those persons who are the old and new inhabitants of Greenwich: Imprimis Jonathan Sherwood, Angell Heusted, Joseph Mead, Joseph Ferris, John Renald, John Hubbe, Weliam Hubbert, Jeames Ferris, Jonathan Renalds, John Bowers, Joseph Finch, Weliam Rundle, Gershom Lockwood, John Mershall, Daniel Smith, Jonathan Heusted, John Tash, Ephram Palmer, Jeams Palmer, Walter Butler, Samuel Peck, Mr. Jeremiah Peck, John Mead Junior, Weliam Hubbert Junior, Thomas Lyon, John Bancks, Thomas Close, Francis Thorne, Daniel How, Joseph Palmer, Henery Rich, Joshua Knap, Georg Hubbert, Joseph Heustead, Angell Heusted Junior, John Renalds Junior, Joseph Knap, Peter Ferris, Thomas Hubbe, John Hubby Junior, John Ferris, Jonathan Lockwood, Robert Lockwood, Caleb Peck, Joseph Mead, John Mead's son and Joseph Mead, Joseph Mead son, Ebenezer Mead, Jonathan Mead. We who are freeholders of the town do admit the other mentioned here as above said to be inhabitants with us also John Cluster and John Heusted are added Jasper Vidito. [1041]

TEN-ACRE LOT TURMOIL

Many grumbled openly after eight people were approved to each receive a ten-acre lot in Horseneck Field, without any payment required. Outrage escalated over this land bonanza, which would change all the rules so carefully crafted by the first townsmen thirty years earlier. It was then even

more radically proposed, in 1697, that *all* qualified residents of Greenwich could receive a ten-acre lot in the Horseneck Field, Belle Haven, *for free.* John Renalds, Joseph Ferris and John Hubby loudly protested this, being a change in precedent, charging it contrary to the Proprietors Act. Townsmen explained that this free land insured "all estates have a like privilege of being a settlement to men of greater estates in their interest in commons undivided." In other words, equalizing the amount of land owned by all planters would permit all to use the town's common lands equally. To satisfy critics, and limit the uproar, the town tried to accommodate complainers by saying these few grants were finite, and all land north of the Country Road at Belle Haven would be sold for private purchase, only to those on the list of 1697. The town reserved any one-hundred-acre "blanks" for itself. The List of 1697 became a seminal real estate document, frequently referenced in recounting land title lineage.[75]

THREE-ACRE HOMELOTS PLUS TEN ACRES BETWEEN THE BROTHERS BROOKS DISTRIBUTED

By May 1697, the town had moved ahead, regardless of criticism, and conducted a lottery establishing the lot locations for the eight sons needing land. They all received a three-acre homelot, plus a ten-acre plot between the Brothers Brooks—land running from North Street to Stanwich Road. This distribution of over one hundred acres dwarfed the (Old) Greenwich lottery of thirty years before. A small compromise was inserted, that these distributions transferred only if they were fenced in and improved for ten years. Roads were laid "up into the woods as are necessary before the ten acre right be laid out." The first three locations were specified:

> *The three first lots are on the west side of the North Street sixteen rods in breadth and thirty two rods in length all equal. On the east side of the street four lots are twenty three rods in breadth and thirty two in length. The fifth lot is seventeen rods in breadth and thirty two rods in length...* [T]*he bounds of the ten acre lots the land layd out is fifty rods long and thirty two rods in breadth and there is to be a hyway pass through the land through the middle of them all a rod wide for people to pass through with their carts provided they leave not the fence down. The draft of these lots are as followeth: beginning at the north side of them Ebenezer Renolds* [the

first], *Nathaniel Meade the second, Benjamin Hobby the Third, Joseph Close the fourth, Benjamin Knap the fifth, Joseph Finch junior the sixth, Benjamin Ferris the seventh, James Renolds the eighth.* [278]

Many found this plan outrageous in its unfairness to those who had previously followed the rules, bought their land and paid taxes based on its purchase price. The town justified its action, "having taken into consideration the necessity of some of the young men." The origins of Parsonage Road were also planned as this time, as the town set aside fifty acres for a parsonage. The town reiterated its promise to set aside common land north of these parcels.[76]

By late May, sixty more men, likely all of the town, demanded a free ten-acre lot, angry that no plans for common land in northern Greenwich had materialized and that the ten-acre lots were not priced "in due proportion." Vocal protests of old townsmen continued throughout the next year, joined by James Ferris Sr., "affirming it to be over and contrary to the proprietors act when they laid out their right in lands in common." John Hobby chimed in that this granting would "damnify," or devalue, his other land holdings.[77]

Free land led to discussions of less expensive land in Horseneck, and it was argued that land farther away from Old Greenwich was less valuable and should be taxed at a lower rate than the Old Greenwich land, because of travel inconvenience. This did not go over well with Old Society residents, who argued passionately against it. The first generation was shocked that their sons and grandsons demanded a departure from founding principles of a uniform price per acre, and they questioned demanding more land than their parents had ever aspired to. Differentiated market value for land was a new issue for the "first comers," as was flexibility in adapting to growth and the needs of populations less anchored to founding ideals.

Seven (Old) Greenwich residents even went so far as to appeal to John Winthrop Jr. for a ruling on the subject. They acquainted him with the old agreement that Horseneck residents should stand related to Greenwich Old Town concerning everything civil, military and ecclesiastical and tried to make this stretch to equal real estate pricing. They noted that Horseneck residents were a larger population than (Old) Greenwich, and this increased their taxation harm, devaluing their land. It "took away their privileges." These "intolerable motions threatened the weak peace and prosperity of the East Society," implored the authors.

In February 1699, the old townsmen succeeded in their long and emotional campaign to uphold the pledges of the Proprietors Act. The

town reversed itself entirely and now required all individuals to pay for their 10-acre lots "per acre in York money or a third adventane in pay" at the traditional Patrick's Rate of £10 per acre. In 1700, twenty-one of these lots, comprising 210 acres, were surveyed. Some of these reaching into Poundridge, New York. The town consoled itself with revenues of £2,100. Distributing this many 10-acre lots at once allowed Horseneck to develop much more quickly than Old Greenwich and Riverside had. In preparation for the 10-acre surveys, the town had more "convenient hyways" laid out "up into the woods."[78]

THE LIST OF 1697

Why so many of the same people owned land throughout Greenwich is explained by the widow Ruth Finch. She tells us that in 1697 an agreement was made that all remaining undeveloped, unclaimed land in Greenwich would be completely distributed, through lotteries, only to those on "the list of 1697," a revision of the List of 1672:

> *Know all men by this present that I Ruth Finch wife of Joseph Finch Senior of Greenwich in the county of Fairfield and colony of Connecticut whereas by a town grant made in the year 1697 in which grant all our outlands above the Country Road was to be divided by the list that year and I being a widow was interested into the above said lands.* [1413]

Even in 1714 and 1716, being on the List of 1697 allowed privileges not available to others.[79] In 1714, the list of eligible land purchasers numbered one hundred men and women (in Land Record Book 2 Part 2 Ledger: 169–70. Not transcribed).

1697 List of Estates, a Copy

[Name]	£:s
Timothy Knap	*47:5*
John Austin	*31:0*
Joseph Finch Junr	*99:0*
Caleb Peck	*98:0*
Thomas Cloose Junr	*26:0*
Joseph Husted	*54:0*

Thomas Hobby	*54:10*
Ebenezer Runols	*30:0*
Stephen Holm	*31:5*
Thomas Cloose Sr	*80:0*
Angel Housted Junr	*41:0*
Elisha Mead	*38:0*
Thomas Studwell	*30:0*
William Palmer	*39:0*
John Runols Junr	*51:5*
James Ferris Junr	*40:10*
Thomas Bullis	*21:0*
Gershom Lockwood Sr.	*47:0*
Joseph Lockwood	*25:0*
Benjamin Knapp	*31:0*
Benjamin Hobby	*29:0*
Joshua Knapp	*54:0*
Samuel Mead	*87:10*
Joseph Studwell	*18:0*
John Banks	*76:10*
Samuel Lyon	*88:10*
Thomas Lyon	*57:12*
Joseph Mead	*25:0*
Joseph Cloose	*24:0*
	1234:17 [sic]

[GLRB 1/1:31]
[Index Tab Q]
[Amounts listed in Pounds:Shillings]

1702: Six more residents were added for a total of 39 households.
1702: Added: David Mead, Ephraim Palmer, Samuel Finch, Joseph Feris, Jonathan Hobby, Isaac [Howe?]
 [39 households]
1704: Added: Jonathan Renalds Senior, Daniel Smith Junior [41 households]
1710: Added Henery Attwood [42 households] [1042]
1714: 100 Households [Land Record Book 2 Part 2: Ledger pages 169–70. Not transcribed]

Changes in the Price Per Acre

In 1705, the price of land in Horseneck changed to four pounds from ten pounds per acre for all those on the List of 1697. A lottery at this price point attracted sixty-eight participants, and it applied to land a mile and a half removed from the Country Road. A second division at this new price was held in 1706, with sixty-eight participants again, including two women. By 1716, the town was looking to make a fifth disbursement to those on the 1697 list, at four pounds per acre.

BYRAM AND PEMBERWICK

Settling the Quakers in Byram Neck

Thomas Young or Youngs was a Quaker who had lived peaceably with the Puritans until he, and the greatly respected Quaker glove maker John Marshall, refused to financially support a Puritan minister. This was an intolerable situation, for their minister tax revenues were vital for recruiting efforts. Joseph Mead and Sargent Gershom Lockwood, acting as town agents, even took Youngs and Marshall to the colony court at Fairfield in 1672, where Young had his land confiscated. Compassionate Jonathan Lockwood and William Hubberts allowed Young some land in Horseneck, even though his grown son and his wife objected to the sale, only to relent ten days later. By 1675, Thomas Youngs had struck a deal to exchange his central Greenwich land for some in Byram. Byram was attractive to him since the town was home to two other Quakers: Thomas Lyon and John Bancks. John Marshall eventually moved to western Greenwich as well and named his land along Byram Long Ridge "Quaker Ridge." The town first installed Quakers as far away from Old Greenwich as possible in 1676, when they made a three-hundred-acre grant of Byram Neck land to Thomas Lyon and John Bancks. John Bancks lived within the Horseneck Town Plot before this transfer, and he purchased land in western Greenwich directly from Native Americans. In return for granting his Native American purchase to the town, Banks received forty to forty-two acres, "the whole plain by Westchester Path and the Byram River," including the Calf Islands off Byram's shore.[80]

Thomas Lyon was a Quaker and an attorney. He had lived in Stamford and Greenwich when married to Martha Johana Winthrop, daughter of Greenwich founder Elizabeth Winthrop Feake Hallett. After Martha's early death, he moved to Fairfield and began a second family. The Byram land grant was likely to compensate Lyon for some inheritance loss of the original Feake-Patrick purchase due to him through Martha Johana Winthrop. Lyon's long-running contention had been that but for the presence and actions of William Hallett, his former mother-in-law's third husband, (whom the English in New Haven had forbidden to marry), some of her land should have passed to him. After the town grant to Lyon and Bancks, the two men divided much of this land between them in one of the longest and windiest documents in the archives.[81]

DEVELOPMENT IN BYRAM
BELOW THE COUNTRY ROAD

Available Byram land, beyond the Bancks and Lyon grants, was surveyed in 1683. Byram Hill was examined to find the best location for a new waterworks. The following year, Byram was further explored for the fencing in "of a field to the river." By 1691, John Bancks had constructed waterworks for livestock watering and planting drainage at Byram Cove.[82]

The town felt the need to strengthen its title to western Greenwich in 1686; as the town itself held no deed to land here, town claims were based on 1650 Treaty of Hartford terms. Hearing that private persons had made purchases in western Greenwich directly from Native Americans was disturbing. The town approached John Bancks, or his father also named John, and offered him a land exchange. In this way, the town, rather than a private individual, would hold title. This was important, since neighboring Rye had begun to claim ownership of some western Greenwich borderland, and it may also have been a lesson learned from dealing with historically alternating Dutch and English jurisdictions—what had now become New York and Connecticut contests.

Mr. Banks was to resign up to the town "that Indian Purchase respecting Birum Neck" and pay a fine for purchasing from Native Americans, which had been prohibited to maintain the integrity of town holdings. Joshua Knap, John Hubby and John Mead made this transfer happen.[83]

By 1704, a lottery had been held for the Byram land, including Byram Long Ridge. This is the ridgeline in Pemberwick, natively, Pimbewalk or Pimbewaug, that runs on the east side of the Byram River along Pemberwick Road. In 1705, John Hubby sold his right in Byram Neck below the Country Road to Richard Ogdin/Ogden of Rye, and from this we know that the price of land here was at Patrick's Rate of ten pounds per acre, but the land was not yet surveyed. By the following year, a road was cut by Byram Long Ridge, likely Pemberwick Road. The next year, Byram Long Ridge and the Crotch land, also called "Byram Crotch," became available. This area's steep ravines, or *crotches*, were the least expensive yet, priced at twenty shillings to the acre. An accounting of land of the deceased Thomas Close Sr. shows that he held forty acres "on a hook of the Byram River" in 1711.[84]

LAND BETWEEN HORSENECK BROOK AND BYRAM RIVER ABOVE THE COUNTRY ROAD

Land distribution east of the Byram River and Riversville Road, including eastern Glenville, plus the surrounding environs—now Round Hill Country Club and the Audubon properties—was discussed for development in 1684. "Each man is to have his land for twenty shillings an acre and to have his full and free choice within the above said bounds and what each man's lot lacks in quality shall be made up in quantity." The bargain price of twenty shillings, or one pound per acre, was far less than the cost of land much closer to (Old) Greenwich. Ten years later, in 1693, the price would rise precipitously to Patrick's Rate of ten per acre.

In 1687, the town put off a lottery for this land, and at first, people could choose land wherever they liked as the town: "doth give liberty to each of those persons so concerned to take their choice where they think meet between Horseneck Brook and Birum River above the Country Road save only Mr. Jeremiah Peck, the town minister, is to have the first choice," giving rise to land known as "Pecksland." Residents were given between January and April to make their lot location choices. Shortly thereafter, the highly respected "old townsman" Leftenant Jonathan Lockwood passed away, and "his brother Gershom Lockwood took his place in town matters."[85]

Many expressed dismay at the unregulated distribution and interest when a lottery was held for these western lands. A survey was made to see if it could host another common field, and the land was laid out "according to

a rule of proportion," a constant price per acre. Surveyors completed their work in the spring of 1688. All buyers were established Greenwich residents, and most bought under ten acres, with only one buying fourteen. The lottery list shows twenty-one men participating, all of whom had lived in the town for seventeen years or more.[86]

GLENVILLE TO PEMBERWICK: CAUK'S OR DICK'S PURCHASE

In 1696, a decade after John Bancks purchased his Horseneck Field land from Native Americans, seven men purchased land along the southwestern border of Greenwich from Native Americans in a prohibited transaction called both "Dick's Purchase" and "Cauk's Purchase." They were John Lyon, Richard Scoffield, John Brandig (Brundage) and four Ogdin/Ogdens: Joseph, John, Richard and David. The four Native American sellers were Cranamateen, Nepawhenn, Waterchehan and Moshareck, or Mashareck. English witnesses were Isack Danham and John Stoakham, and Native American witnesses included Wespahin/Wespahing or "John Cauk," spelled Cak/Caok/Cook/Kook, later referred to as a beekeeper. Other native witnesses were Robbin, Pouscome/Porescome and Kinhotam, "by the English [called] Richard Smith." Dick's Purchase could refer to this man or to English purchaser Richard Ogdin/Ogden. Within the deed, the English purchasers' names repeat six times, like a recurring incantation to secure the sale. Native Americans are listed twice. The parcel in question was

> *a certain parcel of land lying up a river commonly called Byram River being butted and bounded as hereafter expressed. That is to say on the east with Byram River on the west with marked trees on the south with marked trees on the north with marked trees and it is in estimation a mile and half in length and a mile in breadth more or less there being a neck of land within the aforesaid parcel of land.* [300]

Instead of exchanging land with the purchasers, as it had done with John Bancks, the town bought this land from its European purchasers to establish title. To raise revenues for this, the town raised a tax of a half penny and one farthing for each pound of valued assets per person, raising the grand sum of thirteen pounds in 1698. It was then "laid out according to a rule of

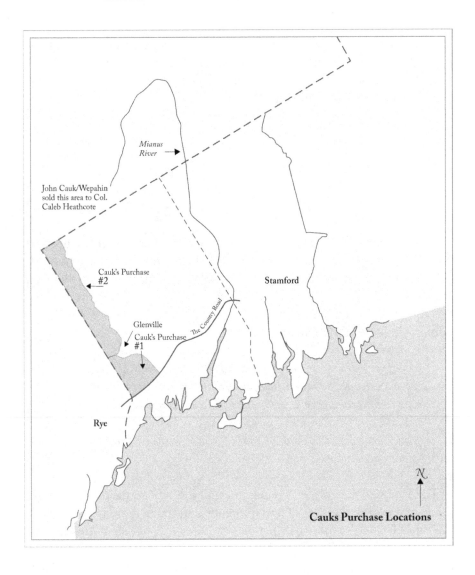

Cauks Purchase Locations

proportion, to the inhabitants of Greenwich according to the 1701 list of estates, reserving a seventy-pound right for the minister."[87]

A lottery divided this land between fifty-nine people, the Widow Mead included, who put in £16. The town received revenues of £3,513, a good profit after its investment of £13. This lottery included all of Byram Neck, except the Bancks and Lyon land north and northeast of Byram Neck. The western border of Dick's or Cauk's Purchase is the Connecticut–New York line running north for one and a half miles to the intersection of King Street and the New York state line. The territory then ran east for about one

mile. The eastern border is near the lowest point of Glenville Road before it ascends upward to modern Sherwood Farm Lane. At this point, there is a pond and a stream running under Glenville Road, which marked the original Cauk's Purchase boundary.

NORTHWEST GREENWICH SOLD BY NATIVE AMERICANS TO THE TOWN FOR TWENTY-FIVE POUNDS

In 1701, other individuals were about to buy northwest land from the same Native Americans, despite prohibitions, but the town gained title to it first.[88] In December 1701, Wespahin/John Cauk sold his northwestern holdings along with Woharness, "Indians belonging to the town of Greenwich." This was the second Cauk's Purchase, and it ran from Glenville to the northern border with New York State. It was

> *a certain parcel of land lying and being in the bounds of Greenwich bounded easterly by Birum River, westerly by the line that parts Rye and Greenwich according to patent granted by Connecticut court and north by the line that parts Connecticut colony and New York province and south that comes to a point where the line between Rye and Greenwich parts from said parcel of land. [668]*

This included the town's current municipal golf course, the Griffith Harris, the Fairview and Tamarack Country Clubs and much more for a purchase price of twenty-five pounds. In this sale, Native Americans Mecron and Kinhotam, "by the English [called] Richard Smith," participated. Wiowas certified that Wespahin/John Cauk and Woharness "were the proper heirs and owners." This important deed was recorded by the town clerk eight or nine years after the transfer.[89] The town took action again in 1716 to protect town land being developed on the west side of the Byram River without due process. In 1719, there was a lottery for land here, one and a half miles north of the Country Road, and in this, "sixth divident," the land was priced at four pounds per acre.

ONE FENCE LINE RAN FROM THE MIANUS RIVER TO BYRAM COVE

To link the fence lines of Cos Cob, Rockie Neck, Pipen Point, Horseneck and Byram Field common fields, by 1689, a single line ran along the Country Road from the Mianus River to Byram.[90]

To maintain this line and assign repair responsibility, posts were marked with names. They faced toward the center of each man's section, "upon penalty of £.12 for each man's defect." People were warned to be present

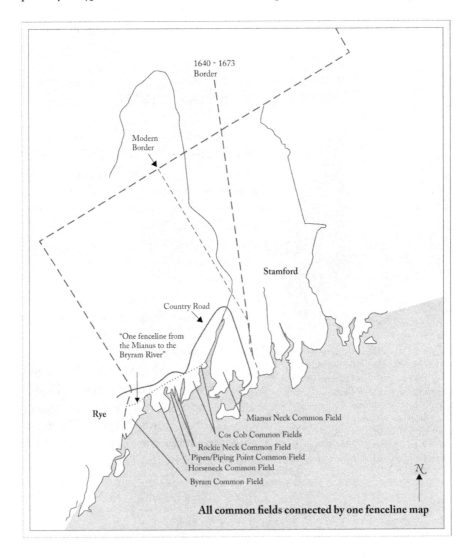

1640 - 1673 Border

Modern Border

Stamford

Country Road

"One fenceline from the Mianus to the Bryram River"

Rye

Mianus Neck Common Field
Cos Cob Common Fields
Rockie Neck Common Field
Pipen/Piping Point Common Field
Horseneck Common Field
Byram Common Field

N

All common fields connected by one fenceline map

when fence responsibilities were recorded—for if absent, the accounting could not be challenged. In the year of this decree, the appointed fence viewers were neglectful, and frustrated townsmen installed a new committee. This extensive line, fencing off all the peninsulas in Greenwich, existed for at least thirteen years.[91]

In 1704, townsmen acceded to the wishes of many and decided that Rockie Neck, which hosts Bruce Park and western Millbrook, would no longer be a common field and would now be divided into sixty lots. Pipen Point, the land that hosts the Greenwich Town Hall, the Boys and Girls Club, the Metro North Greenwich train station and the Arch Street Teen Center, was developed into homelots in 1704, no longer a common field.[92]

COLONEL CALEB HEATHCOTE

Colonel Caleb Heathcote owned much of Scarsdale and Cos Cob and helped establish Episcopalians in Greenwich. *Dixon Ryan Fox,* Caleb Heathcote Gentleman Colonist: The Story of a Career in the Province of New York, 1692–1721 *(New York: Scribners, 1926). Gift of Leo Hershkovitz, New York Historical Society.*

In 1700, residents sold over 60 acres in Cos Cob Neck to Colonel Caleb Hethcut, or Heathcote, a wealthy Englishman who was an early governor of New York. A land speculator in America, he came to own large parcels of land in Westchester and Greenwich, owning much of Scarsdale and Mamaroneck. From 1701 to 1705, many sold their Cos Cob properties to him. This was a departure from keeping most real estate within the hands of local families, and his offer price is unknown. The town also looked to him to build two small sloops on the Mianus River and perhaps the first Mianus River Bridge south of the Palmer Hill Road crossing. In 1711, the town denied Hethcut/Heathcote's further aspirations to place a sawmill on the Byram River.[93]

PROPERTY REASSESSMENTS

By 1694, determining who was responsible to repair fencing at the various Horseneck fields had become so confused that the town assembled a large committee to "go to the town clerk to gain the best insight by ancient writings of each man his property of lands in said fields with the quantity of fence laid to said lands." People were urged to go to the town clerk and register their commitments for each field. The town then negated the responsibilities of 1692 and replace them with the new accounting of 1694. In 1696, a resurvey of responsibilities for fence sections in Myannos Neck Field was undertaken. More action was taken in 1699 to straighten out the jumbled bookkeeping of land ownership for the town's first sixty years. The multiple land parcels, or "dividents," of any one individual were not recorded in the town books for years after they had been willed away or sold among friends and descendants. The 1699 will of John Renalds,[94] for example, indicates that he owned ten or more dividents in Horseneck "Ould Field," in Piping Point, at Cos Cob in the Indian Field, in "the Crotch Land" or steep ravines in Byram, between the two Brothers Brooks in central Greenwich, a homelot at Long Meadow Brook in Old Greenwich, a lot in Myanos Neck Field, another parcel at a place called "the dam," some meadow in the Little Field and land on Elizabeth Neck. Widow Sarah Grigory, "sometime wife of Ephraim Palmer," recorded the family's holdings "laid out and not laid out" in 1699, owed to her son Ephraim; a five-acre homelot in Horseneck Town Plot with a house, barn and fruit trees; one lot in Horseneck Field; one lot at Piping Point; and one piece of meadow at Cos Cob Field.[95]

Disputes occurred as marked boundary trees and bushes died, rock piles were moved, stadles or stakes became lost, claimed land was abandoned, wills were inaccurate, inheritors misremembered and multiple inheritors challenged one another. The archives are littered with tiny written insertions to clarify past transactions. By February 1686, the town tried to clean up their books and decreed that "all lands that each man has in his possession as his proper real estate…both in quantities and bounds" should be brought to a committee to review, approve and record. All former records were to be collected to aid this comprehensive review. Accordingly, the land records for 1686 are an extensive accounting and readjustment of ownership.

Extinct Place Names in Greenwich, Connecticut, in the 1600s

Paihomsing
Cranberry Meadows
The Nut Plain
The Wading Place / Wading Place Creek
Finch's Ridge / Finch's Pound Ridge
The Stone Pound with Horse Neck Brook running through it
The Blind Garden in Mianus Neck
Byram Hill
The Mount / Jenkin's Mount
Plum Tree Brook in Mianus Neck
Horse Neck River
Weir Grass Meadow
Hog Island / Hog Island Brook
The Pine Swamp
The Dinering Rock
Pipen Point
Horseneck Field
Greenwich Town Plot
Mianus Neck Field
Rockie Neck
Byram Long Ridge
Seller's [Sailors?] Neck
Pimbewaug / Pimbewalk
Cauk's Purchase
The Great Swamp
The Great Ridge
The Great Ridge Road
The Deep Brook / Deep Brook Ridge
Clapboard Tree Hill / Clapboard Hill on Mianus Neck
Sticklin's Brook
Tunneyman's / Tunneyman's Ridge on the Greenwich-Stamford border
Boggy Meadow
Sawpit Rock / Sawpit Hook
Byram Crotch / Crotch Land
Weir Grass Meadow

SEVENTEENTH-CENTURY ANIMAL MANAGEMENT

Cruelty

It is enacted by the Governor, Council and Representative...
that no man shall exercise any cruelty towards any bruit
creature, such as are usually kept for the use of man; upon
pain of such punishment as in the judgement of the court, the
nature of the offence shall deserve.

Acts and Laws of His Majesties Colony of Connecticut: 25

THE TOWN REQUIRES A BULL FOR BREEDING

In January 1687, the town, then located only within Old Greenwich,
was "made sensible of the great want of a good and large bull for the
increasing of a large breed of cattle amongst us," and it engaged Ebenezer
Mead to find this great animal. This purchase was necessary to grow the
town's livestock-based economy, which produced meat, leather and its
many end products throughout the region. In return for his search, Mead
would be paid with two acres of swamp and upland, but only if he found
an acceptable beast. It may have taken him two years to locate a proper
purchase, for it wasn't until 1689 that Francis Thorne offered to "winter

the bull" for the next four years. In 1697, the town paid twelve shillings each for two additional bulls and six pence for a third one. This money would be reimbursed through the number of calves born later.[96]

Wolf Killing in 1695

Furthermore the town per vote have passed this act that what wolves the Indians do kill and they bring the wolf to the English that he or they that do buy it shall be allowed eight shillings to the towns rate. The town have hereby upon better consideration of the above specified act conferring the Indians killing wolves the town do repeal said act. But notwithstanding the town per vote have agreed that any English person that is an inhabitant of our town shall kill a wolf he shall be allowed eight shillings in the towns rate. [1099]

Fox Killing

1717: "Further the town passes vote that every man that killed a grown fox shall have two shillings, and for young fox half so much, and Angel Heusted and Ebenezer Renals are chosen to crop their ears to give an account to the town." [981]

1726: "At an adjourned town meeting January 2, 1726/7 the town per vote will not pay anything for foxes heads for the future."[97]

Wild Jadges

Jadges was the word post-Elizabethan Greenwich residents used for wild or escaped horses. On May 20, 1690, the town passed an act "in reference unto wild jadges." It decreed that "all wild jadges unmarked which are caught shall be brought into the town and they are sold by the townsmen at an outcry [an auction], to him or them that will bid the most." As to horse values, Francis Thorne presented a "stone colored horse" to the town in 1689. Appraised at four pounds, ten shillings, it had a black mane and tail with a bald face and four white feet.

Wolves

Whereas great loss and dammage doth befall this Commonwealth, by reason of wolves, which destroy great numbers of our cattle, notwithstanding provision formerly made by this courte for suppressing of them; therefore, for the better any to sett about a worke of so great concernement, it is ordered by this Courte, and authority thereof, that any person, either English or indian, that shall kill any wolfe or wolves, within ten myles of any plantation within this jurisdiction, shall have for every wolfe by him or them so killed, ten shillings paid out of the Treasury of the country; provided, that due proofe be made thereof, unto the plantation next adjoining where such wolfe or wolves were killed; and allso, bring a certificate under some magistrates hand, or the constable of that place, unto the Treasurer.

The Code of 1650:119

Be it enacted…that if any person shall kill and destroy any grown Wolf or Wolves, Cattamount [mountain lion] or Panther, with the bounds of any town or plantation in this colony he shall have twenty shillings in country pay, paid out of the public treasury and half so much for every wolf's whelp that sucks; and every English man that shall kill any Wolf or Cattamount shall also have ten shillings paid by the town in whose bounds the wolf was killed and half so much for every wolf whelp; the head or heads of every such wolf or whelp or Cattamount being first brought to the Selectmen or Constable of such town, which Selectmen or Constable shall cut off both ears from such head or heads.

And it is further enacted by the authority abovesaid that person, English or Indian shall take a wolf out of any pit made to catch wolves in or out of any trap of his due, every such person shall pay to the owner or owners of such pit or trap the sum of forty shillings for every such offence or be whipt on the naked body, according to the discretion of the authority into whose cognizance shall come, not exceeding ten stripes.

1702 Acts and Laws of His Majesties Colony of Connecticut in New-England

A horse pound for unmarked horses was built in 1687, near a shore of Horseneck Field. The fence builders were paid through the sale of the impounded horses. If a wild jadge was not claimed, auction revenues were payable 50 percent to the horse hunter and 50 percent to the town. Also, if "sundry jadges have been caught within a year of the date and have not been presented to the town...that all such charges shall be brought forth and sold." If any jadges had already been sold, the town was to be notified. In 1691, wild horses confined within the common fields caused so much damage that a penalty of two shillings and six pence was levied on the owner of any jadge or horse "found loose, not tethered or without a keeper."

In 1694, rulings about jadges were revised such that "what wild jadges... caught by horsehunters" that had been housed by hunters for over a year were to garner two-thirds of the auction's proceeds, with the town receiving the balance. Also, horsehunters could sell their jadges in either Greenwich or Horseneck, but in Horseneck, the sales lot was at Joshua Knap's house, with Knap remitting all proceeds to the town. Also, "those with a catch of the wild jadges are to bring or send an account unto the townsmen of their natural marks before they make their sale."

In 1695, jadges that had become domesticated or "improved in labor" and damaged the common fields or had no keeper were fined two to six

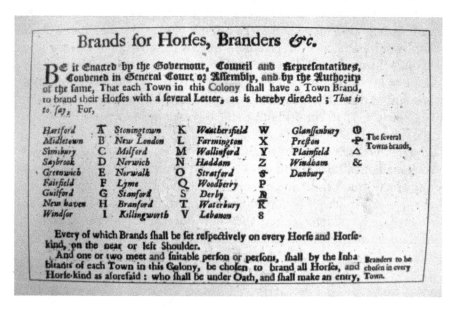

Connecticut Colony town horse brands. *Timothy Green*, Acts and Laws of His Majesties Colony of Connecticut in New England, *first printed 1702. (New York: Case and Lockwood & Brainard, 1901).*

For the Upholding of Good Breed of Horses

[I]t is enacted...that no stone horse [stallion] of above two years old shall be suffered to run at liberty on the commons in any place in the colony (unless he be of a comely proportion and full thirteen hands high, reckoning four inches standard measure to one hand)...[or] such horses shall be forfeited.

Acts and Laws: 52

shillings per head. In 1732, the town granted its Poundridge residents permission to build a pound at their own cost, perhaps originating this name. Round Hill dwellers were also granted permission to build one at their expense. To hold unclaimed, wild and escaped horses, a horse pound was commissioned near the shore "between Horseneck Brook and Rockie Neck." In 1697, another pound was built at Cos Cob for creatures that had damaged the field fences. In 1703, Benjamin Ferris was granted the liberty to make a pound of his yard "to secure such creatures as shall be taken in the field."

COW KEEPING

In the 1600s, cows were described as either "dry," meat, or "wet," milking cows. In April 1671, the herd was to be kept in the Mianus Neck Field until a month after Mikelmass (September 29, the feast of St. Michael), or longer and then moved to the Cos Cob Field on May 8. In March 1677, Greenwich needed a cowkeeper "to keep the milkhouse." There was a charge to keep one's cows in the common fields, and to pay the cowkeeper for his supervision, feeding and milking. To pay his salary of two shillings a week, use of the milkhouse was also taxed, but cows kept in pastures were exempted. Each oxen owner also had to pay part of the cowkeeper's salary. Cognizant of Greenwich rule benders, town leaders extended this

law to those who "pretended" their cows were being kept in the pasture when they were not. In 1680, the town hired a cowkeeper to "keep all the milk cattle" and requested they be all milked together. By 1683, another cowkeeper was hired to care for milk cows and working oxen. There was a need to keep the dry or beef cattle separated, so "a dry herdsman to keep the dry cattle" was hired as well. In 1685, the town directed taxpayers "to keep the milk cows and working cattle and all covens that go upon the common shall pay the cowkeeper rate, or tax."

In April 1668, the town ordered the dry herd "driven out as far as Cos Cob Brook or to the west side of the brook" from the Mianus Neck Field. This was Sticklins Brook, which runs into the Mill Pond in front of the Cos Cob firehouse. The town's cowkeeper was to alert all owners of this timing and drive location. If owners were unable or neglected to drive their own cows, the cowkeeper would do it and charge them for it. On this drive, oxen were also driven to Cos Cob Brook and to the Cos Cob Common Field, "when owners could spare them from their work." If cattle or oxen "roamed home," they were to be driven back to the brook and not neglected.

On May 22, 1687, cowkeeper William Hubbard "went forth with the herd." In 1692, the town set two pasturage rates: one for cows kept in Myanos Neck Field for the whole season and one for half season. Payment to the cowkeeper could be in cows or in mares.[98]

COWKEEPERS, CHOSEN AT TOWN MEETINGS

1711: Gershom Lockwood, Justus Bush, John Hobby, Nathaniel Ferris and Theophilus Peck.

1734: John Hubby and Joseph Ferris

1737: Abraham Rundle, John Hobby, Jonathan Knap and Joshua Mead

1741: Moses Smith, Gershom Lockwood, Caleb Knap and Hezekiah [illegible]

1746: John Hubbe, Gershom Lockwood the second and Isaac Holmes

BEE KEEPERS

1716: Samuel Finch

1734: John Kooks (Cauks)

1744: Abraham Rundle, John Hibley and Jonathan Knap and Gershom
Mead.

1745: Moses Smith and John Ferris, Moses Mead and Jonathan Knapp.

1751: Gershom Lockwood

1766: Joseph Lockwood, Captain Messenger Palmer, Nathaniel Sherwood,
Ebenezer Hobby

SHEEP MANAGEMENT

In July 1678, town meeting members elected Joshua Knap and John Renalds
to ascertain the highest auction price they could get for the town's sheep.
They also ordered the flock to be secured "from being devoured by wolves
or any other varmints or wild beasts." In March, the town sought to join
its flock of sheep with Stamford's for the summer and to hire a shepherd.
In April, anyone owning sheep had to contribute toward the shepherd's
payment.

By 1696, John Tash had been the town shepherd for twelve years.
Eventually unable to support himself, the town agreed to subsidize his care
and enjoined Ebenezer Mead to "entertain John Tash with suitable meat
and drink and washing and lodging for the sum of four shillings three pence
per the year in provision pay." In 1701, it was declared that since Gershom
Lockwood Jr. had offered to maintain a sufficient sheep yard for the securing
of the flock, he could have the benefit of their dung while the sheep lay in
his yard. The town ordered the sheep would no longer be "let" or rented to
others for the benefit of their dung.[99]

SHEEP HURDLES ARE MANDATED

In 1674, the town became increasingly administrative, perhaps due to
an increase in the quantity of livestock now managed. It ordered that a
number of "hurdles," or pens, were to be made to secure sheep in folds. The

"substantial" hurdles were to be ten feet long and wide and five and a half feet high. Each pen was to hold seven sheep, not including any rams, and as many pens as needed were to be constructed. Sheep owners who neglected this work faced fines of two shillings six pence for each hurdle they failed to construct. With the development of Horseneck common field in 1703, the town now had two flocks of sheep, "and the Mianus River shall be the bounds between flock and flock."[100]

SWINE

Swine are very strong and large hogs and pigs that can cause great damage with their strenuous digging or rooting with shovel-like snouts and sharp hooves. They uprooted fences, created wallows or deep holes and trenches in laboriously smoothed planting fields and, if escaped, ravenously devoured crops. Their dung is noxious as well, but their meat and fat—plus their durable leather—were highly valued.

In 1666, swine damaging the Mianus Neck Field were fined twice the rate of horses damaging the field, at twelve shillings per head. Owners were directed to "ring" or "yoke" their noses to help prevent snout digging, and fines were levied for those who neglected this. In 1679, townsmen were informed that "our neighbors at Rye...have brought their swine to Horse Neck and they have left them to our hurt and damage therefore they to wit... are speedy here without delay to clear our lands of their swine and to do it so effectually as that there may not be any more trespass of this kind of for the future." Orders were given when, where and how swine could be let into the commons, or common fields. Miscreants were impounded. Fences had to be at least four feet high for adequate protection against swine depredations. By 1720, the fencing in Horse Neck Field (Belle Haven) was finally sturdy enough to allow swine to roam with other livestock if sufficiently yoked, "free as other creatures."

WORKING THE WATERWAYS

THE MIANUS RIVER FOOT BRIDGE
AT PALMER HILL ROAD

In December 1687, there was "great want of a footbridge being made at Myanus River," which Gershom Lockwood and William Rundle then duly constructed at Palmer Hill Road, crossing to Valley Road. Both roads, linked to the "Country Road," generally followed the route of the Post Road west of the Mianus. This combination of roads came to be called "the Road to Boston."

Mills and Millers

[E]ach miller in this colony, or the owners of grist mills, shall be allowed three quarts out of each bushel of Indian Corne grinds, and for other grain two quarts out of each bushel he grinds, and one quart out of each bushel of malt he grinds, and no more: and if any miller shall presume to take or receive a greater toll or fee for grinding...he shall forfeit and pay the sum of ten shillings.

Acts and Laws of His Majesties Colony of Connecticut: 83

In 1684, forty years after the town's founding, Greenwich settlers tired of travelling to the mill at Stamford at Broad Street and the Mill River. A committee was commissioned to identify those who could capably build and operate a corn mill, a fulling mill and a sawmill on the Mianus River. They had no idea that such a necessary request would ignite a long-term drama. In 1687, the town contracted with Jonathan Whelply to make and maintain a "corn" mill, which meant grinding both wheat and Indian corn. He was given twenty acres of land on the west side of the river and fifteen acres on the east side, above the Country Road, plus ten acres in the "Cranberry Meadows," in North Mianus as planting fields to support the mill. Whelply obliged himself "to grind for the 14th part both of wheat and Indian [corn] and other grain which shall be brought to said mill." The town also contracted for Whelply to build and operate a sawmill.

Whelply and the town soon found fault with their agreement, for six weeks later, the town contracted with Joshua Hoight/Haite/Hait of Stamford to maintain a corn mill, a sawmill and a fulling mill on the Mianus at Palmer Hill Road. The terms given him were exactly the same as Whelply's. To encourage construction, the town promised Hoight "the free liberty of timber of all sorts above the Country Road." Hoight was to saw "foot for foot of such timber, and to make board or plank." In selling lumber, Hoight was to price it to Greenwich residents "at six pence per the hundred cheaper than he doth make sale to others." He was also instructed to grind corn, both "wheat and Indian." Optimistically, the mill was to be built by August 1689 and Hoight completed it near then.

His sudden death caused title to the mill and dam to pass quickly to Joshua Webb, John Westcut and Zachariah Roberts. These men, "undertake our mills a corn mill and a sawmill to present the one for grinding and serving the town for meal building the other for sawing of timber." Like Whelply and Hoight, the town allotted them land. To more adequately finance mill operations, non-residents of Greenwich were now allowed to buy shares.

Greenwich sued Whelply in the colony court at Fairfield for failure to perform, and damages to the town were estimated at forty pounds. The court found for the town, and Whelply was fined. Greenwich townsmen congratulated each other that they "have made recovery of the privilege of the stream of Mianus River. The court also instructed the town "to take the body of said Jonathan Whelply and bring him before the authority that he may be committed to the county jail there to remain until he hath paid the above execution," while Zachariah Roberts continued operations of the Mianus River mill.

After his jail time, the town re-engaged with Whelply for another mill, perhaps to help support his growing family, which would come to include nine children. In December 1692, the town contracted for another mill in Cos Cob with increased rules and restrictions. The town crafted a new mill covenant, "free of contention," in 1697. Whelply was now given five acres between the Mianus and the great ridge in Cos Cob "where it meets the path" to set his new mill, but only if he gave up all claims to the Mianus River mill. This location meant this mill was likely located at the falls at the Greenwich High School property, adjacent to the confluence of the Brothers Brooks. This would be very near the intersection of the Post Road and Hillside Road. Whelply accepted the town's offer, and after thirteen years of grinding here, on "October 31, 1710, Jonathan Whelply, miller, tendereth his gristmill to the town for 100 pounds in cash."

Jonathan Whelply was also contracted to build "a horse bridge over Mianus River for the convenient and safe passing over of people and their horse or feet upon their occasions," in 1695. With "strength for suitable passage for horse to pass over with two bushels of corn on his back without hazard or damage by the rails of said bridge." This, too, was at the Palmer Hill Road crossing. Forgiving townsmen helped him raise its frame, when finished. For payment, Whelpey was given one bushel of Indian corn for every male person on the list of estates of 1695 for his labor. This bridge was constructed by 1696. In 1714, the town petitioned the Connecticut Colony to fund a second, more convenient crossing, south of Palmer Hill Road, but this was denied.

In 1716, after Whelply's death, the town approved a second sawmill set on the Mianus, which may have been a rebuilding of the first one at Palmer Hill Road.[101] In 1748, a second Mianus bridge and dam was built in a more southerly location—by the weir, by the modern Boston Post Road crossing. The town, "have by a vote given Joseph Purdy liberty to beg for money to build a bridge over by the weir [and]... Josiah Reynolds to repair. Further town by vote make choice of Josiah Reynolds for to cull stones and James Rozman to cull stones." This became known as Purdey's Bridge.

Forty years later, catastrophe struck constructions on Greenwich waterways. A note in the records of the First Congregational Church in Old Greenwich, states: "September 19th day 1787 the greatest flood that was ever known since the memory of man swept away Titus and Mianus mill and all ye bridges." One month later, four Titus men were granted the rights to rebuild a mill on the Mianus (at the Post Road crossing), with some caveats:

1. That Purdey's stone dam be used again as a foundation.
2. That two docks be built on each shore of the river.
3. That a flood gate in the form of a field gate be built into the dam.
4. A crane must be erected to swing boats over the dam.
5. A bridge, wide enough for horse-drawn carts must be built.
6. A small boat called a scow must be provided for public use in the mill pond or reservoir north of the dam.
7. All work must be completed within four years.

This work was accomplished, and in 1796, Peter A. Burtus and Company took title and enlarged the docks. In 1884, the old mill building on the west shore of the river in Cos Cob was made into a country store. This burned in a conflagration that consumed many buildings here in 1897.

A MILL ON THE COS COB RIVER, SOUTH OF THE CONFLUENCE, WITHIN BRUCE PARK

In 1704, the town had a need for more mills and "granted liberty to the inhabitants on the east side of the river (Old Greenwich), to build another mill upon any stream where they shall think convenient." It also granted Horseneck residents the right to build a tide mill on the Cos Cob River. This would be downstream or south of the Whelply/Greenwich High School site. The Cos Cob River flows through Millbrook and Bruce Park to reach Long Island Sound. It is a combination of the East and West Brothers Brooks waterways. The confluence of the Brothers is at the Post Road and Hillside Road.

A tide mill is a water-driven mill. A dam with a sluice gate allows water into a holding pond or reservoir, and at low tide, the water's exit is controlled by the gate and directed to power a water wheel. The water wheel powers a saw for sawing wood, millstones that turn to grind grain or machinery that cleans and thickens cloth.

In 1704/5, the town's miller and minister, Joseph Morgan, erected his mill on the Cos Cob River within modern Bruce Park. It is the same site as the Davis Tide Mill. Support for this comes from a deed in Doc. #1437 that states: "I John Lyon Senior of Greenwich…absolutely give and grant unto my loving son Thomas Lyon…the one half of my gristmill in Greenwich standing upon Coscob River…*which I said John Lyon had of Mr. Joseph Morgan*" (emphasis added).

The Cos Cob River is also called Mill Creek, Brothers Brook and Davis Creek. Morgan had been hired to preach on both sides of the Mianus River as the town's only minister. Overwhelmed, he terminated his ministry quickly but remained milling until 1709. The mill was then sold to John Lyon Sr. in 1713/14, who gifted half of it to his son Thomas Lyon. He became called Thomas Lyon, miller, to distinguish himself from his grandfather. (In 1718, the town also granted Thomas Lyon, miller, the right to build a fulling mill on Horseneck Brook "one quarter mile above the road." A fulling mill cleaned linen, made of flax fibers, and sheep's' wool, so the yarn could be spun and woven into fabric. The mill mechanisms pummeled these animal and plant fibers with heavy paddles to beat out dirt and field debris and sheep oil, lanolin.) Thomas Davis eventually acquired title to the Bruce Park area property begun by minister Morgan in 1761, and it became known as Davis Tide Mill into the late 1800s.[102]

BROTHERS BROOK SAWMILLS

In 1691, Gershom Lockwood was allowed to set up a sawmill somewhere along one of the two Brothers Brooks, perhaps giving rise to the name for Old Mill or Sawmill Lane on the western Brothers Brook. John Hubbe Sr. and John Meade Jr. surveyed thirty acres of woods to support it. Lockwood opined that the land given him was "wasteland" and "not convenient" to his needs. He petitioned the town to grant him more suitable land "more downward of the stream." The town agreed, with the caveat that the mill must be built straightaway. If not, the land would return to the town.

A 1728 entry shows Caleb Mead to have lived by "a Brother," meaning on one of the Brothers Brooks. Family legend has it that the Stoneybrooke property on Taconic Road near North Street was an early mill. A second sawmill was approved in 1705 to be set on the East Brother for Joseph Close, "at the upper end of Joseph Palmers stone hill." Close was allowed the use of the stream as long as he maintained a working mill. In 1711, Adward Every (Edward Avery) was also granted use of the East Brothers Brook for a sawmill.[103]

THE BYRAM RIVER

1677: John Robyson/Robison was granted permission to build a sawmill on the Byram River.

1708: Richard Ogdin of Rye successfully petitioned to build a mill or mills on the Byram River below the Country Road. "The town [did] grant him the privilege of the stream below the road to set a mill or mills always provided that it be no damage to the Country Road nor to any former grant."

1711: The town denied Colonel Caleb Heathcote his proposal to build a mill on the Byram River, finding "it to be a great damage."

1717: Josiah Quinby was successful in his proposal for a mill on the Byram River, and he was given some protection for it in that "no man shall build a sawmill a mile below his mill so long as he keeps it in good repair." He could also cut such timber on any common land for own uses, for free for a year and, after that year, then pay five pounds a year for timber taken from common land. In 1718, the town divided boards Quinby had milled evenly between Old Town and Horseneck communities. The town eventually allowed him to also set up a gristmill on the Byram River within a mile of his sawmill.[104]

LONG MEADOW BROOK

In 1715, the town allowed Ebenezer Renals and Joshua Renals the stream of Long Meadow Brook, running through Binney Park, to set up a fulling mill as long as they kept the mill in repair.[105]

HORSENECK BROOK

1715/16: "Justus Bush of New York" was allowed to build a gristmill or mills on Horseneck Brook below the Country Road. This is near the Boys and Girls Club near Belle Haven, though the site is obliterated by the railroad and I-95. He had to build within two years, grind whatever Greenwich residents brought, and not grind for any "strangers." For building, he was allowed stones and timber from common land. He

could also set up a storehouse on a landing. If he failed to maintain a sufficient gristmill within three years' time, use of the Horseneck Brook reverted to the town. In 1726, "The town per vote grant liberty unto Mr. Justice Bush Junior to build a wharf 50 feet wide adjoining on the east side of the wharf stand before his for his own and the towns use."[106] The Bush operations here gave rise to naming the harbor "Bushes Harbor," predating the modern "Greenwich Harbor" name.

1718: The town granted Thomas Lyon Jr. liberty to set a fulling mill on Horseneck Brook, 1.4 miles above the Country Road, provided it is built within a year and "wronged no particular person." This would be Horseneck Brook as it runs near Zaccheus Mead Road.

1724: "Further the town grant liberty Daniel Smith to build a wharf at the mouth of Horseneck Brook off the landing there for the use of the town." This was likely adjacent to the mill of Justus/Justice Bush.

Cos Cob Landing Mill

In 1763, David Bush established a gristmill at "Cos Cob landing," on the west shore of the Mianus River at the inlet that creates the Mill Pond and leads to Strickland Book. The site is very close to the grounds of the Greenwich Historical Society. Burned down in 1899, it was called the Cos Cob Mill. In 1766, the town granted permission for boat building on the road by the Mill Pond: "[L]iberty granted to any person or persons to lift up and build vessels on the road by the Mill Pond near Jesse Hallocks house and not to obstruct the road from the inhabitants between John Hilebeacks house and said Hallocks."[107]

MANDATED MINISTERS
PROVE DIVISIVE

H enry VIII subordinated the powers of the church to the English state, and this paradigm shift reverberated for centuries, changing the chain of command in local communities. Local ministers and ecclesiastical bureaucracy, who used to dominate society, now found their authority subordinated to regional and local governments in America. This generated conflict between clergy and townsmen, ecclesiastical and colony mandates and local enforcement. The state, as a Protestant religious enforcer, ironically had difficulty instituting its mandates because it had also granted local governments powers to order their communities. The many schisms, or divergent opinions on proper Protestant philosophy, also made fitting any town to its minister difficult. Preaching in Greenwich in particular was a challenge because of the physical division of the Mianus River and the town's rugged geography.

The Connecticut Colony also mandated a minister at a certain population size, which became a great problem in Greenwich, for residents found crossing the river quite difficult and populations remained small on each side. Logistically, it was too difficult to bind together as one to support one minister for all. One side or the other would have to face long travel over treacherous terrain. As subsistence farmers, each side lacked even enough carts and horses for group transportation to a distant location. These obstacles set the stage for decades of conflict and strife between Horseneck and (Old) Greenwich and between the entire town and the ecclesiastical court in Hartford as well.

Colonial Protestants and ecclesiastical courts wanted ministers in communities to play the same authoritative roles pre-Reformation clergy had: to act as a town's moral assessor, social arbiter and hawk-eyed critic of the ungodly and socially errant. They were unlike today's warm and caring altruists who assure of God's abundant forgiveness. Preachers stressed fearing God and avoiding his wrath to promote socially positive behaviors. To "fear God" was an admirable trait, an honored, submissive and humble perspective. Early communities looked to their ministers to prevent them from slipping away, in an untamed world, into savagery themselves.

THE FIRST MINISTER: ELIPHALET JONES

Eliphalet Jones was recruited in 1669 to preach in Old Greenwich, almost forty years after the town's founding, because of its limited population. He was enticed with fifteen acres on the east side of Cos Cob Neck, so he could turn his "cattle out upon the [Cos Cob] common." To pay him, additional, new Greenwich residents were also recruited, "men of a good report, men of piety, fearing God." In four short years, however, the Jones home was considered more valuable than the man's sermons, and he was asked to leave. Valuing his house proved difficult and acrimonious, taking well over a year. Stamford appraisers ultimately priced it at twenty-seven pounds in the summer of 1673, including all the fences, gardens and improvements, "the winter wheat excepted."[108]

FIRST PHILANTHROPIST: WILLIAM GRIMES

In July 1670, while Jones was still preaching, a dying, young William Grimes, a friend of Joseph Ferris, bequeathed the town his land. He asked that his property on the west side of the (Old) Greenwich peninsula, in the Shorelands neighborhood, be used "to promote the church and commonwealth." Instead, it became a long-term rental farm which enhanced the town's coffers. Criticized for failing to honor Grimes's will in 1694, the town blamed its decision on a deceased town clerk. Because the Grimes will was never recorded, it explained, his wishes were forgotten. Persistent residents appealed to the County Court at Fairfield to have the land used as intended.

The town must have won its case, for this land remained a town owned rental property for over two centuries.[109] Ultimately, the Grimes land became a property of the First Congregational Church in Old Greenwich, and it held the deed to thirty-two acres of it until 1906, when it was sold to benefit the Grimes Trust Fund.

MR. LOWERICH

A Mr. Lowerich declined the position next, perhaps because of poor lodging. A decision was then made in May 1674 to build a "townhouse" specifically for "a comfortable habitation for a minister's use." This was to have "a pair of chimneys built with stone; and it would be joined with an existing house next to the street." Lacking a minister, it, too, was rented in 1696 for the "full and just sum of three pounds, two shillings in merchantable provision pay."[110]

GREENWICH QUAKERS RESIST SUPPORTING PURITAN MINISTERS

Quakers believed the Puritan way had not reformed Christianity far enough and had failed to incorporate a new way of thinking about Christ's presence in the world. Quakers believed that Christ's second coming had already happened and that it was not a physical event but was instead an inward revelation. They subsequently ignored Puritan rites and institutions and refused to financially support their ministers. Since Christ had already "come again," and because God had established a new covenant with humanity, a new form of worship, the Quakers' approach, was necessary to address this change in the human condition.

Having already experienced Christ in one's soul, no further sermons or ceremonies were necessary. Quakers dispensed with traditional church and meetinghouse buildings, holidays, religious customs, music and sacraments. This was not a dramatic difference from Puritan practices, since their meetinghouses contained no crosses, sculpture, stained glass or other ornamentation. Holidays such as Christmas and Easter were not recognized. The Quakers of the 1640s and 1650s, however, worshipped in

a way that was stripped down to an even purer and more abstract essence than the Protestants' rejection of Catholic symbolism, saints, bureaucracy and rituals.

Quakers worshipped in silence, meditating for up to three hours at a time, rocking back and forth on a bench, or "quaking" when moved by a revelation. Silence, they believed, was both a positive and negative space, the best medium for receiving God's unadulterated guidance. Puritans referred to them as a "frequently annoying people."

STUYVESANT BANISHES QUAKERS

On Manhattan, Governor Peter Stuyvesant, son of a strict Calvinist minister, wanted only the Dutch Reformed religion to operate within New Netherland, and he tried to prevent the Quaker movement, fearing its popularity would challenge his authority. He jailed Elizabeth Feake Hallett's husband and son-in-law, William Hallett and John Bowne, but his bosses soon reversed this. Compromisingly, the West India Company allowed other religions to be practiced in New Netherland but disallowed the construction of their houses of worship.

Tobias Feake, Elizabeth's nephew by Robert Feake, was the first to sign his name to the now-famous "Flushing Remonstrance," which objected to Stuyvesant's muzzling. This document is recognized as the first American treatise, other than Anne Hutchinson's trial record, that demanded the right to religious freedom in America.

GREENWICH QUAKERS ARE DENIED LAND

In 1672, Gershom Lockwood, Thomas Youngs and John Marshall were Quakers in Greenwich, along with Thomas Lyon Sr., John Lyon, John Bancks, Francis Thorne and a Mr. Palmer. When these men declared they would no longer attend any town meetings or provide financial support if town land was given to Puritan ministers, their furious former friends denied them the right to gain further "outlands" or "land in commons." Anger, and the increasing need for full revenue participation, led to litigation. The outcome of the case is not documented, but soon thereafter, some Quakers left town.

WIZWALE, MATHER AND JOHN BOWERS

Bereft of a minister for three years, the town approached a Mr. Wizwale in 1676. The man was considered "well worth the town's pain and cost to procure," but he refused. Local townsman John Bowers stepped in to provide temporary spiritual sustenance. Bowers was an integral member of the community, having been married to both Judith Feake Palmer Palmer Ferris and Hannah Close Knap, the widow of 1664 proprietor Joshua Knap. The town sought to relieve John Bowers with "Mr. Mather at Milford," but Mather also declined.[111]

JEREMIAH PECK

Jeremiah Peck was attracted with "two lotments to be laid out in Horseneck, each worth £70," in 1679. His grown son, Samuel, could also receive acreage worth £50. Assured that Peck would accept, enthusiastic residents hustled to see that the townhouse was "speedily repaired and made fit for Mr. Peck's dwelling." The town planned a tax hike to pay him. Within two short years of his ministry, however, Peck's bountiful benefit package was scrutinized by Jonathan Lockwood and John Renalds Sr., who thought it excessive. By 1688, he too was leaving, amid arguments over unpaid salary, the value of his land and house, low attendance to his services and his refusal to baptize town children.[112]

The dispute over baptisms was one of the many Protestant schisms. First-generation Puritans had testified to a powerful conversion experience to become one of the "elect," an elite status in society—a group deemed graced by God. Their children and grandchildren in America often could not testify to such epiphanies and thus failed to qualify for full church membership. Fearing these generations were drifting from their ethical moorings, a compromise called the Half-Way Covenant was created. This provided partial church membership for those "upright" children and grandchildren of "legitimate" Puritans, who had not had a powerful conversion experience but might hopefully be "born again" at a later date. These generations could be baptized but not take communion or vote. Peck rejected the Half-Way Covenant, believing that one could only be baptized as an adult, fully cognizant of the nature, reason and consequences of its meaning. The search for a minister resumed, led by "old townsmen" John Bowers, John Mead Sr., Joseph Ferris and John Hubby.

Abraham Person/Pierson/Parson

Abraham Pierson was recruited from New Ark or Newark, New Jersey, after he attended the recently established Harvard College. His father had been a member of the "puritanical" New Haven Colony, he helped found Stamford and he left his son over four hundred books, the first private library Greenwich ever had. Offered fifty pounds a year with firewood or sixty without, along with the parsonage and four acres, Pierson agreed to be the Greenwich minister in 1692. Valuing pre-cut firewood, John Hubbe and Daniel Mead were told to "stir up people to supply him in that respect," but there was community resistance. Subsequently, the town was forced to pay residents for this cutting, carting and use of residents' oxen. Always poorly supplied and paid too slowly, Pierson ceased his four-year Greenwich ministry in 1694 and moved to Killingworth, now Clinton, Connecticut, where he began teaching at what would become Yale University. Yet another search committee was appointed.[113]

The First Meetinghouse: 1695, Erected Fifty-Five Years After Town Founding

Tired of traveling to Stamford or using private homes for Sunday services, which hindered recruiting efforts, (Old) Greenwich residents finally built a meetinghouse. "The bigness of it and the form of it" was thirty-two feet long, twenty-five feet wide and fifteen feet high. It had a hip roof, a few tiny windows, bench seats inside and a lecturn for the preacher. It lacked any amenities, save seats. There was no heating or cooling, sanitary facilities, turret, belfry or stained glass and only salt hay packed around the foundation for insulation. It was dark, damp and chilly in the winter, hot and airless in summer. John Renalds insured the work "speedily proceeded," while others were "to cull and count what shingles and clapboards each particular person brings." The exact location of this building, completed in 1695, is believed to have been adjacent to Tomac Cemetery.[114]

SALMON (SOLOMON) TREATE TO PREACH
IN TWO LOCATIONS

Solomon or "Salmon" Treate was provisionally hired for six months in March 1696. His salary of thirty pounds was distinctly less than Mr. Pierson's fifty pounds plus firewood. Based on his performance, his pay was increased by ten pounds, and he, too, was given the parsonage house, an eight-acre homelot and the privilege of undivided land north of the Country Road. This was in (Old) Greenwich, worth seventy pounds—seven acres—and it was called Treat Hill.

Trouble with Treate began when he was asked to preach on both sides of the Mianus River. This was an onerous assignment, for it meant traveling the hilly, rutted and rocky roads from Tomac Avenue to Palmer Hill Road, crossing the river at Palmer Hill in all weather, proceeding down Valley Road to the Post Road through Cos Cob and then climbing the great hill (behind modern Greenwich High School) to the plateau of the Horseneck Town Plot to preach in someone's very small home. He would then return to (Old) Greenwich after conducting a four-hour-plus service. Entirely dismayed, Treat left after six months. Yet again, John Renalds Sr., Jonathan Mead, Joseph Finch and Ebenezer Mead were appointed "to gain a minister."[115]

REVEREND JOSEPH MORGAN:
THE MILLER MINISTER

Joseph Morgan agreed to preach on both sides in 1697, but he also wanted to operate a gristmill, which was eagerly embraced by the town after the Whelply debacle. With Morgan's arrival, the town stirred itself to improve the parsonage house, as it was "much out of repair and rough." Perhaps because (Old) Greenwich lodging was insufficient, Morgan chose to live in Horseneck, where his mill was erected, south of the confluence of the Brothers Brooks in modern Millbook on the Cos Cob River, within Bruce Park. This logistically meant he would minister more often to the Horseneck community, upsetting (Old) Greenwich. Both sides of the river were annoyed, however, when Morgan preferred milling over ministering, which was "a great damage and inconvenience." By September, there was community retribution, and Morgan found himself short of firewood. The town threatened fines for not supplying him, but Morgan ceased his ministry

in 1700. He continued milling however, until at least 1707.[116] In giving his reasons for quitting, Morgan noted (paraphrased):

1. *Because there is not unity in the place viz. Greenwich and Horse Neck for the public worship of God.*
2. *Because I do not see probability of their coming in gospel order having given you warning long ago that if there were not promoters of* [it] *I would desert.*
3. *Because I see not that masters of families do lay restraint upon their families on the Sabbath night which is a hindrance of my work.*
4. *That the aforesaid was one article which I declared to the town when I first came.*
5. *I see several good reasons that I think it may be* [to the town's] *advantage for me to desert the town.*

Not finding these things answered I desire to leave. [1201]

NATHANIEL BOWERS

Nathaniel Bowers, from Rye, was extremely reluctant to serve the town, because of its well-known community strife and the required hardship of east and west society travel. He was enticed with lots of land and buildings, firewood and salary but initially declined. By July 1707, however, Bowers had relented and settled within the Old Society. Shortly thereafter, residents became disenchanted with his performance, and he "deserted" the town in 1709.[117]

JOHN JONES

John Jones of New Haven arrived in 1709 to minister to Greenwich Old Town, but he only served one year and petitioned the court for his back pay in 1711.

ENDURING STRIFE

Because the ecclesiastical court had imposed an unfunded ministry mandate on Greenwich, regardless of its awkward river logistics, the town repeatedly appealed for rules relief, minister tax relief and parish redistricting. The

court responded with gerrymandered parish boundaries that did not solve the town's travel problems. The court proposed a two-parish solution that was Horseneck Parish plus a second one that weirdly married Cos Cob on the west side of the river with (Old) Greenwich on the east side of the river. In 1712, it set the dividing line between the two parishes at the confluence of the Brothers Brooks, which is at the Post Road and Hillside Road, where Whelply's mill sat, possibly at the falls on the modern Greenwich High School property. In this illogical plan, having a parish divided in two by the Mianus River was locally untenable. The court also granted tax relief inequitably to one community over another, which further prolonged rancor between east and west societies.[118]

In 1714, (Old) Greenwich petitioned to have Horseneck help pay for its new minister, Mr. Sackett, and residents there proposed a good solution: to have the Colony's ecclesiastical court help them build a bridge across the Mianus, south of the Palmer Hill Road crossing. This would shorten the trip to the Horseneck Meetinghouse, "two miles at least and be directed from a cracked bad road to a direct straight line and good way for travelers abundant." Such a bridge would also be more "convenient for the post and the expediting occasions for both poor folk and society," and it would result in "the means to make this society and the whole town happy as to the public enjoyment of the ministry, [and] a means to heal our public contention… and make easier [his] majesties road presently great danger to travelers… being a frontier town next [to] her majesties province of New York." The Court appointed a committee to review this strategically brilliant bridge request, but sadly, this funding was denied.[119]

A Meetinghouse at Horseneck

In 1695, the same year that the Old Greenwich meetinghouse was built, Horseneck raised twenty pounds in taxes for its own building, combined with the proceeds from selling Jonathan Lockwood's house, which he had willed to the town. At first, the Horseneck building was to "stand upon the hill between Daniel Smith's house and the lot or house of Ephraim Palmer," but this was protested. The location then changed to "stand in the street between the house of John Renalds and the house of Joseph Ferris at or near unto the sawpit." At first, the meetinghouse was to be identical to that of the (Old) Greenwich structure, but it was quickly enlarged.[120]

The project ran into early cost overruns and continued site issues raised by (Old) Greenwich residents, and capital insufficiencies. By October 1703, passions for and against the building ran so high between communities that Jonathan Renals testified that he had heard several say that Old Town residents would "pull off the shingles [of a second building], as fast as we laid them on." People were warned off from despoiling either building. In 1704, additional money was raised by auctioning off some Upper Hassakey Meadow land.[121]

1715 Census: 51 Households[122]

The number of the inhabitants on the east side of Myanus River are 23 housekeepers.

The number of the inhabitants on the west side of Mianus River taken into the East Society by the dividing line as it now stands is 28 housekeepers.

The number of the inhabitants in the West Society of Greenwich called Horseneck is 26 housekeepers.

There are 19 of the 28 inhabitants as above mentioned that must be expected to come down the great hill to the public worship in case it be [illegible].

RICHARD SACKETT

In 1715, the court considered Horseneck's "sorrowful" complaints that it hadn't had a minister in years and recommended that a new minister should service Horseneck. It also advised that (Old) Greenwich should combine with Stamford as one parish. This would have only religious taxation implications and would not affect any other civil or tax responsibilities of (Old) Greenwich residents. Passed in the upper and lower houses of the court, this plan was utterly rejected by (Old) Greenwich, which immediately petitioned for a reconnection to Horseneck Parish. Newly established minister Richard Sackett relished the idea of leaving the tiny east society, and he transported himself across the river to preach in Horseneck. Horseneck then successfully petitioned the court in 1716 to become a distinct society, cleaving away from (Old) Greenwich.

Sackett's successor, Stephen Monson/Munson, recalled, "Many difficulties arose, which prevented the settlement of the ministry among them until the year 1717 [actually 1714], when the Rev'd Richard Sackit was ordained Nov.

27th. The number of males in the church when first gathered was 7." (His recall conflicts with a town census of 1715 listing twenty-three households in Old Greenwich, so seven males/seven households may have been the attendance in Horseneck.)

Mr. Sackett's twenty-plus-year Horseneck ministry ended, according to Munson, when he "died very suddenly May 7, 1727. He was well on the Sabbath May 6 and preached all day, and on Monday night following departed this life, leaving his church then consisting of ten males. The earthquake in 1727 was felt here, tho not so terribly as in other places. There was a very mortal sickness in town the same year." In 1727 and in 1723, local resident John Renald/Renals, the cooper, or barrel maker, covered for Sackett.[123]

On October 8, 1730, Horseneck men wrote to the general assembly for reimbursement for the settling of Mr. Sackett, a quarter century before, and for the expenses of Mr. Munson, who had just served for only one year. (Old) Greenwich residents also requested reimbursement money for their new, replacement meetinghouse and for tax relief. Both communities complained of their problems and the impositions of the court: "As small as our society is yet alas we seem not all one man's children.…[T]he burden seems almost too heavy. . . in our needy and deporable condition…"[124]

THE HORSENECK MEETINGHOUSE

Sackett's presence, plus tax relief, revitalized plans for a Horseneck Meetinghouse that was finally sited between the houses of Joseph Close and Ephraim Palmer. By 1716, twenty-five years after it was first proposed, the new building was completed and established by the court as the Church of Christ in the West Ecclesiastical Society of Greenwich. In 1860, Joel Linsley, minister of the second (Horseneck) Congregational Church in Greenwich, noted "on the occasion of meeting for the last time in the old house of worship" that the original Horseneck Meetinghouse stood "from 1716 to January 7, 1799… during the latter part of this time it was in a very dilapidated state.…Everything shows that the old building had become unsightly and uncomfortable and that it had been used until the last moment." A replacement had been built by 1799 for a cost of about $6,000. It sat on the same site as the original building, using the original seats from the first Horseneck Meetinghouse. An 1859 *Hartford Courant* newspaper account states that the old church was sold for $520, perhaps moved and refashioned into a home. Linsley recalled, "The pews joined upon the walls and were free for many years until they were rented

in 1802." The preacher's stand was a joiner's bench set behind the old pulpit. The building stood "in front of the western part of the new stone church—was a little the longest east and west—had square pews all-round the sides, and two on each side of the middle aisle. The stairs leading to the gallery were in the front corners of the house. There was a door in front, and one on each side, according to the fashion of those days; it was without turret or belfry, and had no paint to boast of, save that the pulpit was of a bluish color, and it did not lack the sounding-board."[125]

HORSENECK AND OLD GREENWICH PULPITS FACE LONG-TERM VACANCIES

Except for John Renalds, the cooper, who preached there in 1723 and 1727, the first meetinghouse in (Old) Greenwich remained vacant for eighteen years after Sackett's departure to preach in Horseneck in 1715.

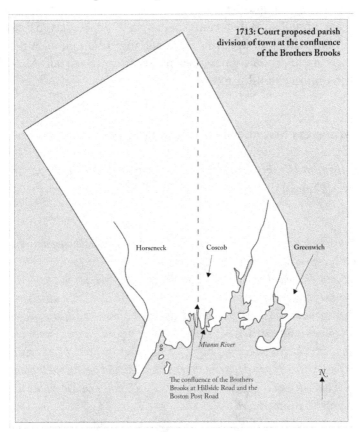

1713: Court proposed parish division of town at the confluence of the Brothers Brooks

Horseneck Coscob Greenwich

Mianus River

The confluence of the Brothers Brooks at Hillside Road and the Boston Post Road

N

EPHRAIM BOSTWICK, EBENEZER DAVENPORT AND BLACKLEACH BURRITT

At long last, in 1733, Ephraim Bostwick began his thirteen-year ministry in (Old) Greenwich. The following year, the court approved a request to build a new meetinghouse, "erected in the place where the old meetinghouse stood," which had been vacant. Financially burdened, the tiny community appealed to the court that "the charge…proves to be exceeding hard and heavy." It was granted fifty pounds. Two years later, there was another appeal for money, and by 1737, "the meetinghouse is erected, shingled, floored…and a good pulpit…also all the windows said meeting is shingled both the rough and sides cedar shingles."[126] After Reverend Bostwick's departure in 1746, the new (Old) Greenwich Meetinghouse remained empty for the next nine years. Ebenezer Davenport arrived in 1767 and stayed until 1773, when a colorful Loyalist, Blackleach Burritt, took over for a year. His ministry was interrupted by the American Revolution, when he was imprisoned. After Burritt left, the meetinghouse was unused, at least for religious services, for sixteen years, until Platt Buffett came to serve in 1796. He stayed for only one year after being struck by lightning while serving communion. A newspaper story, fifty years after the supposed event, recounts the details of this (Old) Greenwich minister's misfortune.

Two Ministers Struck with Lightning at the Communion Table

Burlington Weekly Free Press, Burlington, VT, July 22, 1842 (Originally reported in the *New York Observer*)

A correspondent at North Stamford, Conn. gives us the following narrative:
To the editors of the N.Y. Observer:
Sabbath day, the 3rd inst., was a solemn day to the people in this parish. The morning devotions in the house of God were ended, the exercises of the sacramental feast had commenced, the bread broken and distributed, the cup taken, when the house in which we were assembled was struck with lightning. The venerable Platt Buffet, of Stanwich was present, as assisted the pastor, Rev. Henry Fuller, in the exercises. He had poured out the wine, taken the cup, and was giving thanks to God, when he and Mr. Fuller were instantaneously prostrated to the earth.

The groans and shrieks which instantly broke forth from the congregation it is utterly impossible for me to describe; and yet there seemed to pervade the assembly the most solemn awe; all appeared to feel as if standing on the very verge of death. The bursting thunder, the vivid lightning, the thrilling scene within, continued to render the gloom most terrific.

Mr. Fuller was not so seriously injured, though feeling considerably affected in sore limbs. Mr. Buffet is very seriously injured; we suppose him dead for some ten minutes; no signs of life were apparent until water was presently thrown upon him. He still suffers great distress of the stomach.

The electric fluid entered the chimney top, descended to the stove pipe, and exploded immediately over the communion table, where those servants of God were standing.

Some others were slightly affected, though not so seriously.

WHY STANWICH WAS CREATED

A number of town families who lived in the northeastern section sent notice, in 1731, to the court that they intended to withdraw from Stamford, Horseneck and (Old) Greenwich Parishes and form their own parish.[127] This was because A) the pulpit was vacant in [Old] Greenwich; B) the pulpit was vacant in Stamford; C) Mr. Munson, Horseneck's minister, had just died; D) it was very inconvenient to travel to any of these three places from Stanwich; and E) Stanwich families didn't have enough horses for all to travel to other locations. A new third Stanwich parish would attract both Greenwich and Stamford residents and be four miles square in dimension. They felt they could afford it, "there being 45 families of us in the bounds hereof, and there be 62 male persons that are above 16 and under 50."

As a distinct parish or society, it would perhaps most importantly free Stanwich men from training with (Old) Greenwich and Horseneck militias and from paying minister taxes to either one of them, especially when either one lacked a minister. Stanwich had already hired their own minister, likely Benjamin Strong. Anticipating a positive response from the court, Stanwich residents had already "got a commendable meetinghouse raised." The location of the first Stanwich Meetinghouse was on the northwest corner of Taconic and North Stanwich Roads. The court initially denied this request however, because Stamford had not given permission for so many families to withdraw. Stanwich petitioners reminded the court that this permission was

impossible to receive, since Stamford had "neither magistrate nor justice of the peace." In 1732, the court agreed and directed Stanwich to give notice to Horseneck that it was now its own parish. A map was drawn of its new bounds, showing the meetinghouse located near Stamford's boundary, in the middle of the land boundary between Stamford and Greenwich. Finding it more convenient, and less expensive, nine Stanwich residents living in the southwest corner of Stanwich Parish decided to recant and stay with Horseneck Parish. These were the families living between Lake Avenue and North Street, just north of Clapboard Ridge Road.

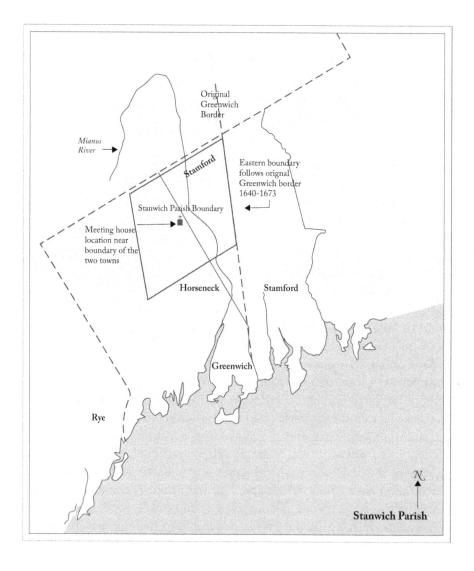

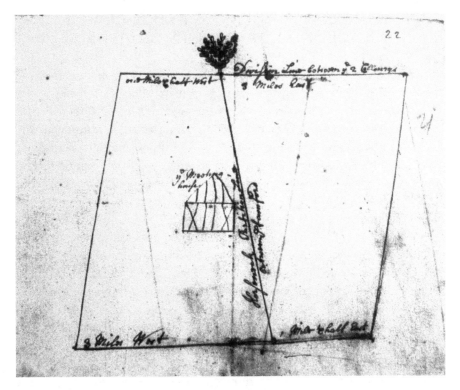

The CT Colony Court plan for Stanwich Parish, incorporating Stamford and Greenwich. *Connecticut State Library, Connecticut Archives,* Ecclesiatical Affairs, *IV:22.*

HORSENECK FIGHTS THE FORMATION OF STANWICH

Very quickly, disturbed Horseneck residents wrote the court as to why the Stanwich split should never, ever occur. They complained that siphoning off some of their parishioners would make it even harder for them to afford a meetinghouse or pay a minister and, it would prevent their own growth. Horseneck's prospects for growth suffered another blow in 1732, when one hundred families living on the western border of town also requested secession. They wished to establish an Episcopalian society called the Church of England of King Street. This reflected successful Anglican inroads made by Colonel Caleb Heathcote and the Reverend Muirson from Rye. In less than one hundred years, the dream of a purely Puritan Greenwich was denied by the Quakers and Episcopalians. Horseneck's petition to prevent the formation of Stanwich was denied in 1733.[128]

"THE REMARKABLE COLDNESS AND BACKWARDNESS OF SOME AND INDIFFERENCE OF OTHERS"

By 1755, Connecticut Colony leaders again sought to annex the tiny population of (Old) Greenwich with Horseneck. They "lay before your honors the melancholy state of the estate and society of Greenwich, a place within our district. They have been without a settled minister of the gospel for about nine years together [since 1746] and that after all proper pains taken by us in order to bring them to what we judge proper…several schemes or methods have been proposed and pressed upon them." But "they are indeed so small a people.…[T]hey are not able themselves to settle and support a minister among them…a difficult case."

Horseneck and Old Greenwich made it clear they did not want to be reunited for the same reasons as always. The long, troubled church history of Greenwich was reviewed in May 1756. The court "consider[ed] the temper and disposition of many of the inhabitants in both the East and West societies, the remarkable coldness and backwardness of some and indifference of others and…we your honorable petitioners must confess and lament it to be very true."[129]

The court recognized that Greenwich had never embraced any of its previous prescriptions yet once more proposed the old solution, which Greenwich once again ignored, of dividing the two parishes at Hillside Road, putting the Mianus River through the center of the east society, a combination of Cos Cob and (Old) Greenwich as one parish. They felt the plan might now work since "the population west of the Mianus has grown significantly in the 40 years since 1713" and "is as large if not larger than the list of those who live east of said river." (Old) Greenwich and Horseneck, however, continued to draw the line between parishes at the Mianus River.[130]

THE ANGLICANS ARRIVE

Colonel Caleb Heathcote, who owned most of Scarsdale and, for a time, over sixty acres in Cos Cob, championed the introduction of the Anglicans, or Episcopalians into Rye and Greenwich. He criticized Connecticut Puritan towns hosting ministers who were not ordained, noting, "Many, if not the greatest number among them, being little better than in a state of heathenism; having never been baptized nor admitted to the communion"

and indicated this was true for about twenty Greenwich residents. For Connecticut in general, he opined, there were an "abundance of odd kinds of laws" and an "endeavor to keep the people in as much blindness and unacquaintedness with any other religion as possible." They "looked upon [the Episcopal Church as] the most dangerous enemy they have to grapple with…an abundance of pains is taken to make the ignorant think as bad as possible of her" and that more than half the people "think our church to be little better than the Papist."[131]

Heathcote and the Reverend George Muirson from Rye were successful in their efforts, aided further by James Wetmore and James Caner. In 1749, the Episcopalian Horseneck Chapel, thirty-six feet long and twenty-five feet wide, with windows, was built. It stood for seventy-two years, ministered by Ebenezer Dibble. It blew down in a gale in 1821. This building was replaced in 1832 and called Christ Church. The current stone building was erected in 1857.

Ministers and Meetinghouses: A Timeline

Founders' children were baptized in Dutch Fort Amsterdam, Manhattan, in the 1640s. After 1656, under New Haven Colony jurisdiction, Greenwich residents likely traveled to Stamford for services until 1669.

NAME	TERM	YEARS	SERVICE LOCATION
Eliphalet Jones	1669–73	4	[Old] Greenwich
No Old Greenwich Minister	1673–77	4	[Old] Greenwich
Jeremiah Peck	1678–89	11	[Old] Greenwich
Abraham Person/Pierson	1691–94	3	[Old] Greenwich
[Old] Greenwich 1st Meetinghouse finished	1695		[Old] Greenwich
Solomon Treate	1696	1	Both societies
Joseph Morgan	1697–1700	3	Both societies
No [Old] Greenwich Minister	1698–1706	8	[Old] Greenwich
Nathaniel Bowers	1707–10	3	Both societies
John Jones	1710	1	Both societies

Name	Term	Years	Service Location
No [Old] Greenwich Minister	1710–12	2	[Old] Greenwich
Richard Sackitt/Sackett	1712–17	5	[Old] Greenwich
No [Old] Greenwich Minister	1728–33	6	[Old] Greenwich
Ephraim Bostwick	1733–46	13	[Old] Greenwich
[Old] Greenwich Replacement of 1st Meetinghouse	1737		[Old] Greenwich
No [Old] Greenwich Minister	1746–67	21	[Old] Greenwich
Ebenezer Davenport	1767–73	6	[Old] Greenwich
Blackleach Burritt	1779	1	[Old] Greenwich
Horseneck 1st Meetinghouse finished	1716		Horseneck
No Horseneck Minister	1716–18	2	Horseneck
Richard Sackitt/Sackett	1718–27	9	Horseneck
Temp. John Renalds, cooper	1723 & 1727		Horseneck
Stephen Monson/Munson	1728–30	2	Horseneck
Horseneck Chapel (Anglican/ Episcopal) finished	1749		Horseneck
Abraham Todd	1733–72	39	Horseneck
Jonathan Murdock (Tory)	1774–84	10	Horseneck
Horseneck Cong. 2nd Replacement Meetinghouse finished	1799		Horseneck
Isaac Lewis	1786–1818	32	Horseneck
Isaac Lewis Junr	1818–28	10	Horseneck
Joel Mann	1830–36	6	Horseneck
Noah Coe	1837–45	8	Horseneck
Joel Linsley	1847–63	16	Horseneck
Horseneck Cong. 3rd Stone Replacement Meetinghouse	1858		Horseneck

NAME	TERM	YEARS	SERVICE LOCATION
Stanwich Meetinghouse finished	1732		Stanwich
Benjamin Strong	1735–67	32	Stanwich
No Stanwich Minister	1767–74	7	Stanwich
William Seward	1774–94	20	Stanwich
Platt Buffet	1796–1835	39	Stanwich

1730 Census[132]

The names and lists all the persons underwritten belonging to the West Society in the Township of Greenwich

[Name]	£	pence
Charles Taylor	24	00
Jonathan Austin	98	00
Joshua Mead	46	13
David Palmor	54	12
Samuel Hurley	47	10
Benjamin Knapp	67	10
John Brush	97	07
Daniel Wheaton	32	00
Abraham Hubbert	39	00
Nethaniel Ferris	60	08
Daniel Hubbert	71	10
John Perry	22	00
Stephen Brosh	33	00
Benjamin Brush	84	08
Joseph Palmer	52	10
Jonathan Finch	98	04
Peter Palmor	56	04
Henry Smith	34	00
John More	47	00
Samuel Palmor	71	00
John Ferris Junior	46	06

The Quakers that have tickets out of the other side namely

David Palmor, his list	54	12
Daniel Wheaton, list	37	00
Peter Palmor, list	56	04

The churchmen that have assigned to the maintenance of the Church of England minister out of the other side namely

Charles Taylor List	24	16
Jonathan Aickling	98	10
Benjamin Knapp	67	10
John Brush	97	10
Nathhaniel Ferris	60	18
Joseph Knapp	142	10
The Quakers List above	142	16
Total Church & Quakers	532	11

A true copie of the list of the persons above name taken
In the year 1730
James Reynolds, Listers
Jonathan Holmes
Joshua Reynolds

1739 LIST OF ESTATES[133]
(PROPERTIES EAST OF THE MIANUS RIVER)

Greenwich list taken in the year 1739 by us listers which is 15960-4 s- 6p [Period document figure]

John Borly	41-9-0
Nomicah Knap	96-0-0
Henry Atwood	52-16-0
Jonathan Whelply	29-9-0
Joseph Lockwood Junr	83-09-0
Abraham Nickels	35-00-0
Acariah Winchel	20-0-0
Moses Smith	80-10-0
Gershom Lockwood Junr	80-19-06
Gershom Lockwood	93-02-06

Samuel Ferris	74-07-06
Widow Mary Ferris	52-04-0
Nathaniel Heusted	89-13-0
Joseph Heusted	16-10-0
Peter Peck	46-00-0
Samuel Peck	46-00-0
Abraham Knickell	13-00-0
Caleb Knap	86-00-0
Timothy Knapp	21-00-0
John Palmer Junr	80-00-0
Zachariah Alen	18-00-0
Jonathan Rodgers	21-00-0
John Gune	18-00-0
John Mead	18-00-0
John Mecok	18-00-0
Nathaniel Jeames	18-00-0
William Gensen	18-00-0
Reuben Mead	18-00-0
John Reed the third	18-00-0
Jonathan Lockwood	28-00-0
Daniel Lockwood	77-00-0
Samuel Lockwood	62-00-0
Samuel Adams	22-00-0
William Shaw	18-00-0

333-10-0 [actual document figure]

Friends [Quakers]	
Nathaniel Peck	10-00-0
John Hiatt	30-00-0
John Peck	50-00-0
Robert Peck	40-00-0
John Brush	60-00-0
Jonathan Whelply	80-00-0
Thomas Johnson	10-00-0
Reuben Mead	06-00-0
Abraham Rundell	50-00-0
Nathaniel Heusted the 3rd	50-00-0
Jonathan Lockwood	10-00-0

3187-10-0 [actual document figure]

Greenwich list taken in the year 1739

John Avery	37-0-0
John Husted	14-0-0
Joseph Pardey	20-0-0
For head	
Abraham Pinito [Videto?]	30-0-0
Jonathan Hibbard	05-0-0
Samuell Worden	06-0-0
Justus Mead	05-0-0
Justus Buch Mead	50-0-0
Thomas Hoostead	10-0-0
Jeams Cummill	10-0-0
Loranes Scott	12-0-0
Justus Bush	12-0-0
Joseph Sherwood	10-0-0
Thomas Lyon	10-0-0
Richard Rodgers	10-0-0
Samuel Lyon	10-0-0
William Robyson	10-0-0
Henry Fromkling	20-0-0
Ezekial Lockwood Junr	08-0-0
Jenkins Pett	03-0-0
Joshua Knap	10-0-0
Joseph Barton	08-0
Stephen Houling	05-0
Benjamin Cloos	05-0
Jonathan Hubby	05-0
SamuelBrush	05-0
Elisha Mead	04-0
John Chapman	06-0
John Johnson	10-0
Col. B. Finch	05-0
Phipes Barber	05-0
Henery [?] Palmore	09-0
Daniell Ogden	09-0
John Joyce	08-0
Herbert White	06-0
Israel Mead	05-0
Daniell Worden	03-0

Robert [?]	10-0
John Slatur	08-0
Ch Parson	10-0
Thomas Kirk Junr	08-0

Greenwich List taken in the year 1739 by us Listers
John Palmer Junr
Joshua Renolds
John Ferris
Nathaniel Finch
Entered December the 20th day 1739
Mr. John Knap Recorder

NOTES

The transcribed Town of Greenwich Archives located in the Town of Greenwich Town Hall Vital Records Vault include:

Land Records Book One Part One:	*Documents #1–406A*
Land Records Book One Part Two:	*Documents #407–733*
Land Records Book Two Part One:	*Documents #1275–1552*
Common Place Book One:	*Documents #734–1176*
Common Place Book Two:	*Documents #1177–1272*

This document and page numbering sequence has been developed to supplement the numbering system used by the Grantee/Grantor Index Book #1. Numbered stickers have been placed on all pages of the transcribed books to note both page number and document number such that citations may read: [GLRB 1 / 2: 114, Doc. #167] (Greenwich Land Record Book One Part Two, Page number 114, Document #167, or by document number alone: [###]. References in this text to a specific document appear as [100], which means Document #100.

Chapter 1

1. E.B. O'Callaghan, ed., *Documents Relative to the Colonial History of the State of New York* (Albany, NY: Weed, Parsons and Company, 1856) 15 vols., 1:142, 542–43 (hereafter referred to as DRCHSNY).

2. Missy Wolfe, "Always a Wayward Daughter: The First Dutch Jurisdiction of Greenwich," *Connecticut History Review* 54, no. 2 (Fall 2015): 193–216.

3. Ebenezer Hazard, *Collections of the New York Historical Society for the Year 1809* (New York: L. Riley, 1811), 274.

4. E.B. O'Callaghan, trans., *History of New Netherland or New York Under the Dutch* (New York: D. Appleton, 1845), 1:252.

5. Charles J. Hoadley, *Records of the Colony and Plantation of New Haven, from 1638 to 1649* (Hartford, CT: Case, Tiffany and Company, 1857), 110.

6 A.J.F. Van Laer, trans. and ed., *Council Minutes 1638–1649* (Baltimore, MD: Genealogical Publishing Company, 1974), 487, Doc. #305; personal communication with Dr. Charles T. Gehring, November 1, 2009.

Chapter 2

7. It has been discovered that Greenwich resident Susannah Lockwood shared the same maiden name, Alford, as did Hallett's mother, and he may have been her nephew.

8. Van Laer, *Council Minutes 1638–1649*, 487–88; Town of Greenwich Archive Document no. 365 (Hereafter referred to as [###]).

9. Missy Wolfe, *Insubordinate Spirit: A True Story of Life and Loss in Earliest America* (Guilford, CT: Globe Pequot Press, 2013). A full treatment of the dramatic life of Elizabeth Fones Winthrop Feake Hallett.

10. DRCHSNY, 14:116.

11 Charles Gehring, trans., *Correspondence 1647–1653* (Syracuse, NY: Syracuse University Press, 1982), xvi.

12. DRCHSNY 13:24; in Charles T. Gehring, ed. and trans., *Land Papers Volumes GG, HH & II* (Baltimore: Genealogical Publishing Company, 1980), 62–63, Doc. GG 222, the Byram River is said to be the Seweyruc here, but in personal communication on March 28, 2015, Dr. Gehring allows it is more likely the Seweyruc is Stamford's Mill River. Linguists in the 1800s consistently stated that the native name of the Byram River was the "Armonck," or "Armaug." See Edward Manning Ruttenber, *History of the Indian Tribes of Hudson's River* (Albany, NY: J. Munsell, 1872), 367, also William Martin Beauchamp, *Indian Names in New York* (Baldwinsville, NY: H.C. Beauchamp Recorder Office, 1893), 89.

13. Malcolm Freiberg, ed., *The Winthrop Papers 1650–1654* (Boston: Massachusetts Historical Society, 1992), 6:17–18.

14. Gehring, *Correspondence 1647–1653*, xiv.

15. Ebenezer Hazard, *Historical Collections: Consisting of State Papers and Other Authentic Documents* (Philadelphia: T. Dobson, 1794), 2:178.
16. O'Callaghan, *History*, 2:227.
17. Freiberg, *Winthrop Papers*, 6:68–69.

Chapter 3

18. Robert Steven Grumet, *The Munsee Indians, A History* (Norman: University of Oklahoma Press, 2009), 330–31, Siwanoy word placement on Long Island.
19. Ibid., 32, Delaware origins. See also Ruttenber, *History*, 366, and Robert Bolton, *History of the County of Westchester* (New York: A.S. Gould, 1898), 1:182, defined Wiechquaesgeck place of the bark kettles.
20. DRCHSNY, 1:186–88. Dutch massacre document.
21. J. Franklin Jameson, and Wendell Hosmer, eds., *Winthrop's Journal 1630–1649* (New York: Charles Scribner's Sons, 1908), 153–54.
22. DRCHSNY, 1:186.
23. Freiberg, *Winthrop Papers*, 4:188–189. John Winthrop considers Kieft's request a Dutch plot to involve the English against the Indians.
24. DRCHSNY, 1:187.
25. Ibid., 2:205, document no. 101b, Underhill's tavern rampage.
26. Jeanne Magdalany and Edith Wicks, *The Early Settlement of Stamford, Connecticut 1641–1700* (Bowie, MD: Heritage Books, 1990), 14, map of Stamford.
27. DRCHSNY, 1:213, massacre aftermath.
28. Ibid., 13:23–24, lenient Indian policy.

Chapter 4

29. Ann Lloyd married Thomas Yale before she married Theophilus Eaton. Her children by Yale were Ann, David and Thomas Yale. Ann Yale would marry Edward Hopkins, a governor of Connecticut who owned the land on which modern Hopkins School stands in New Haven. David Yale was the father of Elihu Yale, namesake of Yale University. Thomas Yale was a signer of the Fundamental Agreement of the New Haven Colony.
30. Hoadley, *Records*, 185.
31. Ibid., 243–47.

32. Charles M. Andrews, *The Rise and Fall of the New Haven Colony* (New Haven, CT: Yale University Press, Tercentenary Commission of the State of Connecticut Committee on Historical Publications, 1936), xlvii.

Chapter 5

33. Greenwich Town Archive document #10 (hereafter [10]).
34. [1123], cansey/cassy/cosse work was the word used for bridge or bridgebuilding.
35. [827].
36. [168].
37. [1039].
38. Marion Hobart Reynolds, *The History and Descendants of John and Sarah Reynolds: 1630?–1923, of Watertown, Mass., and Wethersfield, Stamford and Greenwich, Connecticut* (Greenwich, CT: Reynolds Family Association, 1924), 37–38; [330, 1226].
39. Freiberg, *Winthrop Papers*, 5:362, Martha Johana letter.

Chapter 6

40. [5, 879].
41. [415].
42. New York Historical Society, *Map of Stamford Township*, M3.44.31, April 21, 1789, H. Holly.
43. Connecticut State Library, Connecticut Archives, *Towns and Lands*, I:157; James Trumbull, ed., *Public Records of the Colony of Connecticut* (Hartford, CT: Case, Lockwood & Brainard Company, 1852), 202–3.
44. *Towns and Lands*, I:13; Elijah Baldwin Huntington, *A History of Stamford* (Stamford, CT: Wm. W. Gillespie & Company, 1868), 457.
45. Spencer Mead, *Ye Historie of Ye Town of Greenwich* (Harrison, NY: Harbor Hill Books, 1979), 51–53, Greenwich patent.
46. Philip J. Schwarz, *The Jarring Interests: New York's Boundary Makers 1664–1776* (Albany, NY: SUNY Press, 1979); [715, 736, 866, 867, 869, 882, 899. 901, 905, 1079, 1100, 1110, 1133, 1134, 1187, 1196, 1231].
47. [42,43].

Chapter 7

48. New York Historical Society map, *From Sawpitts to Stanwich, Stamford, Bedford, & Pine's Bridge on Croton River. No. 24*, Robert Erskine (1735–1780), Simeon DeWitt (1756–1834), Richard Varrick De Witt, donor, United States, Continental Army Surveying Department.
49. [21, 33, 159, 170, 1174].
50. [180, 185, 843, 1075, 1076, 1178].
51. [834, 1329, 170, 872]; Havemeyer was named Shady Lane on the 1853 Bissell Map and was likely an extension of Lattings Rock Road.
52. Laddings Rock is named for Richard Latting, who moved on from Greenwich to found Lattingtown, on Long Island, very near to where John Underhill and some of the Feake sons lived. The "Legend of Laddings Rock," wherein Indians chase European men off this cliff, printed in the *(NY) Evening Post* on June 11, 1849, page 1, is unsubstantiated.
53. [865].

Chapter 8

54. Livestock was pastured in Cos Cob well before families established homelots there.
55. [636, 1398, 74, 69]. The Blind Garden in Mianus Neck Field (Riverside) place name may have derived from a Puritan devotional. The will of Jonathan Renalds calls his property the Blind Garden, perhaps the same.
56. [256, 1107, 1137, 321, 258]. The location and purpose of "Seller Neck" (Sailor Neck?) is not documented. Shell middens were large shell piles created over centuries by Indians casting away shells. If the Dinnering Rock still exists, it is an important early geographic feature.
57. [1060]; Freiberg, *Winthrop Papers*, 6:35.
58. [694]; Connecticut State Library, Connecticut Archives, *Private Controversies*, VI:70, VI:69.
59. DRCHNY 13:24. Mention of the Kechkawes and the Seweyruc in the Stuyvesant purchase of eastern Greenwich called "Deed to Westchester County, Eastern Half"; Grumet, *Munsee Indians*, 296, notes that Seyseychimmus was originally from Long Island and he moved to Wiechquaesgeck and later Wappinger territories after selling his lands in Brooklyn; Beauchamp, *Aboriginal Place Names*, 242–45, 247, reports Kechkawes is Maharnes/Mianus, meaning a chief or principal stream.

Meharnes is Mianus is the Kechkawes; Kechkawes is the Mianus River in *Proceedings of the New York State Historical Association* (1906), 6:35; Foster Harmon Saville, "Within a Montauk Cemetery at Easthampton," *Long Island* 2, no. 1; Reginald Pelham Bolton, *New York City in Indian Possession* (New York: Heye Foundation, 1920), 263. The Kechkawes is the Mianus River.

60. [838].
61. [875].
62. [918].
63. [704, 707, 1053].

Chapter 9

64. [1093, 1033, 1112].
65. [1238, 1241].
66. [8, 909, 910, 912].
67. [233, 83, 89].
68. [104, 1536, 1451]. The steps carved into granite at the top of the great ridge by Old Church Road are a 1902 construction. The first steps down the Great Ridge were individually placed stepping stones. Spencer Mead, *Ye Historie*, 165, states that the original road "before reaching the brink of the precipice ran nearly east and west, then turning a short right angle ran north about thirty rods [500 feet], when it turned directly about and ran south along and under the precipice to about five rods [83 feet] below the causeway forming the present road, where it again turned eastward." Mead also reports that the old steps were removed before the Revolutionary War.
69. [67, 741, 744, 778, 779].
70. [36, 93, 233, 379, 1029].
71. [7, 1136, 1237, 617, 970].
72. [996, 1000, 1120].
73. [1029, 1044, 1051, 1089].
74. [673].
75. [31, 1123, 1288].
76. [1117, 1147].
77. [686, 1130, 1138, 1284].
78. [355, 688, 1143, 1280].
79. [974, 982].

Chapter 10

80. [28, 135, 822, 824].
81. [578].
82. [746, 1063].
83. [126, 673, 904, 1063, 126].
84. [214, 171, 194, 548, 570, 670, 1303].
85. [1034, 1035].
86. [208, 683, 1298].
87. [300, 1114, 1124, 668].
88. [1154].
89. [668, 1156].
90. [1045].
91. [1045, 1112, 1045, 1046,1162].
92. [1194].
93. [288, 414, 401, 555, 556, 557, 559, 560, 985].
94. Reynolds, *History and Descendants*, 35–37.
95. [398, 334, 309, 418, 335].

Chapter 11

96. [1034, 1054, 1122].
97. [1005].
98. [776, 946, 1028, 1057, 1086, 1199].
99. [740, 745, 880, 846, 1215, 1030, 1044, 1045, 1073].
100. [1111, 1159, 1185].

Chapter 12

101. [978, 260, 277, 346, 771, 1035, 1186, 262, 1064, 261, 1119, 347].
102. [585, 986, 1416, 1437].
103. [277, 1186, 1063, 1187, 1302].
104. [926, 927, 1227, 985, 984].
105. [976].
106. [979, 1006, 986, 1002].
107. [1276].

Chapter 13

108. [78, 856, 894, 895].
109. [1082].
110. [1082].
111. [920, 921, 928, 930].
112. [934, 936, 944, 946, 769, 961, 1040].
113. [1080, 1087, 1089].
114. [896, 1070, 1071, 1086, 1088, 1096].
115. [303, 376, 1096, 1106, 1098, 1099, 1112].
116. [956, 1118, 1119, 1127, 1201,1128].
117. [1145, 1153, 1154, 1246, 1276, 1115, 1282]; Connecticut State Library, Connecticut Archives, *Ecclesiastical Affairs*, 1:173; *Towns and Lands* 2:116, 1:110–20. Nathaniel Bowers relationship to John Bowers is unknown. John Jones back pay, *Ecclesiastical Affairs*, 2:25a.
118. *Ecclesiastical Affairs*, 1:194–96, 2:31; [966, 1140].
119. *Ecclesiastical Affairs*, 2:28, 1:94, 2:32–33a, b.
120. [1086, 1089, 1096, 1104, 1091, 1153].
121. [1203, 1313, 1234, 1286]; *Ecclesiastical Affairs*, 1:166.
122. *Ecclesiastical Affairs*, 2:37.
123. Ibid., 2:41, 43; [983, 1237, 997]; J. Hammond Trumbull, *Collections of the Connecticut Historical Society* (Hartford, CT: Case, Lockwood & Brainard Company, 1895), 3:312–13. "John Renalds, cooper" distinguishes him from his period contemporary "John Renalds," in the archives and on tally lists.
124. *Ecclesiastical Affairs*, 3:232.
125. Joel H. Linsley, DD, *A Commemorative Discourse Delivered on the Occasion of Meeting for the Last Time in the Old House of Worship of the Second Congregational Church in Greenwich, December 5ᵗʰ 1858* (New York: John A. Gray, 1860).
126. *Ecclesiastical Affairs*, 5:89.
127. Ibid., 4:7, 4:10, 4:14, 4:15, 4:19, 4:21, 4:22 (map).
128. Ibid., 10:176.
129. Ibid., 10:176.
130. Ibid., 10:177.
131. George P. Fisher, Timothy Dwight and Wm. L. Kingsley, eds., *The New Englander* (New Haven, CT: Thomas J. Stafford, 1866), 296.
132. *Towns and Lands*, 17–18.
133. [968].

INDEX

ABOUT THE AUTHOR

M issy Wolfe has also published a comprehensive study of the life of Greenwich founder, Elizabeth Winthrop Feake Hallett, and the northeastern Munsee massacres called *Insubordinate Spirit: A True Story of Life and Loss in Earliest America* (Guilford, CT: Globe Pequot Press, 2013), which won the Washington Irving Medal for Literary Excellence. She also published "The First Dutch Jurisdiction of Greenwich," an article providing proofs on this subject in the Fall 2015 *Connecticut History Review*. She attended Columbia Business School, experienced an advertising and marketing career and raised a family of three fine children with her husband, Scott Wolfe. She received certification in fine arts appraisal at New York University and serves on the board of the New York Genealogical and Biographical Society. Her nonfiction research reveals the lost world of Connecticut in the First Period.